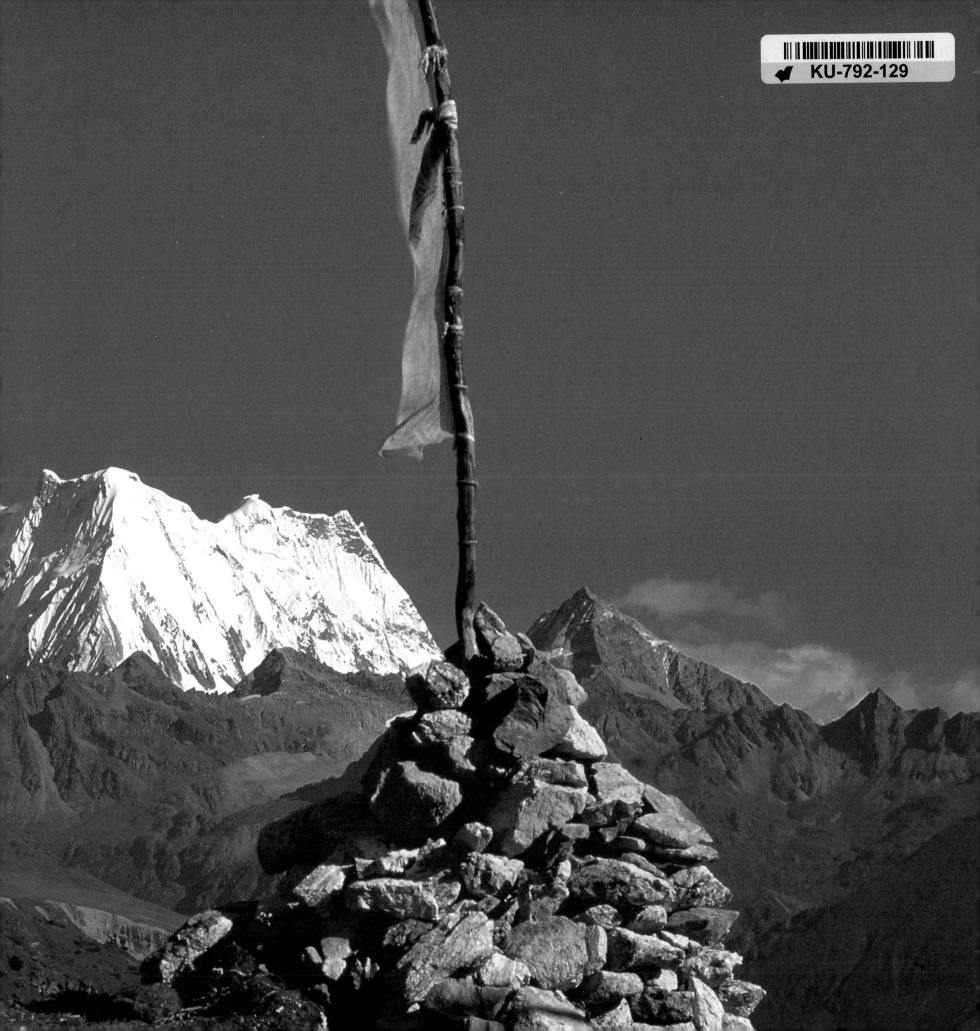

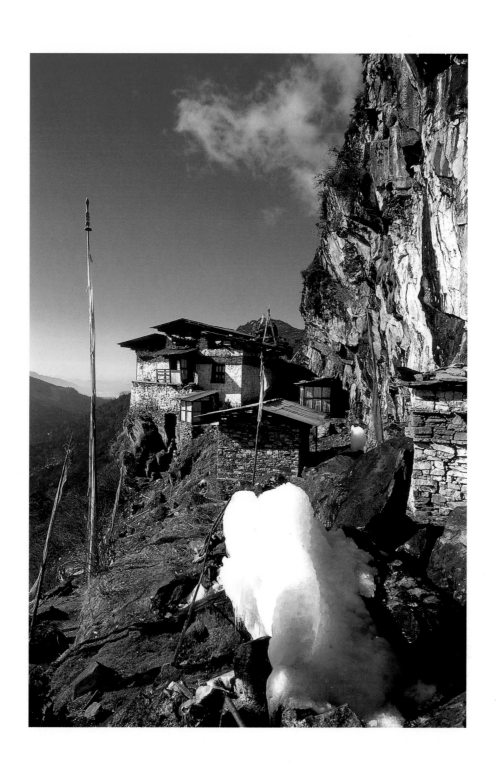

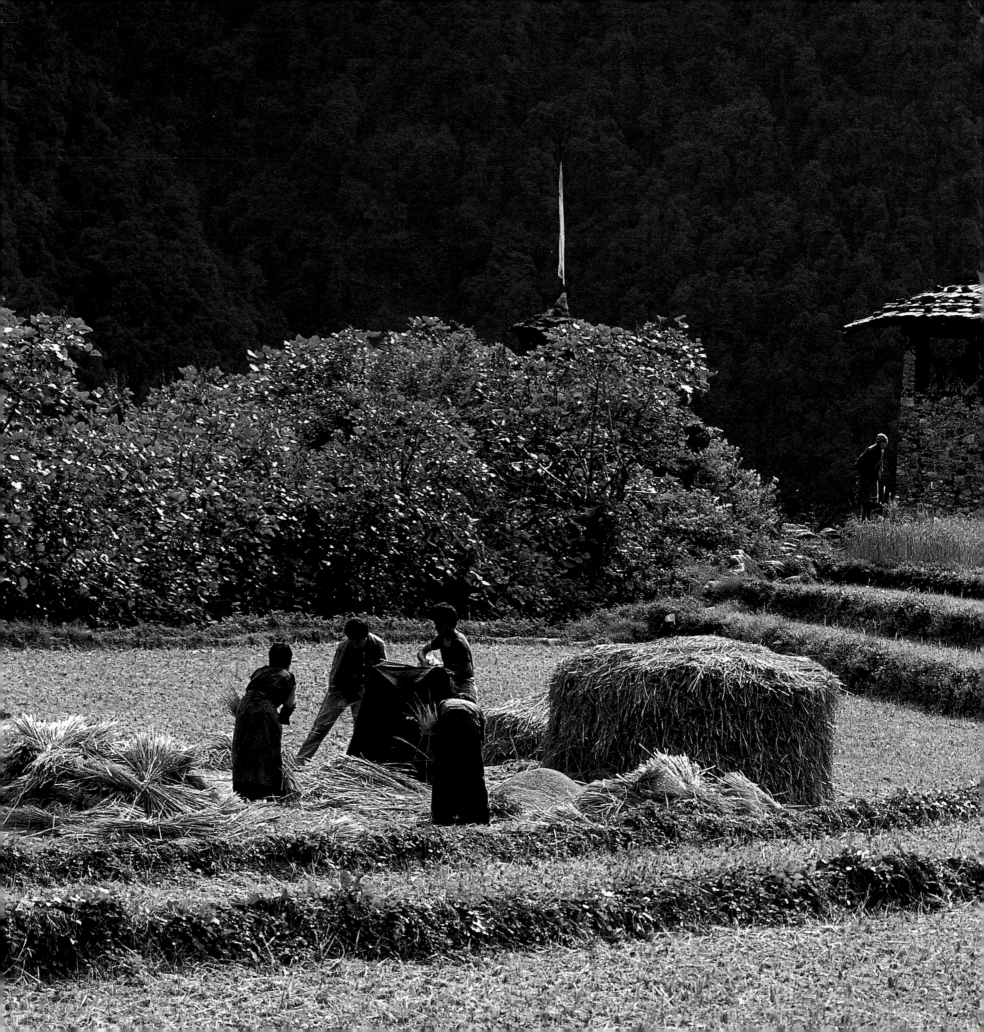

BHUTAN

KINGDOM OF THE DRAGON

Robert Dompnier

LOCAL COLOUR

Local Colour Limited
Unit 504, 5th Floor, Westlands Centre,
20 Westlands Road, Quarry Bay, Hong Kong
E-mail: ppro@netvigator.com

A CIP catalogue record for this is available from the British Library

Distributed in the United Kingdom and Europe by Hi Marketing
38 Carver Road, London SE24 9LT
Fax: (0171) 274 9160

Distributed in Australia and New Zealand by Allen & Unwin
9 Atchison Street, St Leonards, Sydney, NSW 2065
Fax: (61 2) 9906 2218

ISBN 962-8711-02-4

Editor: Tom Le Bas

Map: Tom Le Bas

Picture editor: Geoff Cloke

Design: Philip Choi, Geoff Cloke

Printed and bound in Hong Kong

Front jacket: Gasa Dzong and Kangbum mountain (6500 m).

Back jacket: Wangdue Phodrang in the morning light.

Front endpapers: Kangchenta (6800 m) from the Jarela pass, on the track from Lingzhi to Laya.

Half title page: Phajoding, Thugjedra temple, where Phajo Drugom Shigpo meditated.

Title spread: Autumn harvest at Goem Tamji, on the way to Gasa.

Back endpapers: Tserim Kang (6535 m) from the Jarela pass, on the track between Lingzhi and Laya.

CONTENTS

Bhutan

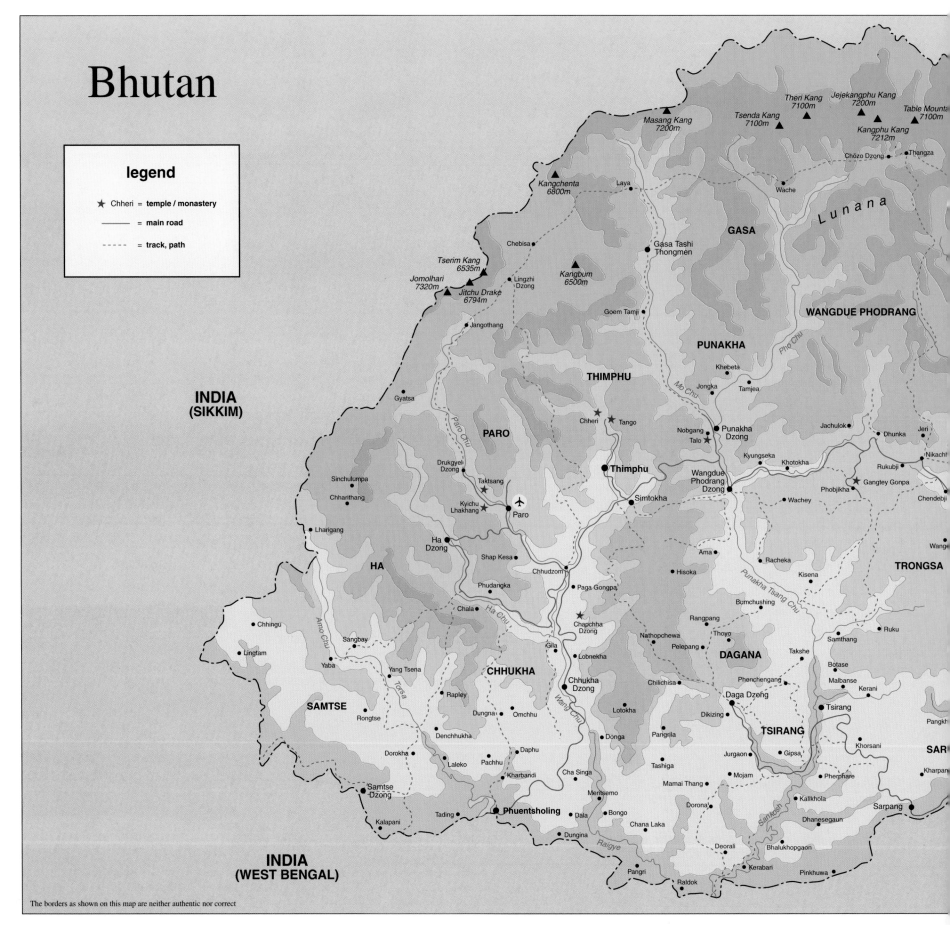

legend

★ Chheri = temple / monastery

—— = main road

- - - = track, path

INDIA
(SIKKIM)

INDIA
(WEST BENGAL)

Masang Kang
7200m

Theri Kang
7100m

Tsenda Kang
7100m

Jejekangphu Kang
7200m

Table Mountain
7100m

Kangphu Kang
7212m

Chözo Dzong ● Thangza

Lunana

Kangchenta
6800m

Laya ● Wache

GASA

Chebisa ● Gasa Tashi
Thongmen

Tserim Kang
6535m

Lingzhi
Dzong

Kangbum
6500m

WANGDUE PHODRANG

Jomolhari
7320m

Jitchu Drake
6794m

Goem Tamji

PUNAKHA

Jangothang

Khebeta

THIMPHU

Jongka ● Tamjea

Gyatsa

Chheri ★ Tango ★

Nobgang ● Punakha
Dzong

Jachulok ● ● Dhunka Jeri

PARO

Talo ★

Kyungseka

Khotokha

Rukubji ● Nikachl

Sinchulumpa

Drukgyel
Dzong

Taktsang ★

● Thimphu

Wangdue
Phodrang
Dzong

★ Gangtey Gonpa
Chendebji

Chharithang

Kyichu
Lhakhang ★

✈ Paro

Simtokha

Phobjikha ● Wachey

Lharigang

Ha
Dzong

Shap Kesa

Chhudzom

Ama ● Racheka

TRONGSA

HA

Phudangka

Paga Gongpa

Hisoka

Kisena

Wang

Chala

Ha Chu

★ Chapchha
Dzong

Bumchushing

Chhingu

Sangbay

Gila

Lobnekha

Nathopchewa

Rangpang

Ruku

Lingtam

Yaba

Yang Tsena

CHHUKHA

Chilichisa

Pelepang

Thoyo

DAGANA

Samthang

Takshe ● Botase

SAMTSE

Rongtse

Rapley

Dungna ● Omchhu

Chhukha
Dzong

Lotokha

Dikizing

Daga Dzong

Phenchengang

Malbanse ● Kerani

● Tsirang

Denchhukha

Donga

Pangrila

TSIRANG

Khorsani

Dorokha

Daphu

Cha Singa

Jurgaon ● Gipsa

SAR

Laleko

Pachhu

Kharbandi

Tashiga

Mojam ● Pherphare ● Kharpan

Kalapani

Samtse
Dzong

Tading

● Phuentsholing

Meritsemo

Dala ● Bongo

Mamai Thang

Dorona

Kalikhola

Sarpang

Chana Laka

Dhanesegaun

Dungina

Pangri

Raldok

Raigye

Deorali

Kerabari

Bhalukhopgaon

Pinkhuwa

The borders as shown on this map are neither authentic nor correct

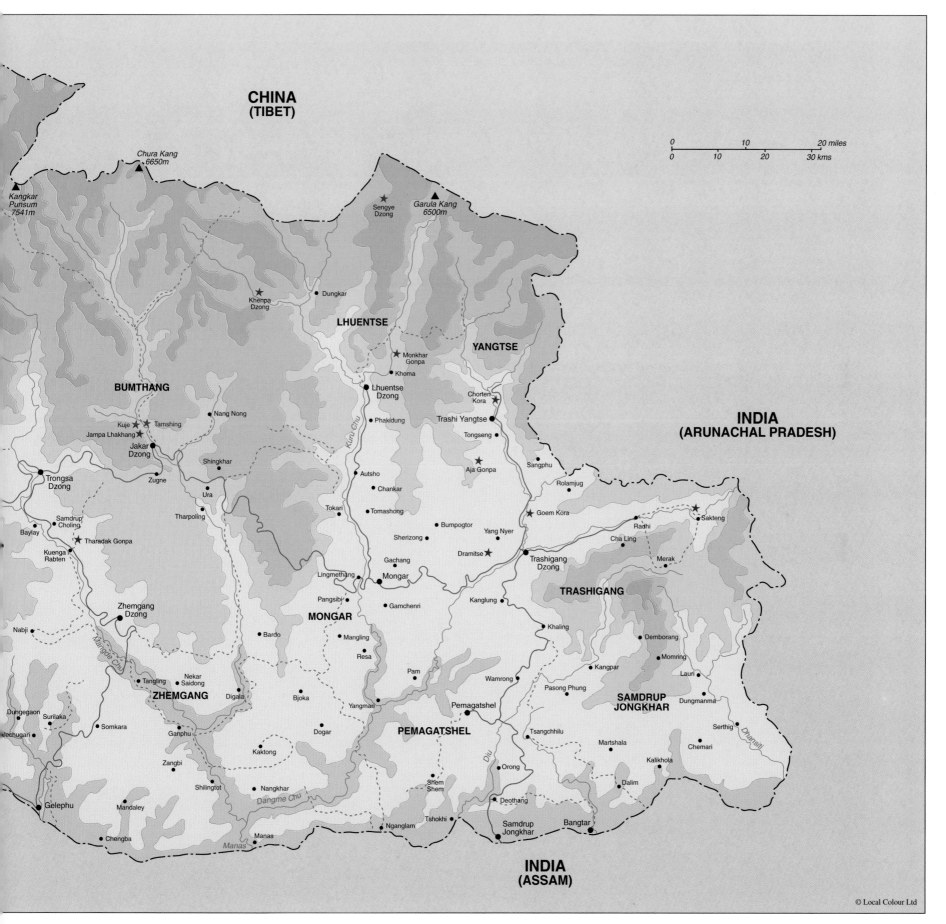

CHINA
(TIBET)

▲ Kangkar Punsum 7541m

▲ Chura Kang 6650m

★ Sengye Dzong

▲ Garula Kang 6500m

★ Khenpa Dzong

● Dungkar

LHUENTSE

YANGTSE

INDIA
(ARUNACHAL PRADESH)

BUMTHANG

★ Monkhar Gonpa

● Khoma

● Lhuentse Dzong

★ Chorten Kora

● Nang Nong

★ Kuje ★ Tamshing

● Phakidung

● Trashi Yangtse

Jampa Lhakhang ★

● Tongseng

● Jakar Dzong

● Shingkhar

● Zugne

● Trongsa Dzong

● Ura

● Autsho

★ Aja Gonpa

● Sangphu

● Tharpoling

● Chankar

● Rolamjug

● Samdrup Choling

● Tokari

● Tomashong

● Goem Kora

★ Sakteng

● Baylay

● Bumpogtor

● Radhi

Tharadak Gonpa ★

● Sherizong

Yang Nyer

● Cha Ling

● Kuenga Rabten

● Gachang

Dramitse ★

● Trashigang Dzong

● Merak

● Lingmethang

● Mongar

TRASHIGANG

● Zhemgang Dzong

● Pangsibi

● Gamchenri

● Kanglung

● Nabji

MONGAR

● Khaling

● Demborang

● Bardo

● Mangling

● Momring

● Resa

● Lauri

● Nekar Saidong

● Pam

● Wamrong

● Kangpar

● Tangling

● Pasong Phung

SAMDRUP JONGKHAR

● Digala

● Bjoka

● Yangman

● Dungmanma

ZHEMGANG

● Dogar

PEMAGATSHEL

● Tsangchhilu

● Serthig

● Dungegaon

● Surilaka

● Ganphu

● Kaktong

● Martshala

● Chemari

● Somkara

● Kalikhola

● Zangbi

● Nangkhar

Shem Shem

● Orong

● Dalim

● Shilingtot

● Gelephu

● Mandaley

Dangme Chu

● Deothang

● Chengba

● Manas

● Nganglam

● Tshokhi

● Samdrup Jongkhar

● Bangtar

Manas

INDIA
(ASSAM)

© Local Colour Ltd

7

PREFACE

Although the media bring us endless details every day about what is going on around the world, most people have never even heard of Bhutan. This amazing paradox leaves some hope that there are still a few unspoilt corners of the earth. In any case, it is true of this tiny Himalayan kingdom, nestling between China and India at the foot of the world's highest mountains. Bhutan is a jewel, a haven of Buddhist peace far from the noise and bustle of the great cities. Its awesome natural boundaries and the determined efforts by the Bhutanese government to restrict foreign influence have helped to preserve its unique character. So travellers who are privileged to visit this fascinating country will find that it is in many ways unique in today's world.

While the landscapes of Bhutan sometimes recall the lush jungles of Sikkim or the snow-capped mountains of Nepal, they are embellished here by an original, elegant style of architecture that is unique to the kingdom. While the main features of Bhutanese culture recall Tibetan civilisation, it has been adapted here to suit the people's own inner nature. Over the centuries, customs and habits have been blended together to form a typically Bhutanese identity that the people vigorously defend, taking pride in their lifestyle culture and traditions. This is now all too rare in any country, especially as today's world becomes increasingly uniform, adopting a bland, featureless international culture.

It was this Bhutan's truly authentic identity that immediately struck me when I first discovered the country 12 years ago. During my many subsequent visits, I have also been constantly surprised by the kindness, warmth and attentiveness of the Bhutanese people, who have always been welcoming, hospitable and generous, and have sometimes gone to endless trouble when I needed their help in carrying out research or taking photographs. This book devoted to their colourful country is one way of showing my gratitude. I should like to thank all the people I have been privileged to meet while travelling in Bhutan, from the ministers who gave me special permits and members of the Royal Family who encouraged me in this work, to the humblest people in the kingdom: the shepherds who offered me the best share of their simple meals and the farmers who transformed their modest homes into five-star hotels so I could spend a comfortable night there. Many of them are now my friends.

What will happen to Bhutan in the next ten, twenty or fifty years is anyone's guess. Will it have been swallowed up by the modern world, with its advanced technology, fast food and standardised culture? It can only be hoped that, by showing how much this Himalayan Kingdom is unique, this book will in some modest way help to preserve its riches.

Robert Dompnier
La Tamarissière, March 1999

INTRODUCTION

THE THREAD OF HISTORY

Nestling in the heart of the Himalaya and protected by a complex geography of high mountains and deep valleys, Bhutan is certainly one of the most mysterious countries in the world. Impenetrable jungle to the south and daunting ranges of snow-capped mountains to the north have always barred access to the remote valleys of the kingdom. In spite of many incursions by both Tibeto-Mongol troops and the armies of the British Empire stationed in India, the country has not been colonised since the 8th century. Bhutan has therefore kept alive its extremely rich heritage, doggedly maintaining its distance from the modern world, proud of its own values and traditions.

The origin of the name Bhutan is still a mystery. It may be derived from the Sanskrit *bhu-uttan*, meaning "the high country" or from the Indian word *bhot'anta*, referring to those regions that border Tibet. It may also mean "the country of the Bhotias", in reference to a Tibetan people who settled in the foothills of the Himalaya.

The people themselves call their country "Druk Yul", the Land of the Dragon, or more exactly the land of the *drukpas* who forged its unity in the 17th century. The *drukpas*, a branch of the *kagyupas*, took their name from the monastery of Druk, founded in 1189 by Tsangpa Gyare at a spot near Lhasa where legend says a dragon appeared.

Little is known of prehistoric Bhutan. However, stone implements and megaliths marking places of worship or hunting grounds indicate that people lived here at the end of the Neolithic period, around 2000 BC. During the first millennium BC, nomadic tribes of Indian or Tibeto-Mongol origin appear to have mixed with these native peoples.

THE DEVELOPMENT OF BUDDHISM

One has to wait until the 7th century to find the earliest texts referring to Bhutan. They relate the construction of the temples at Kyichu in the Paro valley and Jampa Lhakhang in Bumthang by the Tibetan king Songtsen Gampo, who reigned from 627 to 650. Through these acts, the monarch helped to spread Buddhism into the southern valleys where at that time animist and shamanic religions prevailed.

But it was with the arrival of the great Indian master Padmasambhava in the 8th century that Buddhism really began to spread throughout this Himalayan land. Known as Guru Rinpoche by the Bhutanese and Tibetans, Padmasambhava is said to have arrived in Bhutan in 747, invited to the country to cure an ailing king. He meditated, taught Buddhism and had several temples built. The places he visited are still venerated today. Moreover, Padmasambhava hid sacred texts in various parts of the country; their profound meaning was incomprehensible to the people of the period. "Treasure-finders", known as *tertöns* in the local language, would be led to discover them much later so as to complete the master's teaching and finish his work. With the coming of Padmasambhava, Buddhism began gradually to replace the local cults, occasionally absorbing some of their rituals and beliefs. The growth of Buddhism was accelerated with the influx of Tibetan Buddhists fleeing persecution by King Langdarma in the 9th century. Many settled in eastern Bhutan, where they formed small principalities.

The second period of Buddhist expansion took place after the arrival of certain great religious teachers in the 13th century. These included Phajo Drugom Shigpo (1208–1276), a Tibetan lama who came from Kham. He founded Tango monastery and began to spread the doctrine of the *drukpas* in the western part of the country. Another venerated lama was Longchen Rabjampa (1308–1363), a *nyingmapa* master who settled in the Bumthang valley.

Following this period, the country's religious life was marked by the emergence of great families whose influence would also strengthen the people's faith in the doctrine of the Buddha. Pemalingpa (1450–1521) belonged to one of these families. A famous *tertön*, he discovered many texts that had been hidden by Padmasambhava many centuries earlier and

became especially revered in central Bhutan. His descendants extended their influence to the east of the country, where they built the monastery at Dramitse.

However, while Buddhism was gradually becoming the focus of Bhutan's spiritual unity, political unity was far from becoming reality. The hard conditions and rugged landscape made any attempt at centralised authority extremely difficult. With each valley controlled by eminent local families, Bhutan was a jigsaw of tiny, rival territories in an almost permanent state of war with each other.

UNIFICATION

In 1616, due to a quarrel over the succession to the throne of Ralung, the seat of the *drukpa-kagyu* order in Tibet, Ngawang Namgyel was forced to flee to Bhutan. Born in 1594, he belonged to the princely Gya family, whose most eminent member, Tsangpa Gyare, had founded the *drukpa* school. Since 1189, the abbot's throne of Ralung had been in the family's possession. However, the prince of Tsang now claimed the position for another lama and Ngawang Namgyel, fearing for his life, escaped south to Bhutan. He was welcomed in the southern valleys by the Bhutanese disciples of the *drukpa* school, whose influence had continued to grow since the 12th century.

His arrival in Bhutan would be a major turning point in the country's history and organisation. Ngawang Namgyel, who is still referred to as *Shabdrung* "He at whose feet one falls", quickly imposed his political and religious authority throughout western Bhutan. In just a few years, he succeeded in bringing together all the independent principalities and initiating a process of unification. When he died in 1651, order had been restored almost everywhere.

The great fortresses of Simtokha, Punakha, Wangdue Phodrang or Trongsa were built during his reign. While ensuring the country's security, they also served as relays for the central authority and its administration.

Resisting many invasions by the Tibetans and Mongols during the course of his reign, Ngawang Namgyel quickly became both feared and admired inside Bhutan and beyond its borders. His great sense of organisation enabled him to introduce order into the monasteries and to set up a religious hierarchy dominated by the *Je Khenpo*. He appointed a regent, the *Desi*, to head the civil administration, giving him temporal power throughout the country. This double system of government, known as *chhoesi*, remained in force in Bhutan until the creation of the hereditary monarchy in 1907. Because of his legacy of administrative, legislative and religious reforms, Ngawang Namgyel is considered to be the principal architect of modern Bhutan.

THE PERIOD OF TROUBLE

The 19th century was a period of conflicts between the Bhutanese and the British. The all-powerful East India Company was seeking new outlets in Tibet and Central Asia. Several missions were sent to Bhutan to try and negotiate commercial agreements and rights of passage with the *Desis* of the period. However, the British were also attempting to establish their political influence in the Himalaya and extend their territories. Tension therefore grew and border skirmishes became increasingly common. At the same time, central power in Bhutan was becoming weaker as local lords began to win back some of their former importance. It was they who led the armies when the so-called *duars* war was declared, taking its name from a strip of fertile land situated under the first range of foothills of the Himalaya. After several battles, the British advance was stopped by Jigme Namgyel, the *penlop* of Trongsa. In 1865, the Treaty of Sinchula brought an end to the war. The Bhutanese lost the *duars* but in exchange received an annual compensation of 50 000 rupees paid by the government of British India.

After his victory over the British, Jigme Namgyel took control of Bhutan. Ending years of interminable conflict, he tried to restore the unity that successive *Desis* had been incapable of preserving during the 19th century. To do this, he had to impose his will on the various local

governors, if necessary by force of arms. When he withdrew from power in 1873, he ordered his son, Ugyen Wangchuck, to continue his work of unification - the second in Bhutan's history.

THE ESTABLISHMENT OF THE MONARCHY

In 1885, the battle of Changlingmithang marked the decisive victory of Ugyen Wangchuck over his last enemies, the governors of Thimphu and Punakha. Having now subdued all his opponents, he became the undisputed master of the country. He then started a long process to strengthen the central power in order to recover the unity that Ngawang Namgyel had achieved 250 years earlier. He gradually rallied all the lords throughout the country to his cause and on 17 December 1907 was proclaimed King of Bhutan by an assembly including representatives of the clergy, Council of State and local governors. He took the title of *Druk Gyalpo*, thus ending the system of *chhoesi*. The position of *Desi* disappeared and only that of *Je Khenpo* remained as the spiritual leader of Bhutan.

In strengthening the central power, Ugyen Wangchuck relied considerably on certain strong personalities such as Ugyen Kazi Dorji, who was appointed High Chamberlain in 1911. Ugyen Wangchuck reigned until his death in 1926.

Jigme Dorji, born in 1905, was crowned King in 1927. He continued his father's reforming work, bringing the country out of a system that in many respects was still feudal. In 1948, he signed a friendship and cooperation treaty with India, replacing the previous agreement with the British Empire dating from 1910. This treaty, which paved the way for a close relationship with India, was to become one of the cornerstones of Bhutanese diplomacy.

But a new era really began with the succession of Jigme Dorje Wangchuck, the third monarch to rule over the country. Born in 1928, he was crowned king in 1952. A reformer and man of progress, one of his first acts was to set up the National Assembly in 1953. Known as the *tshogdu*, this comprised representatives of the people, civil administration and clergy. Other bodies were created one after another, in particular the Royal Council and a Council of Ministers. Jigme Dorje Wangchuck separated the judiciary from the executive, creating a High Court of Justice, and abolished serfdom.

But it was in the economic field that his actions enabled the country to make a great leap forward, with the creation of five-year development plans. Like his grandfather, he secured the services of progressive thinkers committed to innovation. Among these was Jigme Palden Dorji, who was appointed Prime Minister in 1958. He was a strong advocate of modernisation. Until his death in 1964 he embodied the desire to change and open up the country to the outside world. This twofold action pursued by the King of Bhutan in the administrative and economic fields gradually reinforced his country's position and nurtured a sense of national identity in the minds of the Bhutanese people. Thus, after centuries of isolation, Bhutan began to emerge slowly on the international scene. Its entry into the UN in 1971 was a final recognition of the country by other nations. Jigme Dorje Wangchuck reigned until his death in 1972.

His Majesty Jigme Singye Wangchuck was born in 1955 and, when he succeeded his father in 1974, became the world's youngest monarch. He has since continued a policy of development and modernisation while taking care to preserve the natural and cultural heritage of his country. On many occasions, he has demonstrated his determination to give greater responsibility to the Bhutanese people, by creating elected decision-making bodies in the villages and districts. A further proof of this desire to involve the people was the 1998 Royal Decree giving power to the National Assembly to ratify or reject the nomination of Ministers, who were hitherto appointed solely at the King's discretion. While the third King was the father of modern Bhutan, Jigme Singye Wangchuck seems destined to be the father of democracy. He is wisely preparing Bhutan to enter the 21st century, maintaining a harmonious balance between a respect for tradition and a commitment to economic development.

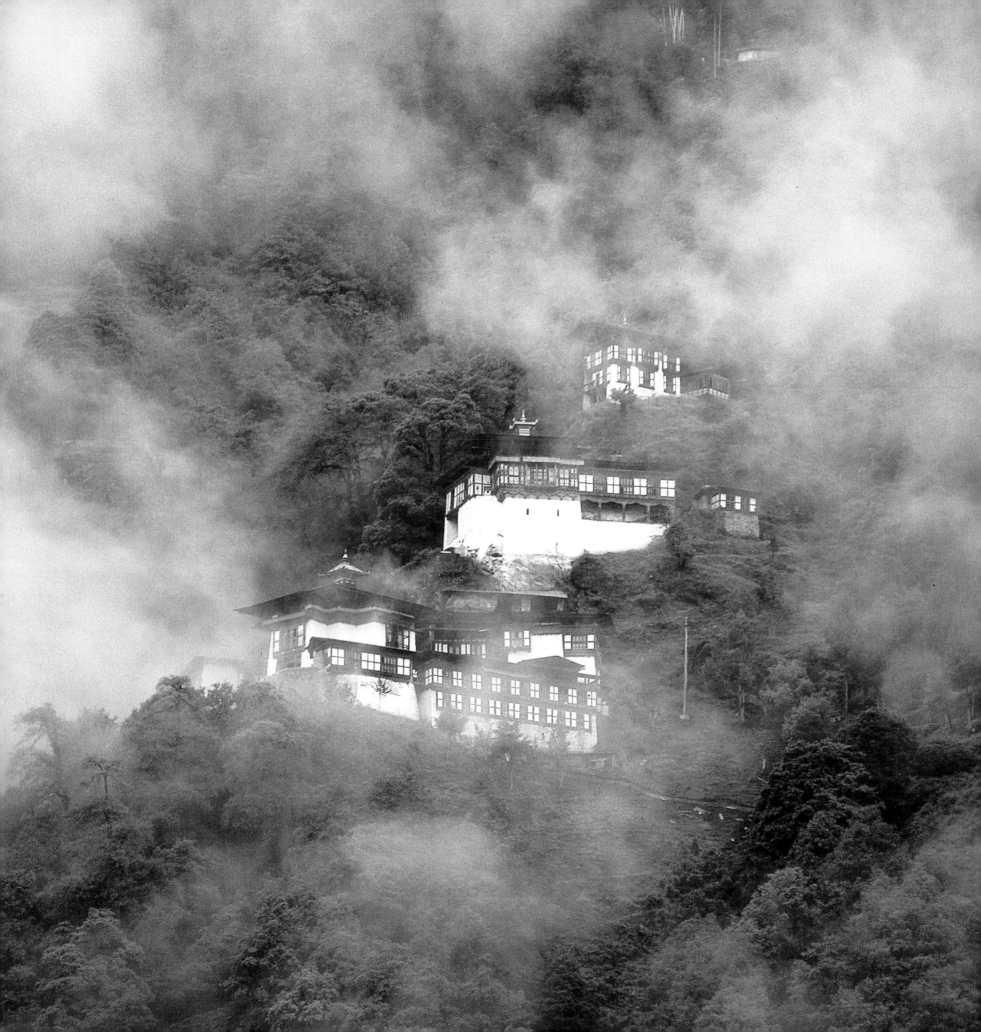

BETWEEN JUNGLES AND GLACIERS

Bhutan rises stage by stage, step by step, hill by hill, from the luxuriant jungles in the south to the dizzy summits of the Himalayan range. Over a north-south distance of about 170 km, these differences in altitude produce a great diversity of climates and an extreme range of environments, with sub-tropical vegetation in close proximity to frigid wastes.

The relatively low-lying south of the country is the region of the *duars* and piedmont areas. Strips of fertile land, the *duars* run from the Indo-Ganges plain to the first foothills of the Himalaya. Hills then rise up to altitudes of between 300 and 1500 metres, where there is a hot, humid sub-tropical climate that sometimes produces violent storms during the summer. Much of this region is covered with impenetrable jungle. A few cultivated areas nevertheless produce rice and many tropical fruits are harvested there, including bananas, mangoes and pineapples. These regions are inhabited mainly by people of Nepalese origin, who settled here at the end of the 19th century.

The central Himalaya have a temperate climate, though with a major monsoon from mid-June to mid-September. This area consists of a series of alluvial valleys running north-south and separated from one another by high mountains. To cross from one valley to the next, the roads wind up through passes over 3000 metres high, which are often closed by snow in winter. There are eight major valleys ranged across the country from west to east: Ha, Paro, Thimphu, Punakha-Wangdue Phodrang, Trongsa, Bumthang, Lhuentse-Mongar and Trashigang.

Depending on the altitude, the vegetation of this central region consists of forests of bamboo, magnolia, oak, poplar, ash, maple and cypress, while above 3000 metres are the conifers: pine, larch and fir. Rhododendrons often several metres high are common between 2500 and 4000 metres.

Most of Bhutan's people live in these valleys. The *Drukpas*, who are of Tibeto-Mongol origin, are farmers and animal breeders. While the west has many rice fields and orchards, central Bhutan produces barley, buckwheat and potatoes. Maize is cultivated in the eastern part of the country. The highest valleys, Ha and Bumthang, are home to yak and sheep breeders.

Finally, the north of the kingdom is dominated by the snow-capped peaks of the high Himalaya, many of which have never been climbed and remain the inviolate homes of the gods. A dozen summits rise to over 7000 metres. This great barrier is crossed by a single river valley in the extreme east – that of the Kuri Chu, which rises in Tibet. Above the tree line, situated around 4300 metres, vegetation is sparse. There are some junipers, but mainly just mosses and lichens. High pastures run up to the edge of the glaciers. A few villages are to be found in this harsh mountain region, home to the semi-nomadic *Layap, Lunap* or *Brokpa* shepherds of Merak and Sakteng.

The extreme geographical conditions partly explain why Bhutan was isolated for so many centuries. While the passes through the Himalaya could only be crossed for a few months of the year, the deep, jungle-covered gorges in the south made travelling difficult and perilous.

Specialists from all over the world come to study Bhutan's unique flora and fauna. Many of the plants are used in traditional remedies of various kinds, and for this reason the Tibetans called the country *Men jong*, "the valley of medicinal herbs". Wildlife is rich and varied. Ten nature reserves, representing about 20% of the total area of Bhutan, have been created to protect species that are sometimes extremely rare. While the jungles in the south are home to elephants, single-horned rhinoceros, tigers, buffaloes and monkeys, including the *golden langur*, the mountains of the central regions provide refuge for deer, white-collared bears, boars and red pandas. Blue sheep graze in the high pastures at the edge of the glaciers, where they are preyed upon by the rare and beautiful snow leopard.

Ornithologists can observe species such as the famous black-necked cranes that inspired the 6th Dalai Lama, Tshanyang Gyatso, in the 17th century. Leaving Tibet for the winter, these majestic birds take refuge in the Bumdeling and Phobjika valleys.

Clinging to the mountainside at the end of Thimphu valley, Chheri Dorjidhen monastery was built by the *Shabdrung* Ngawang Namgyel in 1620. It was here that he set up the State's first monastic community.

Although small towns are gradually springing up, Bhutan is still an essentially rural
country. Farmers and animal breeders account for 85% of the entire population, living in
attractive villages built beside the rivers or on the gently sloping hillsides
overlooking a patchwork of terraced fields.

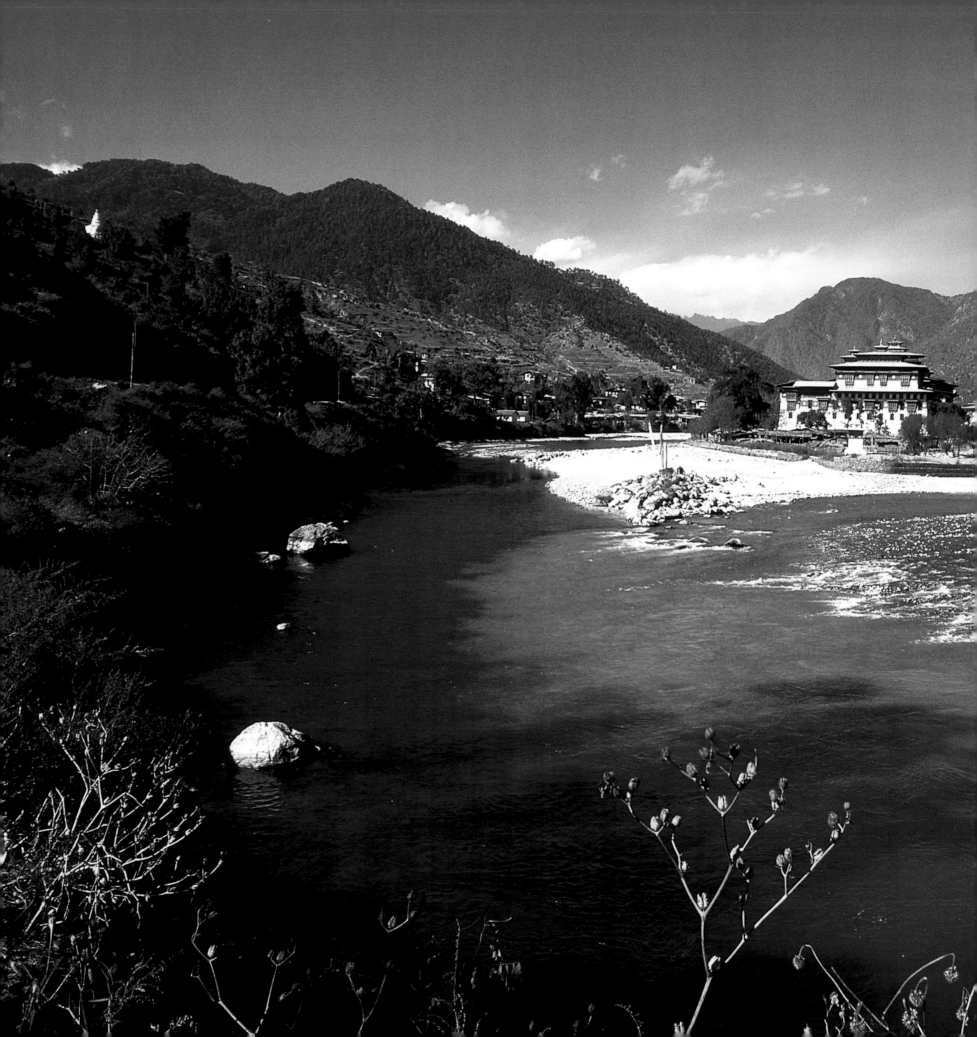

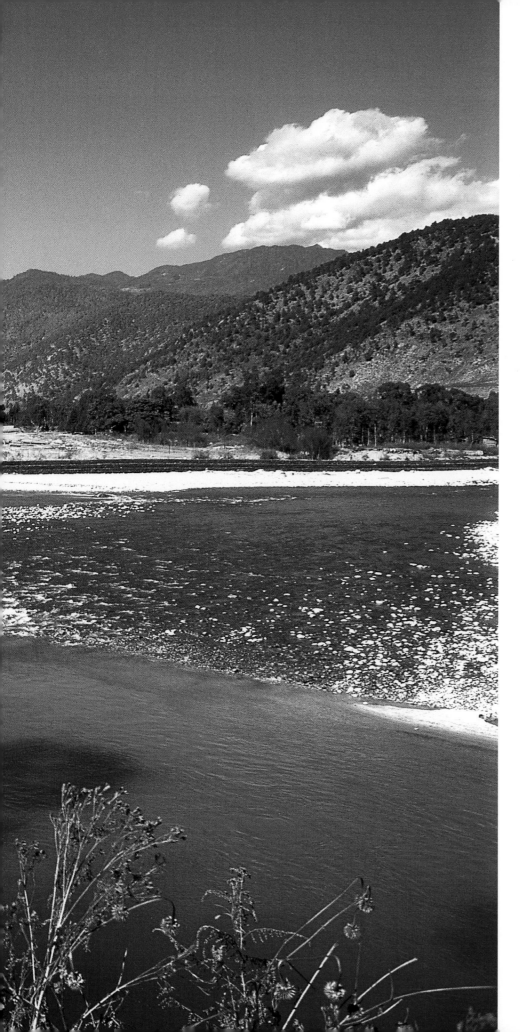

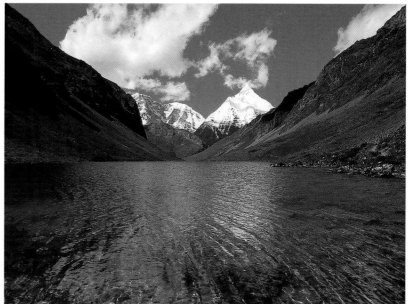

Descending from the glaciers and snow-covered ranges forming the border with Tibet, innumerable torrents and rivers flow towards the lower valleys of Bhutan. The water is diverted to irrigate cultivated land and represents an enormous potential for hydroelectric power, which would greatly boost the country's economic development.

Above: Glacial lake at the foot of Jitchu Drake.

Left: Punakha *dzong* at the confluence of the Pho Chu and Mo Chu.

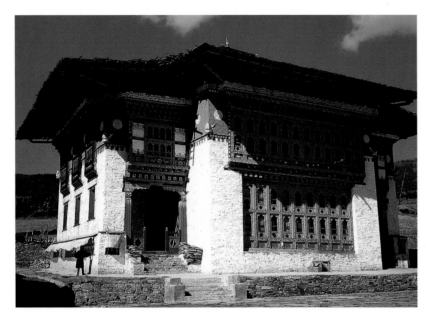

From its cultivated valleys to its wooded hillsides, Bhutan's landscape bears witness to the profound faith shared by all its people. Monasteries, *chortens* and prayer flags are to be found along every track and even in the remotest corners of the mountains.

Above: Temple dedicated to Guru Rinpoche in the village of Ura.

Right: Prayer flags at Dochula pass (3050 m) on the road between Punakha and Thimphu.

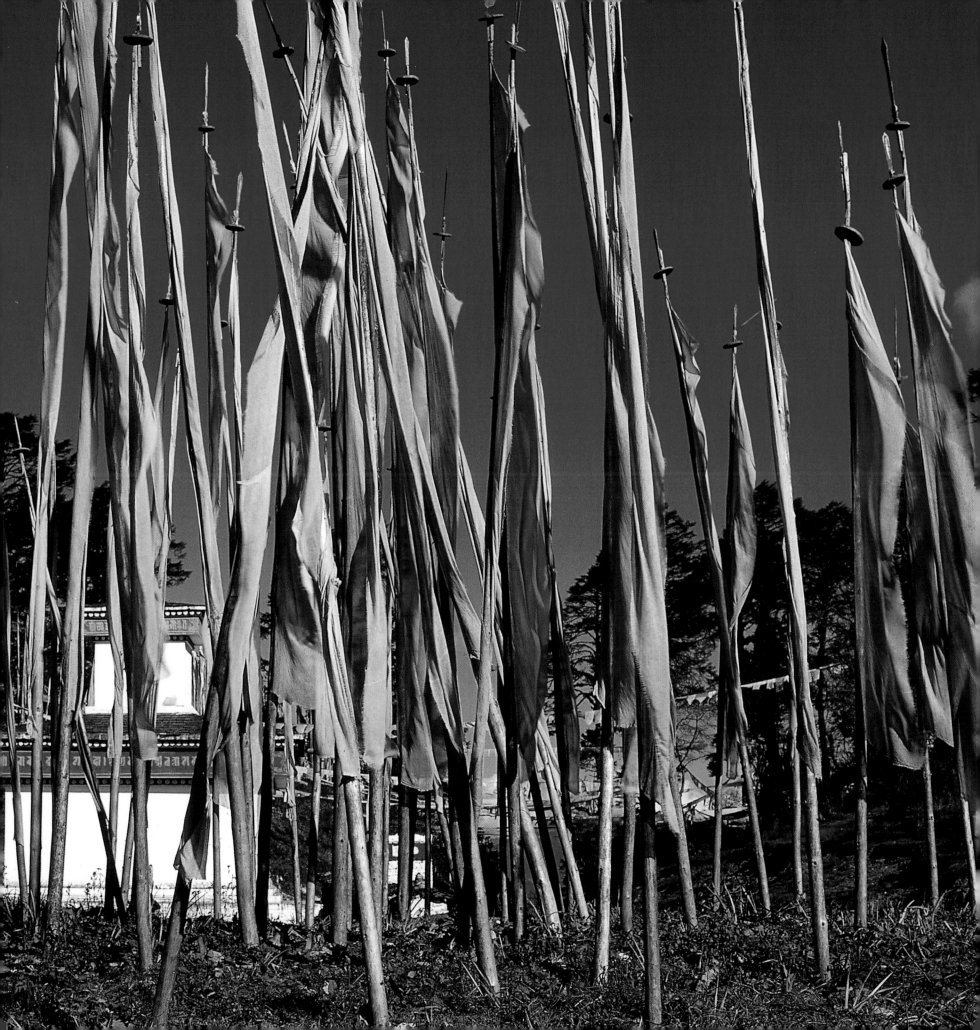

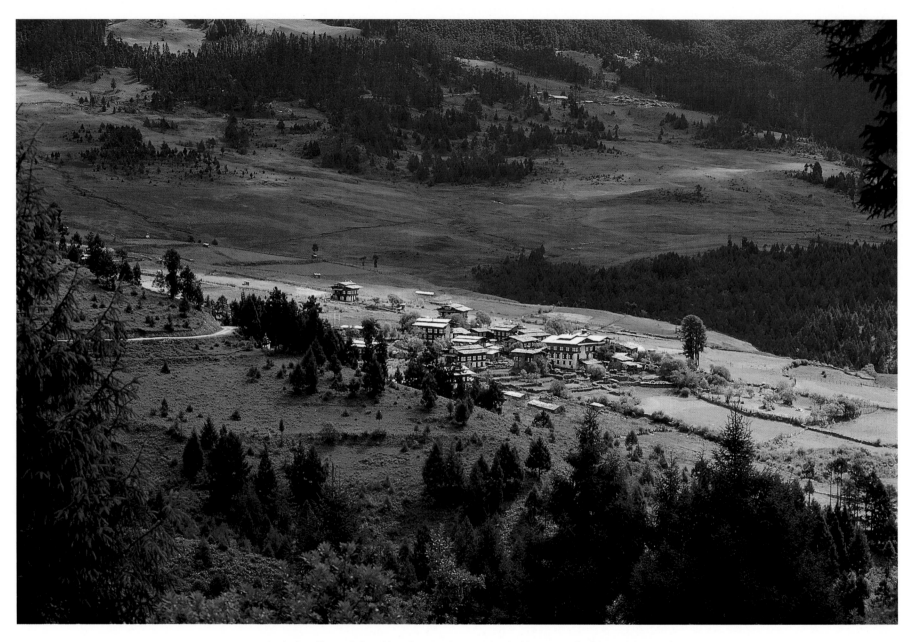

The little village of Shingkhar (3400 m) is surrounded by pines, larches and firs
in a typical mountain setting. Its monastery, one of the oldest in the Ura valley,
was built in the 14th century by the *Nyingmapa* master Longchen Rabjampa.

In contrast to the Alpine landscapes of central Bhutan, the Wamrong region situated between Trashigang and Samdrup Jongkhar has luxuriant vegetation, with ferns and banana trees framing the yellow and pink fields of mustard and buckwheat.

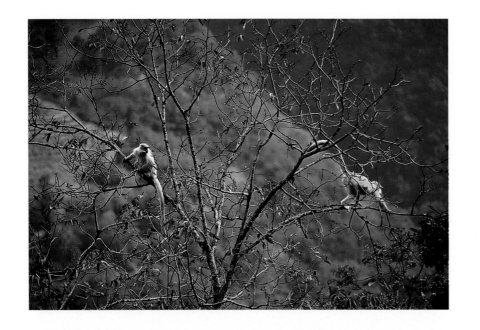

Thanks to the heavy monsoon rains, Bhutan is densely wooded, with tropical jungle in the south giving way to mountain forests in the central regions. *(top left)* The abundant wildlife includes such rare species as the *golden langur,* which lives in the south. From March to October, the montane forests are ablaze with an infinite variety of flowers. *(right)* koiralo *(Bauhinias variegata),* magnolia, rhododendron and orchids *(Pleione praecox).*

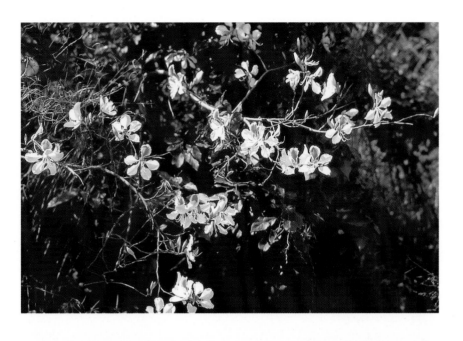

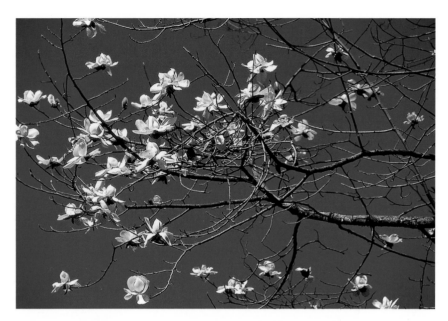

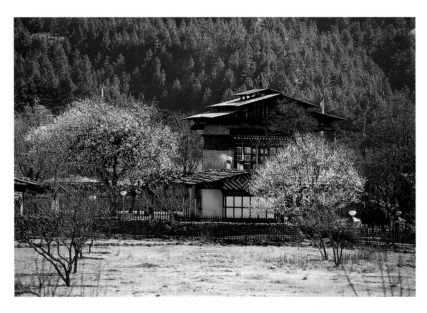

In the spring-time, flowers and buildings blend harmoniously to form a typically Bhutanese scene.

Above: Wangdichoeling palace in Bumthang valley.

Right: Norbgang village above Punakha.

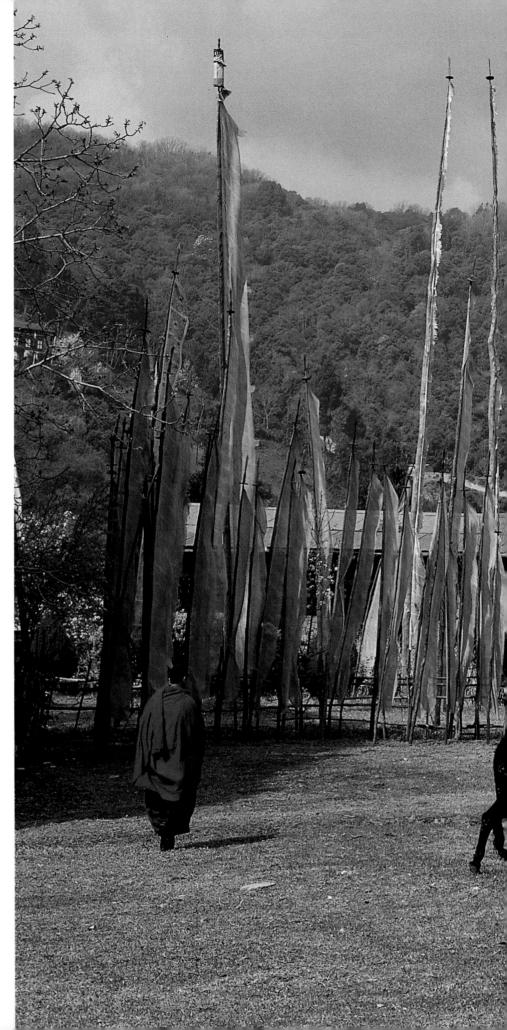

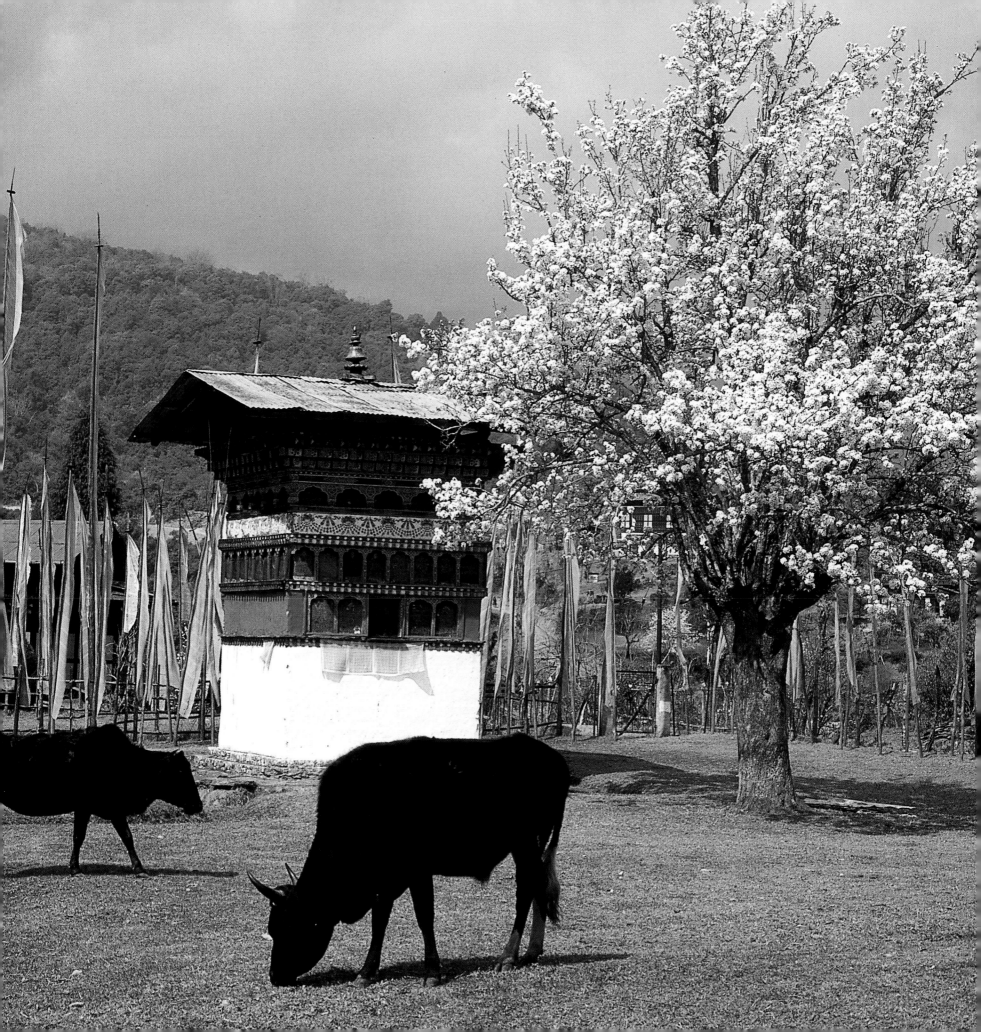

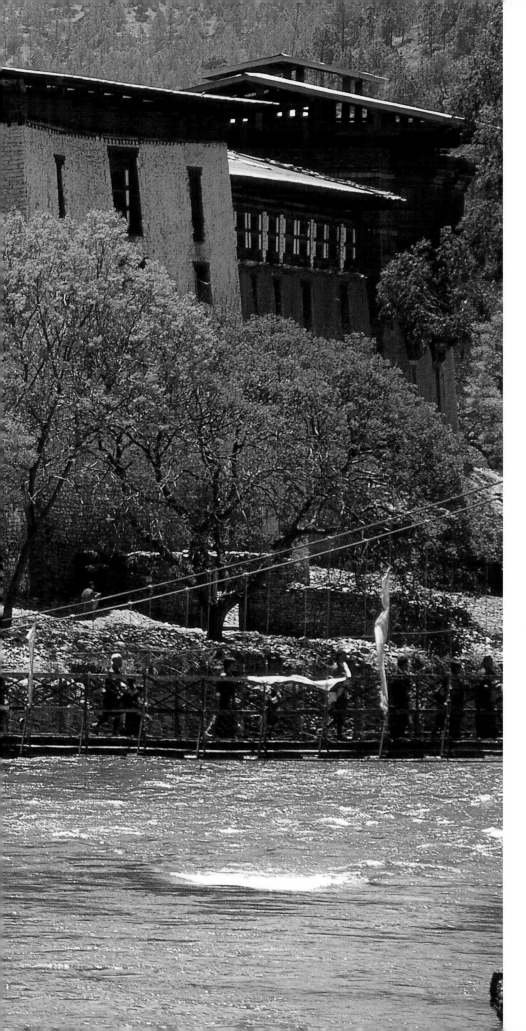

Jacarandas elegantly framing Punakha *dzong* (*left*) and subtropical vegetation in the Mongar region (*above*).

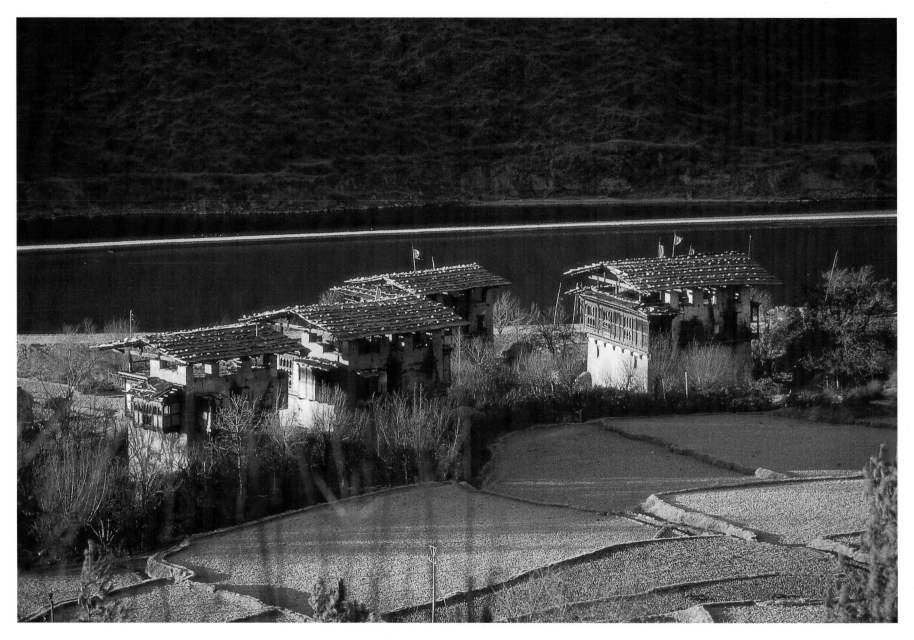

In addition to rice, maize and potatoes, the varied climate of Bhutan produces a wide
range of cereals and vegetables. High-quality fruit, including many type of citrus,
is canned or dried by local industries and either sold domestically or exported.

(*above*) Rice-fields near Simtokha (*right*) Orange trees in the village of Yadi.

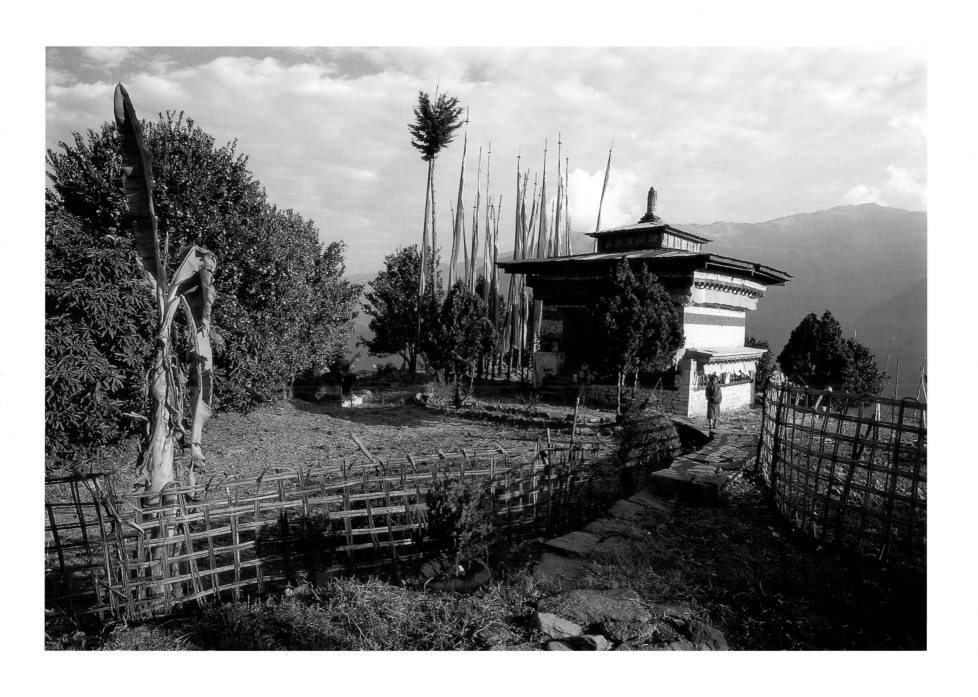

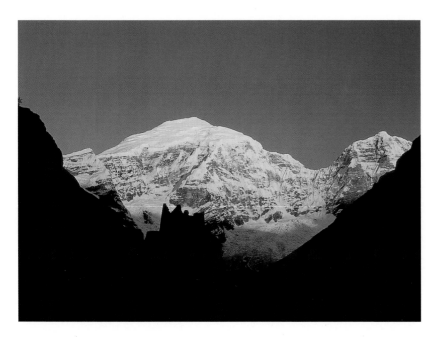

In the west and north, soaring ranges of snow-covered mountains form a natural boundary between Bhutan and the high plateaux of Tibet. They can only be crossed by a few passes at more than 5000 metres, which were formerly used as trading routes between the regions to the north and south of the Himalaya. *(above)* Jomolhari (7320 m), with the ancient ruined fortress of Jangothang at its feet. *(right)* Jitchu Drake (6794 m), with its magnificent ridges running northwards from the Jomolhari massif.

Following spread: Terraced fields near Mongar.

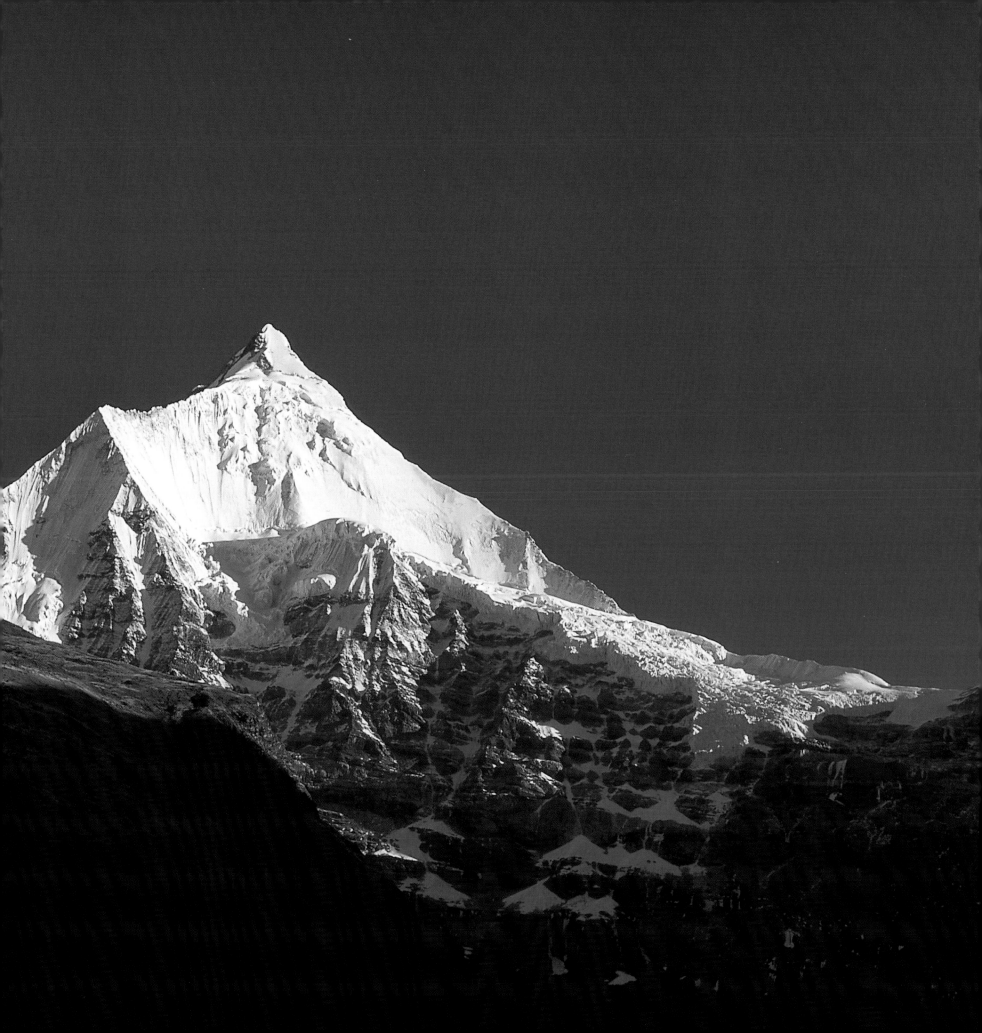

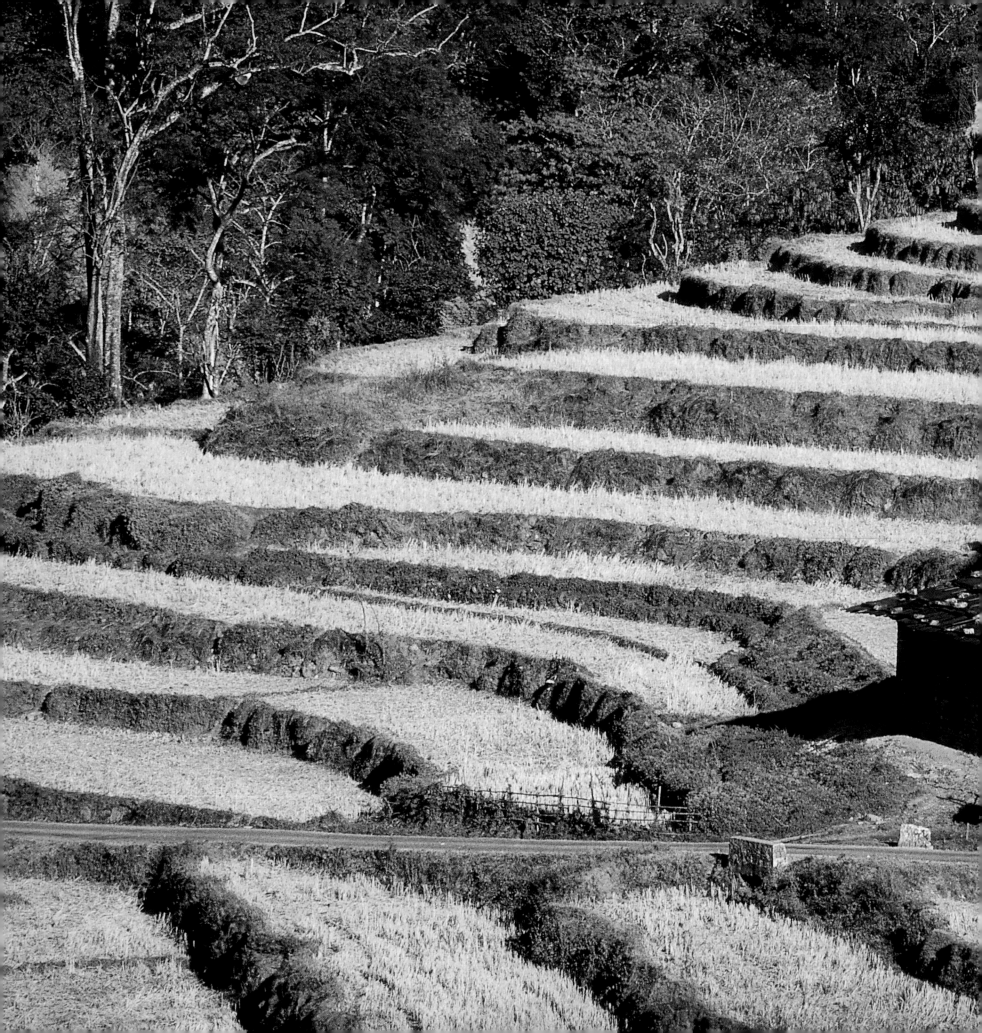

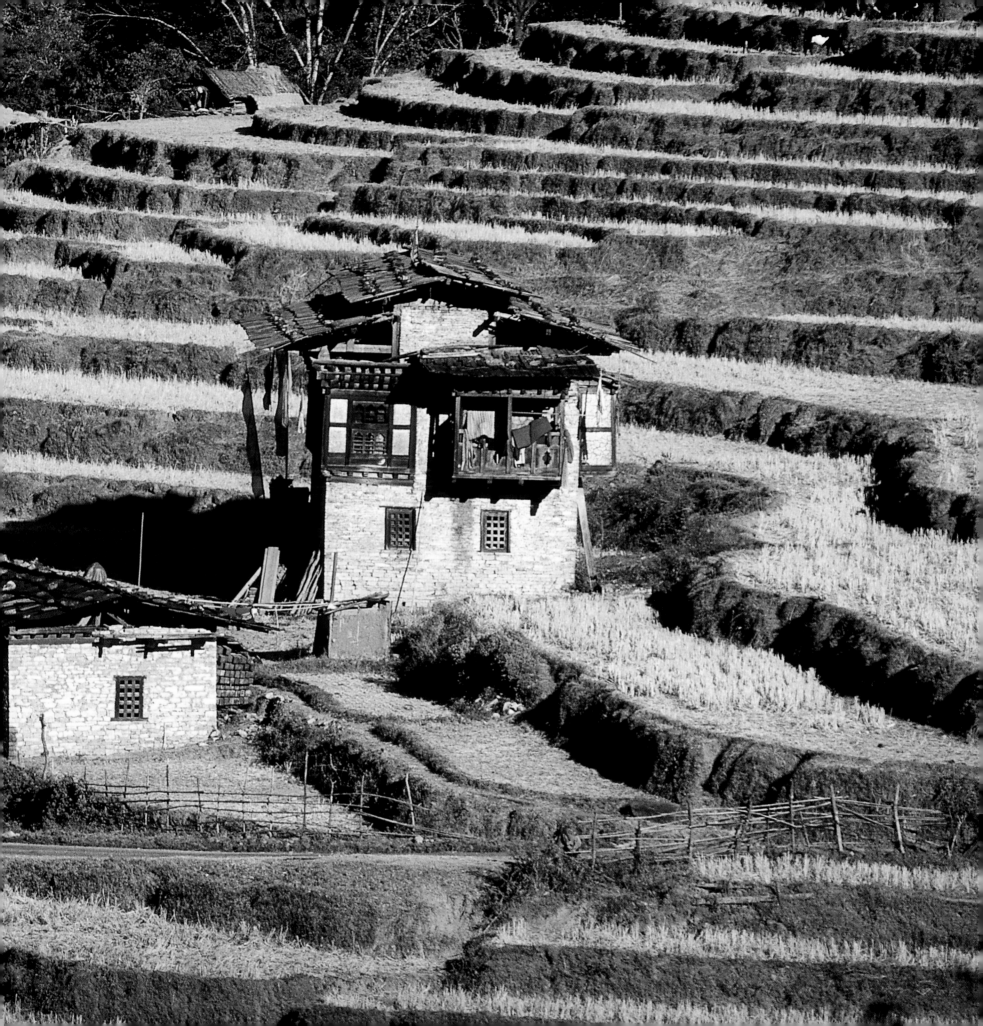

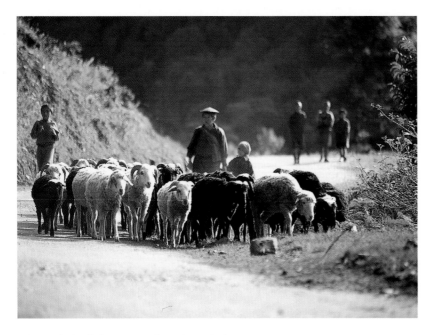

Above: Flock of sheep at dusk in the Rukubji region.

Right: Planting rice at Rangjikar in eastern Bhutan.

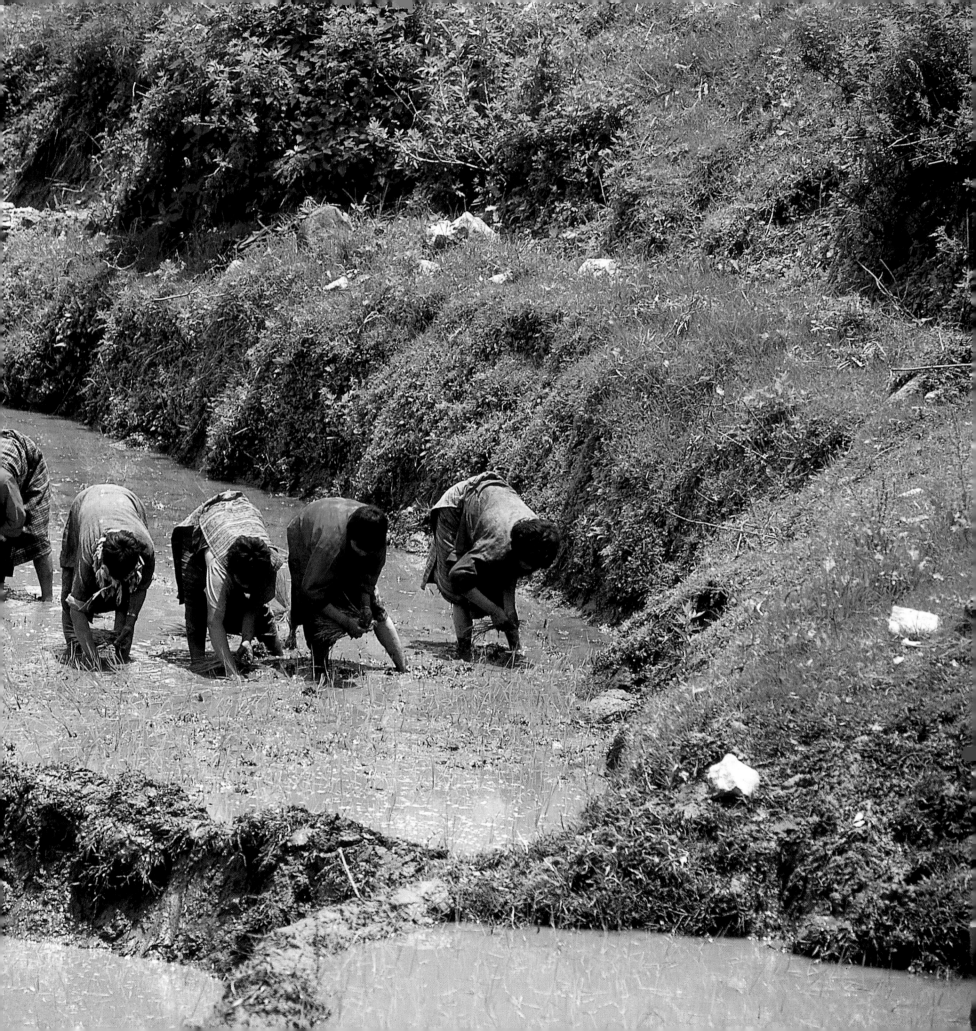

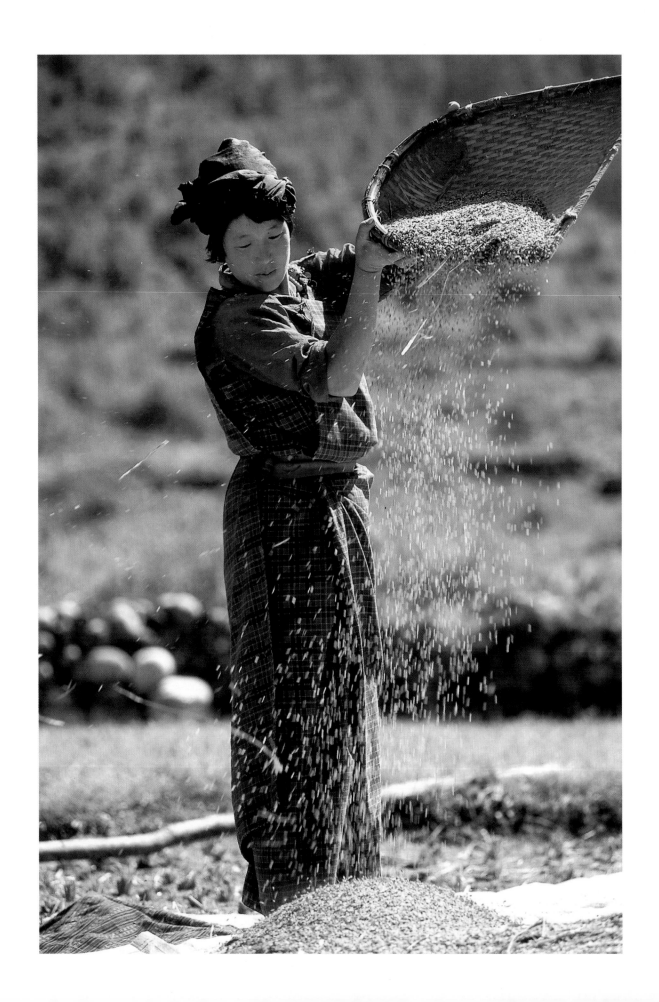

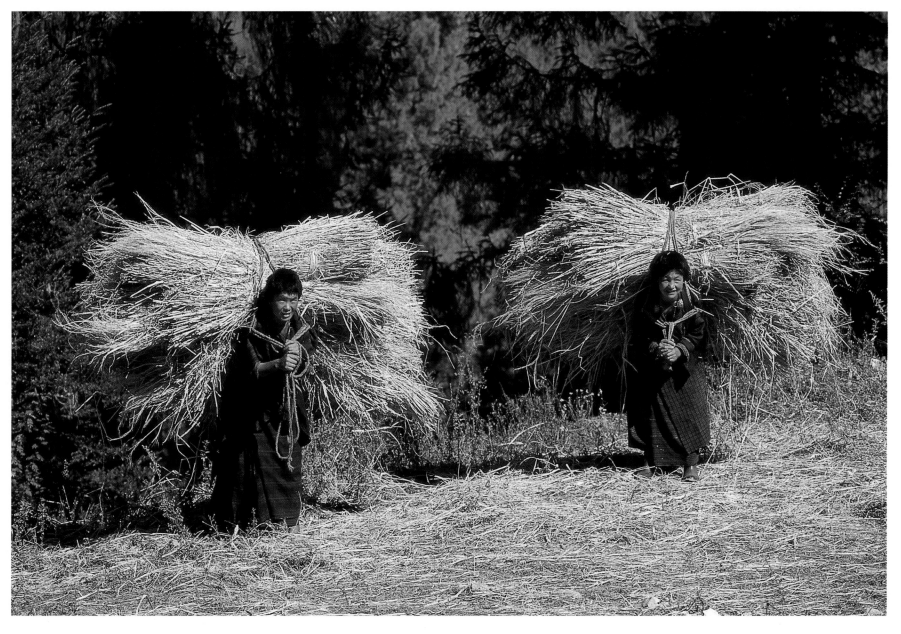

Above: After threshing, the heavy bales of straw will be carried home to be used for bedding for the livestock during the winter.

Left: As they winnow, the women sing or whistle to call the wind that will clean the grain.

Following spread: Thimphu, the Royal Cottage in winter.

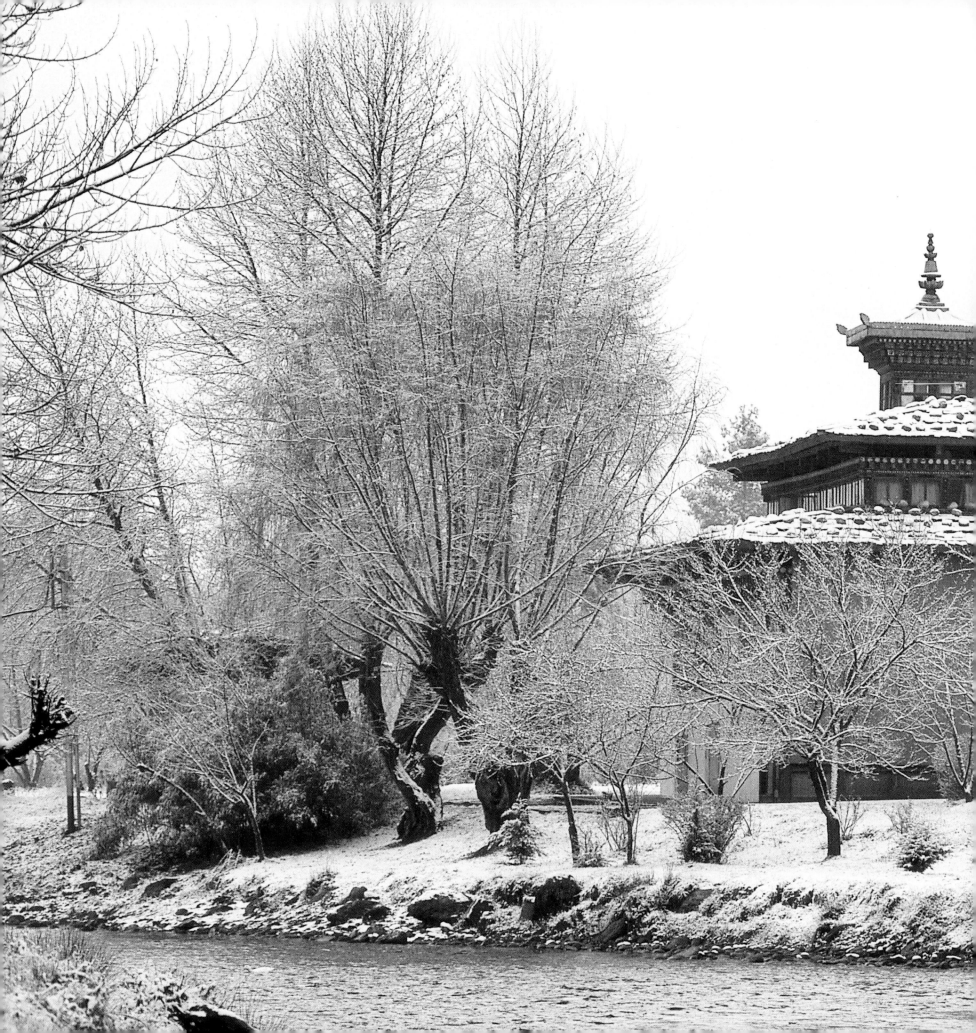

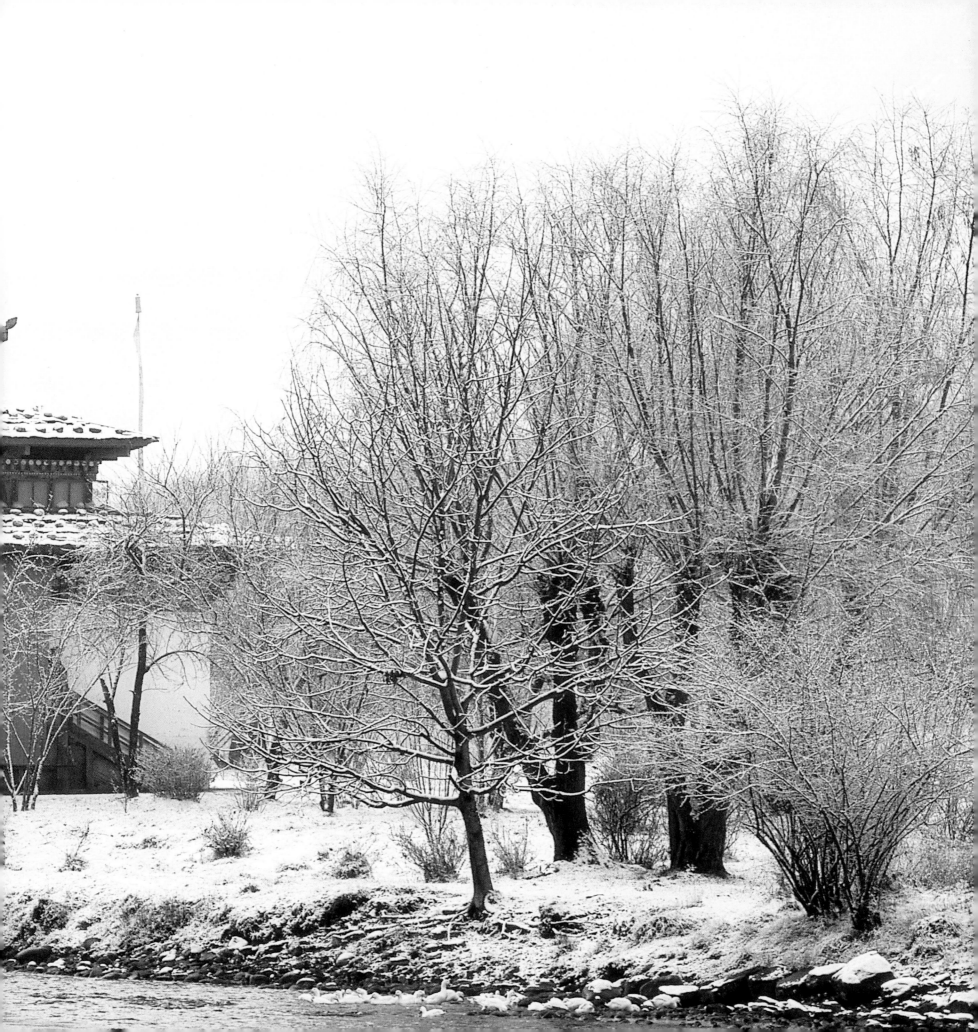

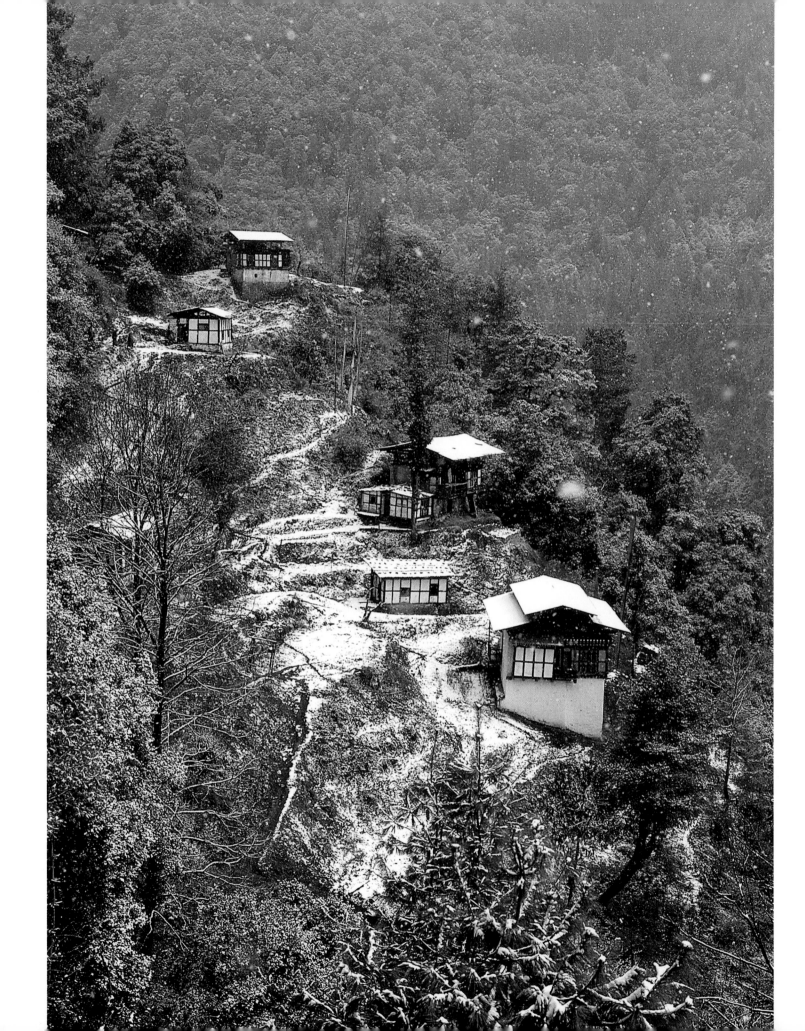

Left: Monks' dwellings at Tango, as the first snow falls.

The winter frosts will gradually work their delicate designs along the wayside.

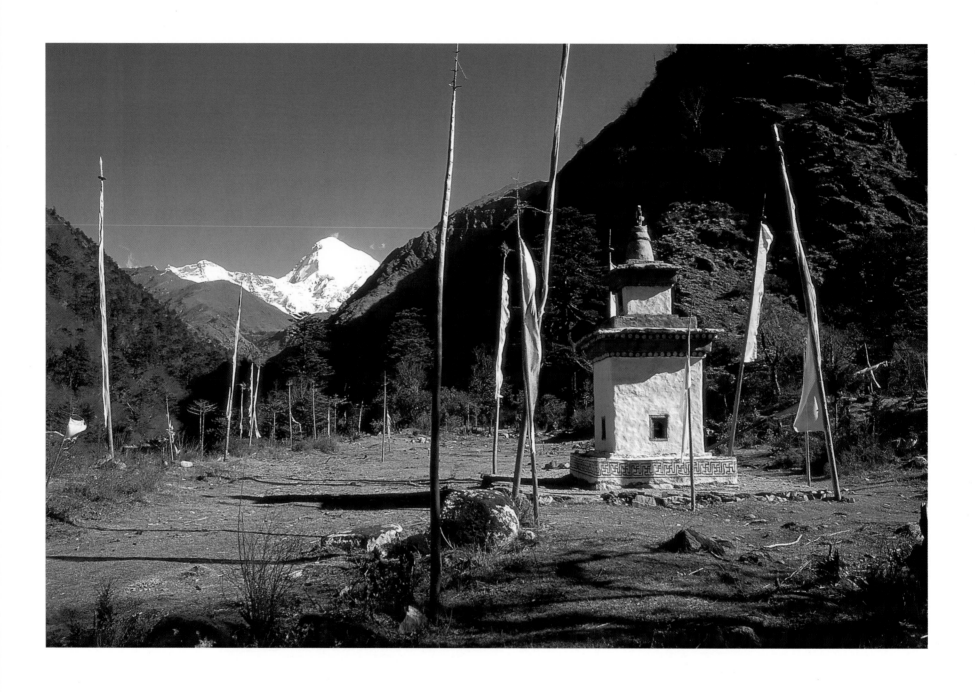

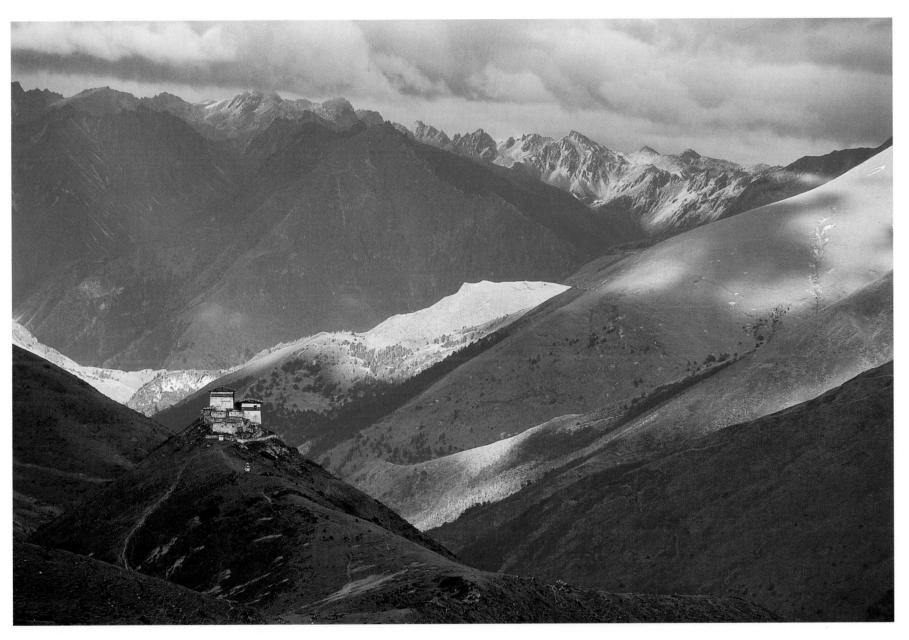

The Bhutanese have built *chortens* and fortresses even in the remotest corners of the mountains to honour the gods and defend their country against attackers.

(*left*) *Chorten* on the track to Soi Thangka. In the background, the snow-capped dome of Jomolhari rises to 7320 metres. (*above*) Lingzhi *dzong*, close to the Tibetan frontier, was built by Phajo Drugom Shigpo (1208–1276) and enlarged in the 17th century by the third *Druk Desi*, Minjur Tenpa.

Following spread: Like Lingzhi, Jakar *dzong* was built by Minjur Tenpa in 1646. It occupies the site of a temple built a century earlier by Ngagi Wangchuck, who was inspired by a vision of a white bird settling on the hill at that spot. It was he who named the place Jakar, "*dzong* of the white bird".

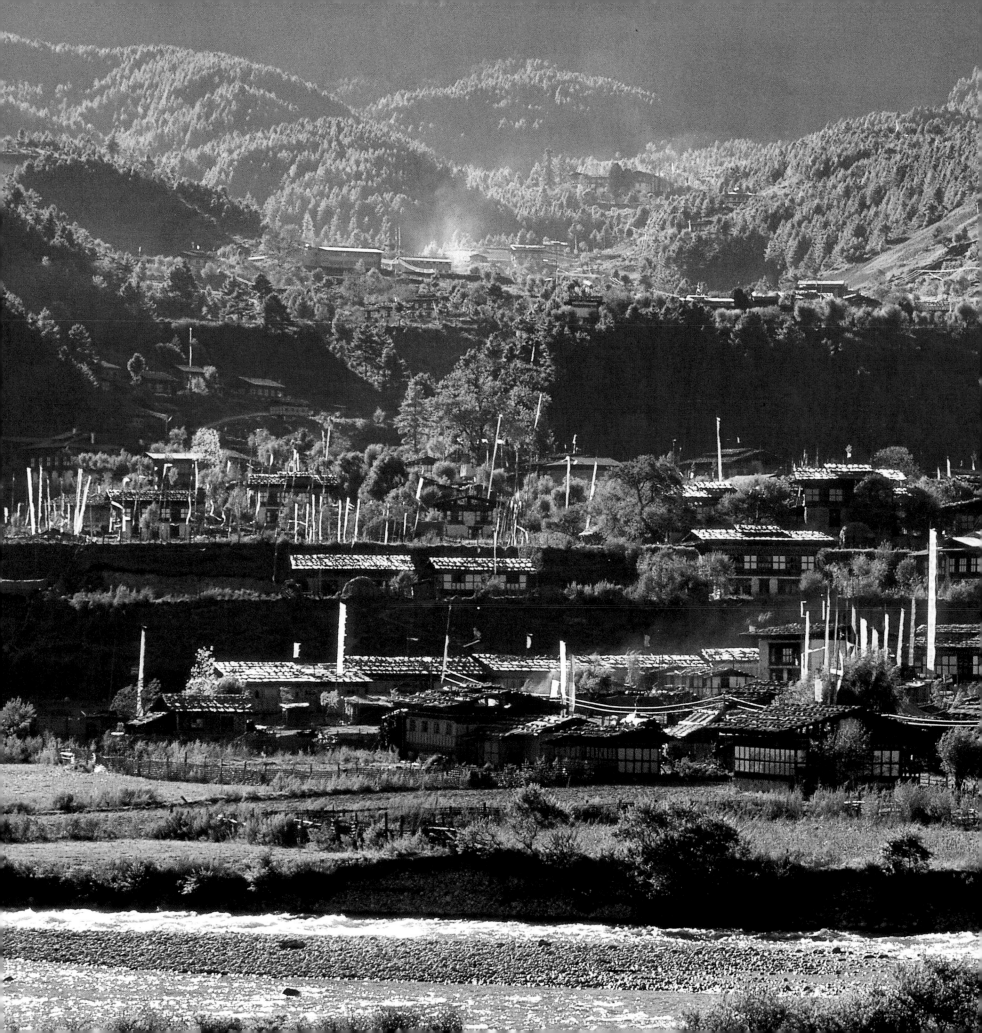

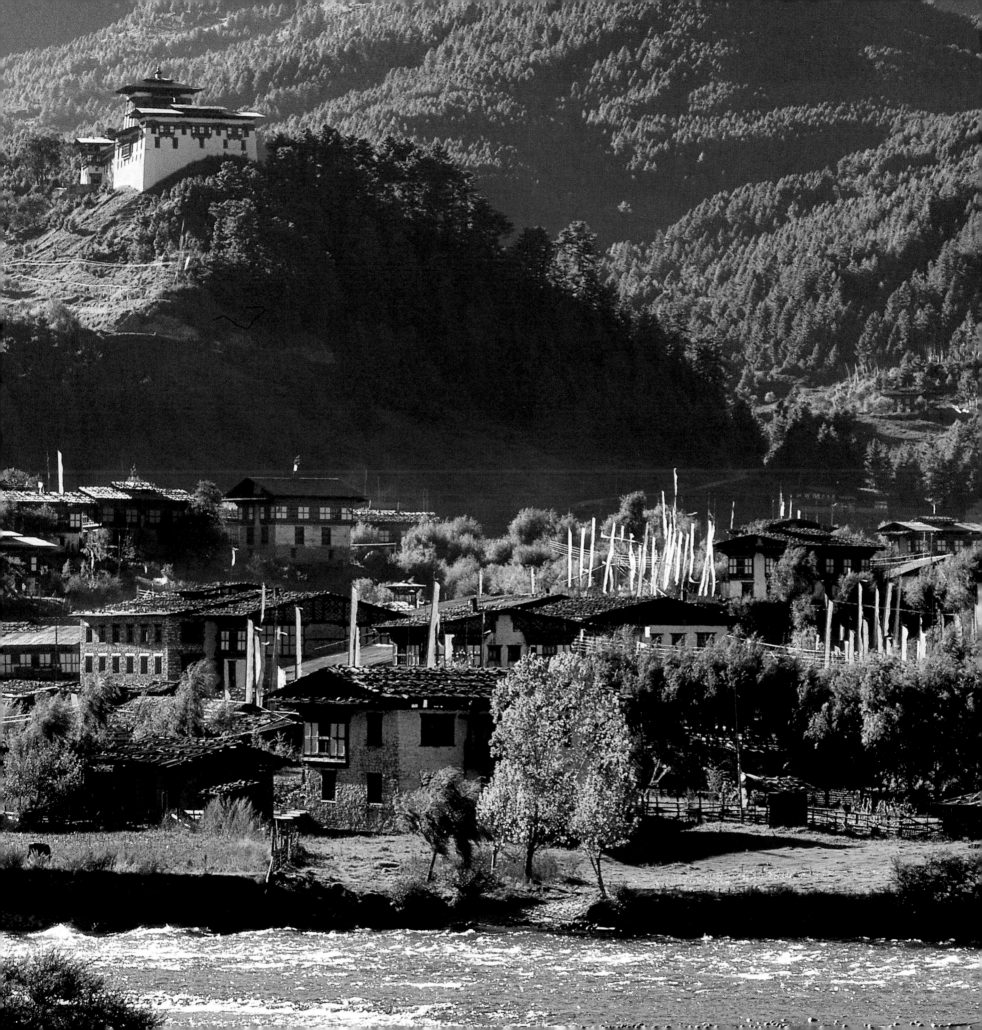

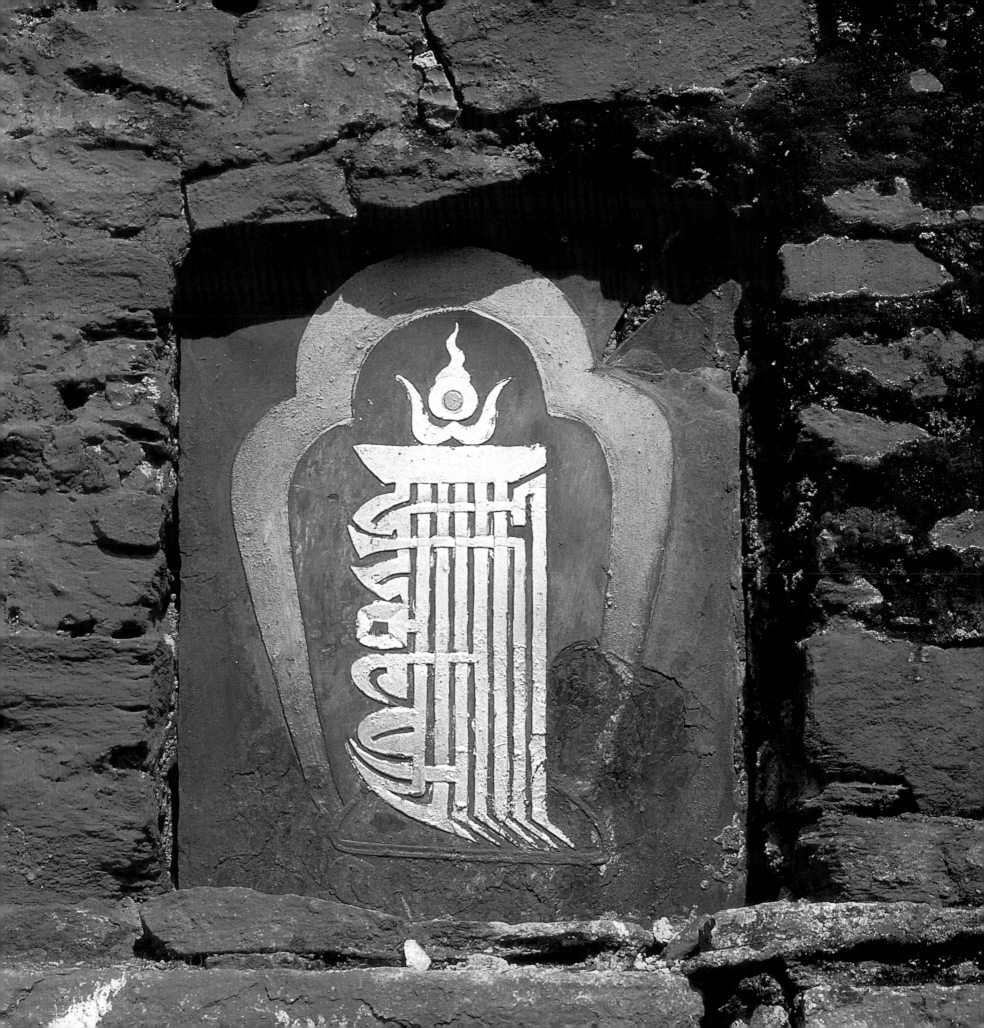

2

OF STONE, EARTH AND WOOD

In terms of quality and originality, Bhutanese architecture is without doubt one of the best expressions of the country's cultural identity. It has undergone very few modifications over the centuries, and its roots are to be found in the architecture of Tibet, which was itself strongly influenced by China and the Middle East. Drawing inspiration from older forms, ideas and models, the architects of Bhutan developed a style which is peculiar to their country. Each building was designed and built to harmonise with the environment while fulfilling certain specific functions.

The climatic conditions and the great wealth of trees to be found in Bhutan have naturally given birth to an architectural style in which wood occupies a prominent role: shingle roofs and half-timber construction are common. But a human factor must be added to these climatic and environmental circumstances. Living in less severe conditions than the Tibetans, the Bhutanese appear to have chosen a model that is closer to their mentality and temperament, one of elegance and gentleness.

The great fortresses known as *dzongs* are among the most striking examples of Bhutanese architecture. Built in the first half of the 17th century by the first *Shabdrung*, Ngawang Namgyel, they acted as relays for the central authority and helped in the running of the country, while at the same time fending off any attacks from beyond its borders. But in addition to these administrative and military functions, Ngawang Namgyel gave the buildings a religious function; each *dzong* is home to a monastic community.

Symbolising the history and long independence of Bhutan, the *dzongs* are located in strategic places, at the entrance to a valley, at the summit of a hill or at the confluence of two rivers. Most of them are built according to the same design, the oldest example being Simtokha, which dates from 1627, but there are regional variations due to the landscape and environment. Perhaps the most spectacular is Trongsa, which is built into the hillside in several stages, overlooking the river below.

Generally speaking, *dzongs* are square or oblong in plan. From the outside, they look mostly like defensive structures. Their great stone walls, massive and steep, lean very slightly inwards, rising shear up to the roof. They are broken only by high windows, which are totally

inaccessible from the outside. The windows' outlines are marked in black paint, making a sharp contrast with the white of the walls. The lowest windows are very narrow and let in very little light. The upper rows are usually wider, and give into the living quarters. Just below the roof, a wide red stripe, the *khemar*, recalls the religious nature of the building. The gently sloping, overhanging roofs are normally raised one or two metres above the top storey.

However, the commonest structures in Bhutan are not the great fortresses but the *chortens*, known as *stupas* in India. There are thousands of these monuments all over the country, ranging in size from the very small to the very large. Witnesses to the profound faith of the Bhutanese, they can be found at crossroads, near *dzongs* or monasteries and on high mountain passes. They all have an indefinable presence, radiating serenity and peace.

Often isolated, rising from the floor of a valley or suspended against a cliff face, the temples and monasteries of Bhutan have played an import role in the country's history. Over the centuries, saints and lamas have supervised their construction. As in Tibet, the temples are called *lhakhang* (home of the gods) and the monasteries *gompa* (solitary place). However, while a temple will house only a few monks who are responsible for its maintenance and upkeep, the monasteries can house a large community with often more than 100 monks. The monasteries are primarily places of study, with the teaching and training of novices forming an important part of their work.

The villages of Bhutan often take the form of small hamlets of between five and fifteen houses, arranged in such a way as to mitigate the harsher effects of the climate. They are built close together to provide mutual protection against the wind and cold. The foundations are made of stone and the walls of clay or rammed mud, and are sometimes half-timbered on the south-facing side. The upper part of the window frame ends in a trefoil arch cut out of the cross-beam. Glass panes are still a rarity in the countryside of Bhutan. Generally speaking, there are sliding wooden shutters to close the window and protect the inhabitants against the weather.

Painting of the Kalachakra symbol on the prayer wall of Chendebji chorten.

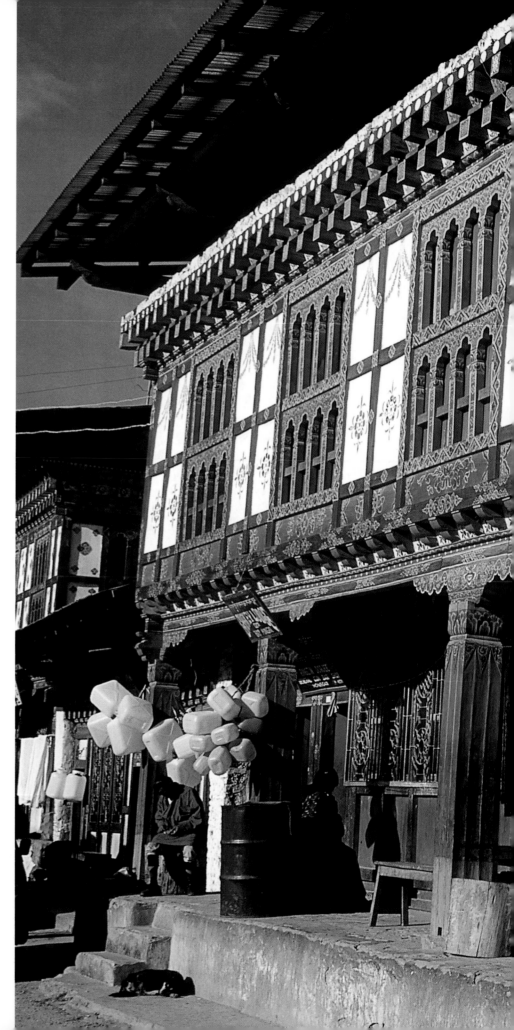

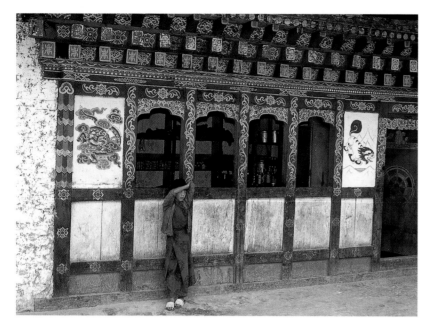

Traditional Bhutanese houses in Thimphu (*above*) and Mongar (*right*). North-facing walls are made of clay, while those facing south are half-timbered, with large windows. The timbering consists of wooden frames assembled with pegs. A clay mortar on bamboo trellis-work is used to fill the gaps between the wooden elements. Elegant trefoil windows make a pleasing contrast to the pronounced vertical and horizontal lines of the facades, while other decorative features break up their apparent rigidity. The wooden elements are painted black or brown and the enclosed areas are whitewashed before being decorated with flower or animal motifs.

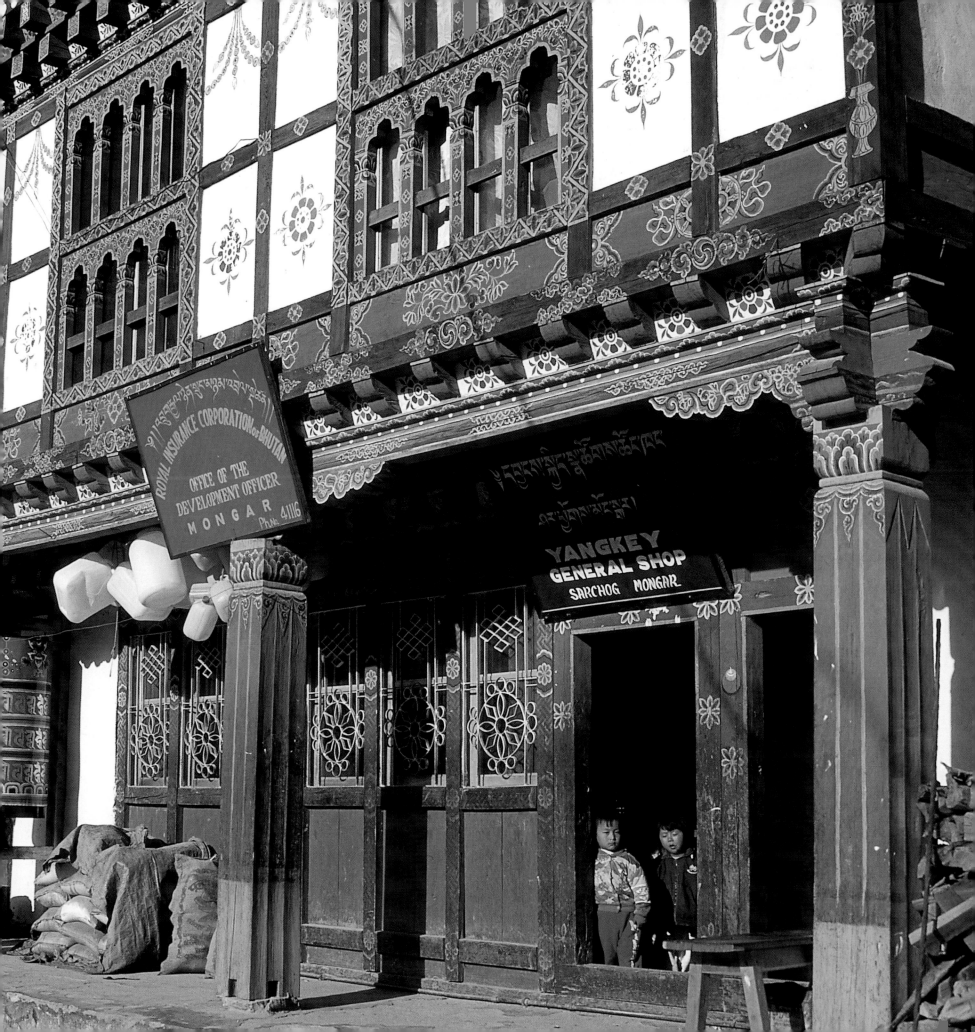

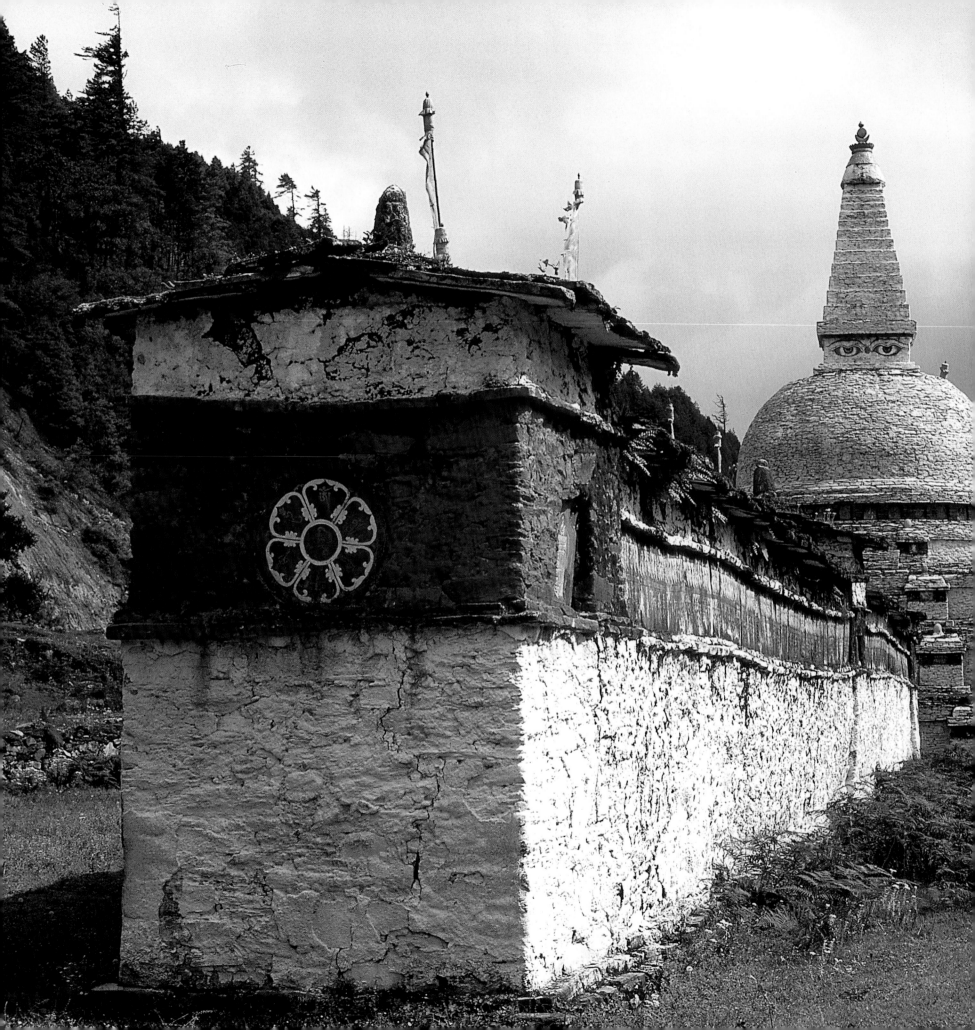

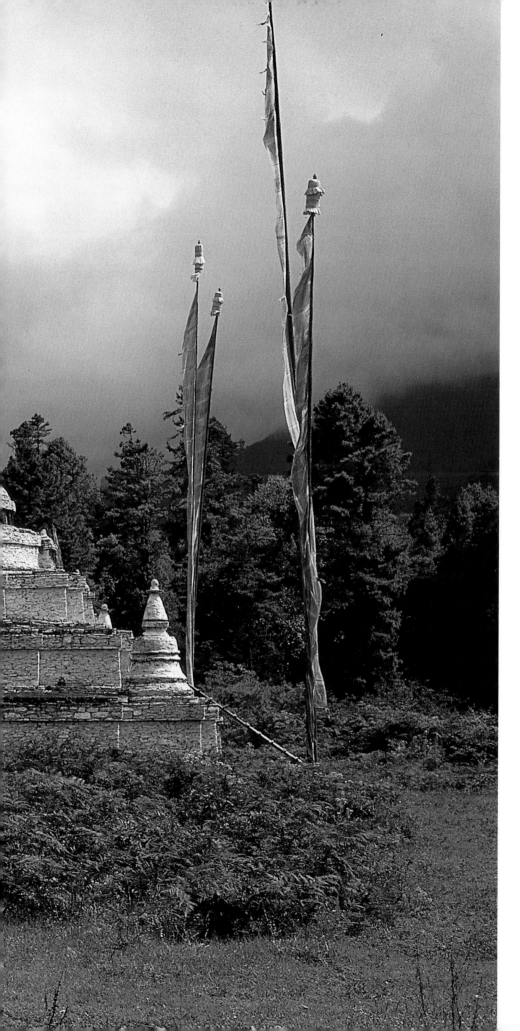

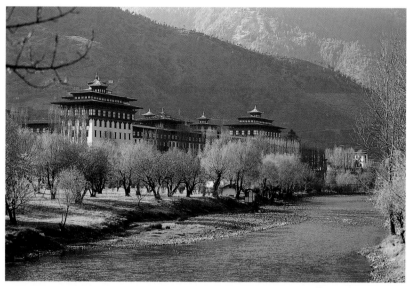

Like Chorten Kora (see page 163), Chendebji *chorten (left)* is based on the design of that at Bodnath in Nepal. The huge stone structure is whitewashed. At the top, two eyes on each side symbolise the omniscience of the Buddha. Although *chortens* can be found throughout the Himalaya from Ladakh to Arunachal Pradesh, *dzongs* are much more representative of Bhutanese architecture. *Above:* Thimphu *dzong.*

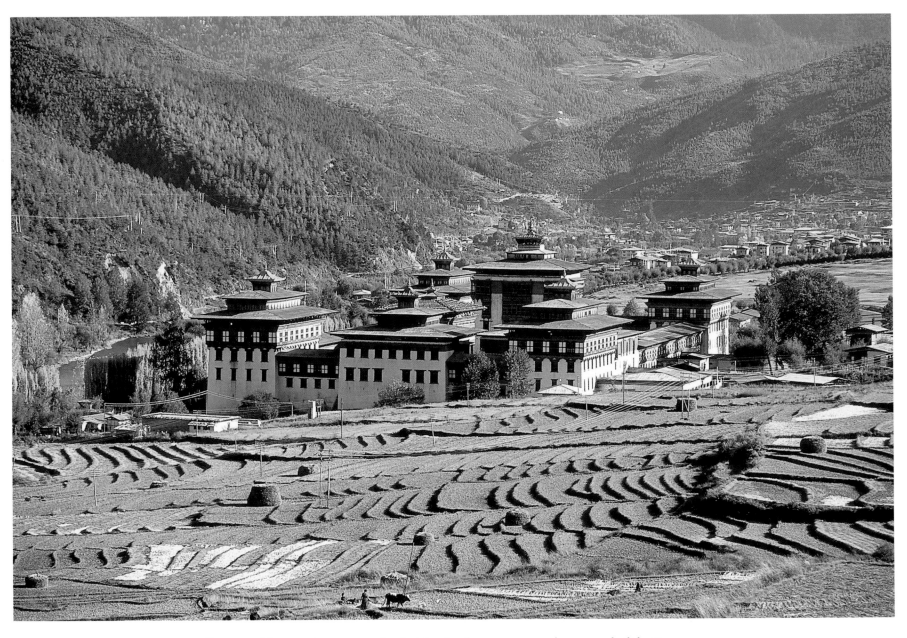

Outposts of the central government in administering the country, most *dzongs* were built by Ngawang Namgyel in the first half of the 17th century. While these fortresses recall those that existed in Tibet, it is only in Bhutan that they reached this level of architectural perfection.

Above: Tashichhodzong, seat of Bhutan's government. The present *dzong* was erected in 1968 around an older building, of which the central tower is a visible feature. The government ministries moved here as soon as it was completed.

Right: An architectural masterpiece, Trongsa *dzong* rises in stages up the side of a hill overlooking the river. It was built in 1644 by Minjur Tenpa on the site of a temple erected a century earlier by Ngagi Wangchuck. Trongsa has been constantly enlarged and today comprises more than twenty temples.

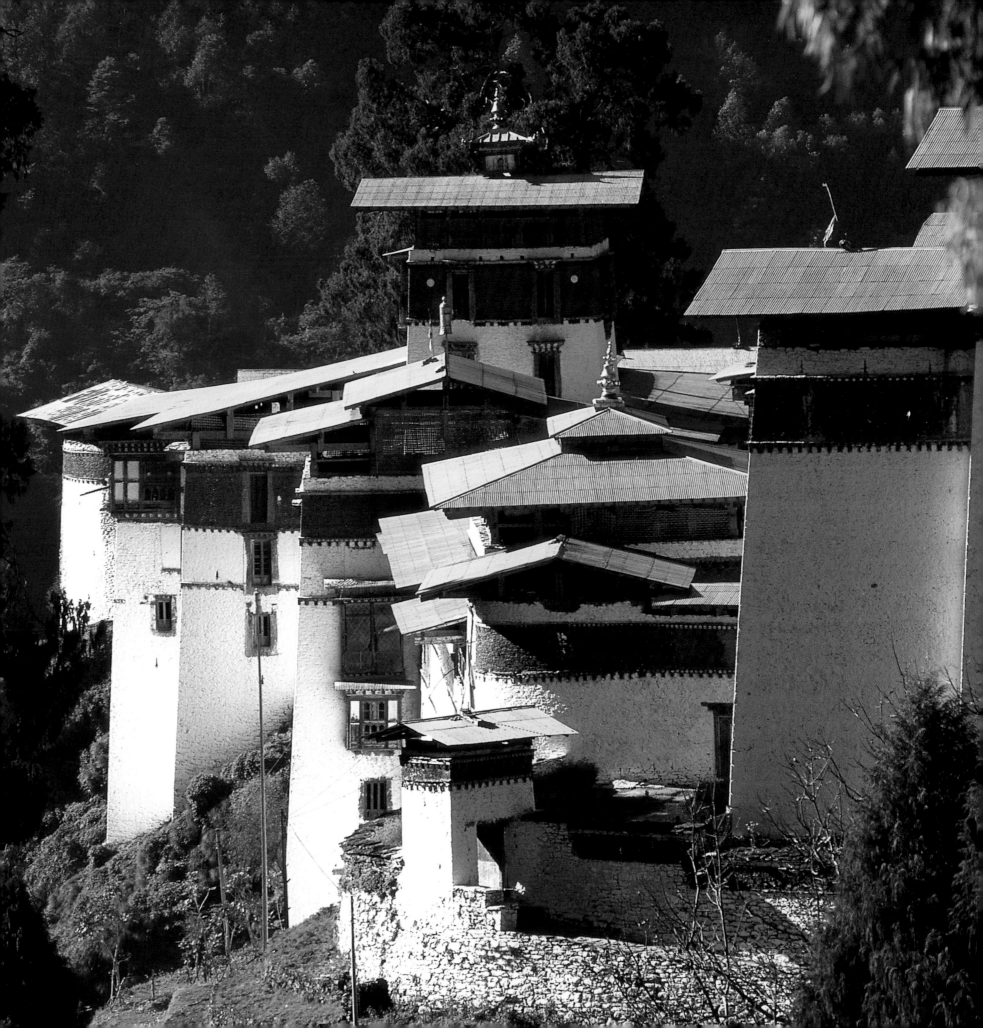

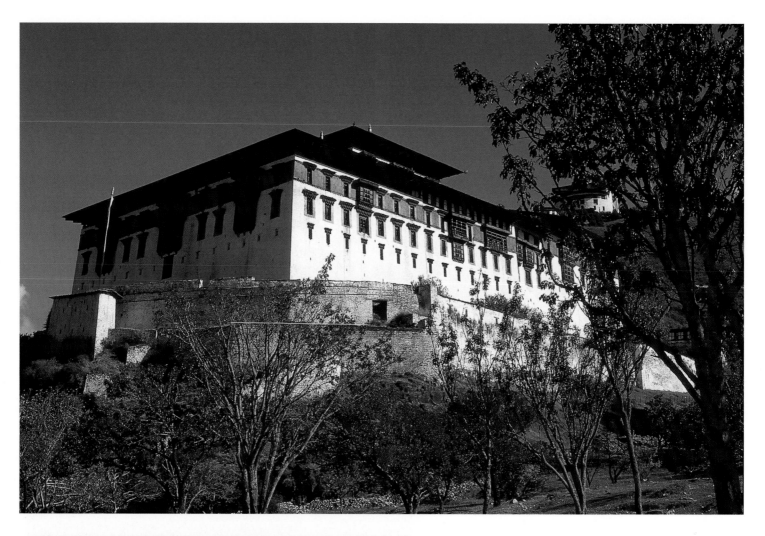

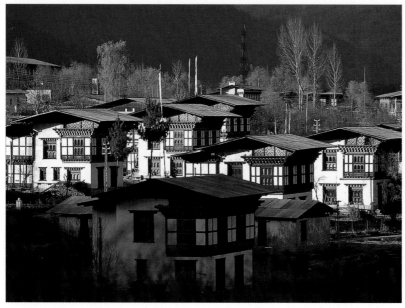

Above: Built in 1646 on the site of an ancient temple, Paro - or more correctly Rinchen Pung - *dzong* is a magnificent example of Bhutanese architecture. The impressive building dominates Paro village and the valley.

Left: Traditional Bhutanese houses in Thimphu.

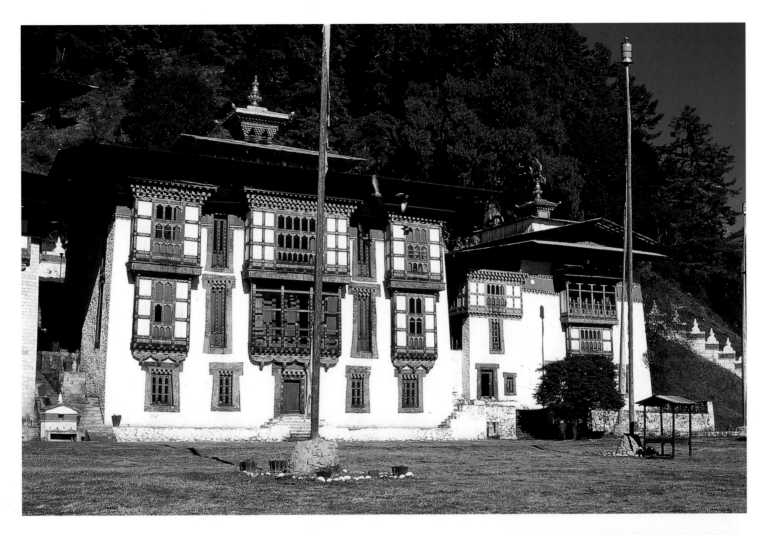

Above: Kuje *lhakhang* is particularly venerated in Bhutan. Guru Rinpoche came here in the 8th century to subjugate the demons living in the valley. He meditated on this spot and left the imprint of his body on a rock.

Right: Takse *lhakhang* in Trongsa valley.

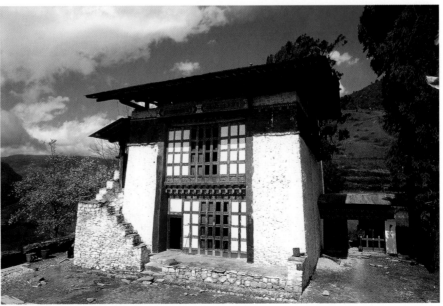

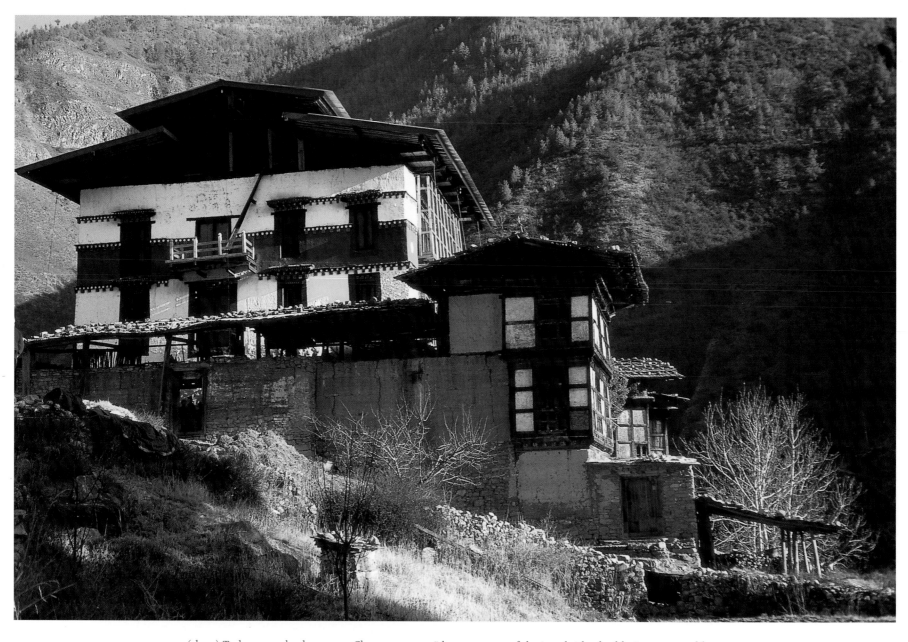

(*above*) Tachogang, also known as Chagzam *gompa* "the monastery of the iron-bridge builder" was erected by the Tibetan saint Thangtong Gyelpo (see page 169). An architect, poet, artist, sculptor and, in particular, an engineer, he is reputed to have had the temple built in the 1420s. In 1421 he also ordered the construction of the elegant, *chorten*-shaped temple at Dungtse (*right*).

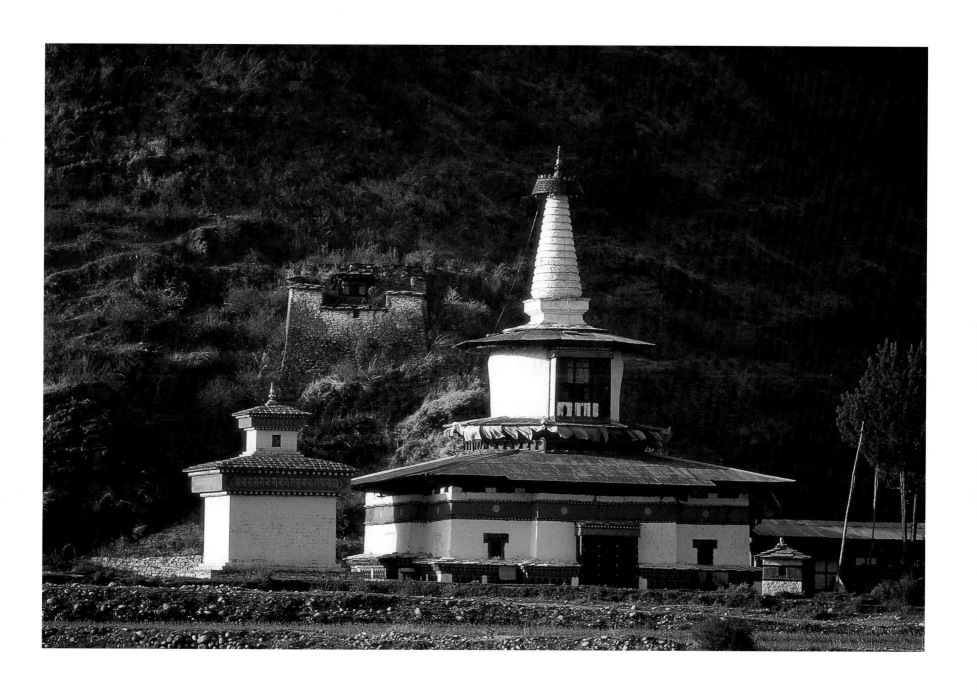

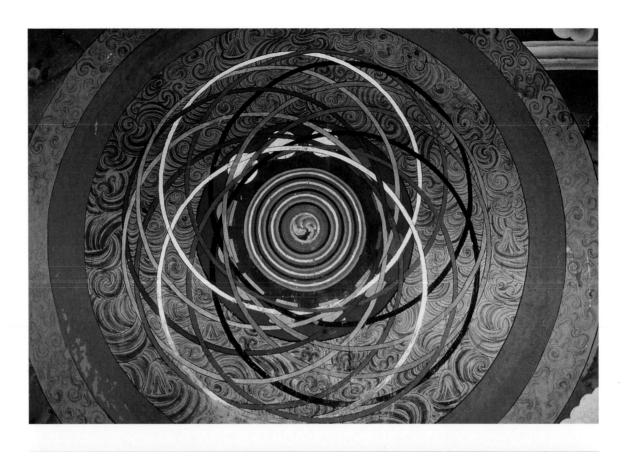

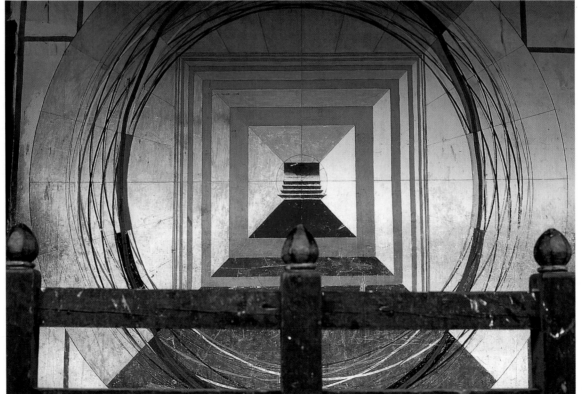

The courtyards of *dzongs* are often decorated with splendid paintings like these cosmic mandalas, which can be seen at Paro *(top)* and Simtokha *(left)*.

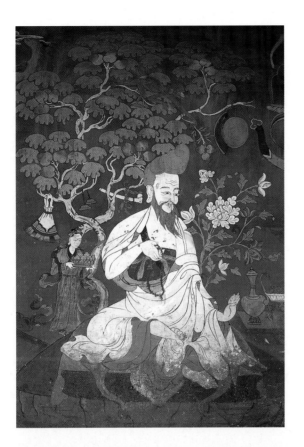

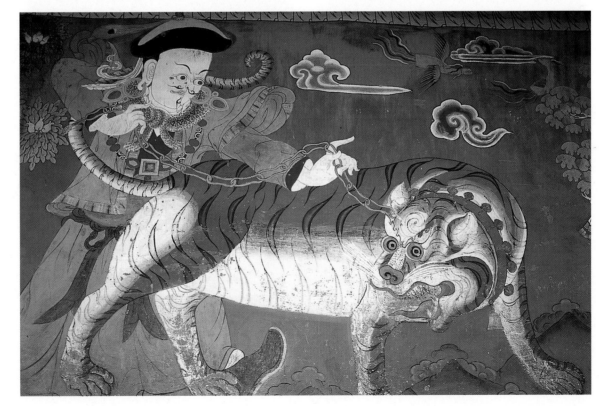

(top) Paintings in Paro *dzong* represent an old man, symbol of long life, surrounded by animals *(Tsering Namdruk)* and an image of the famous Mongol with his tiger *(right)* (also see page 116).

Following spread: Interior courtyard of Tashichhodzong in Thimphu.

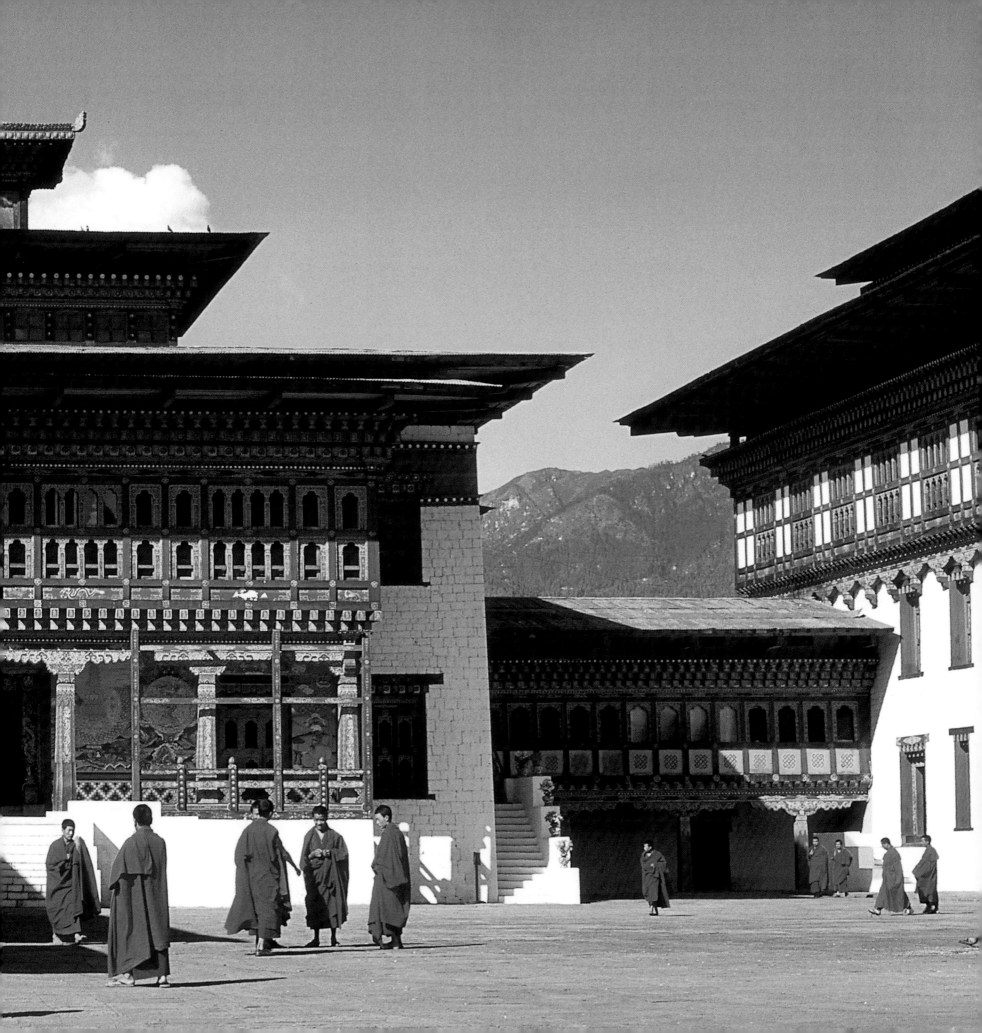

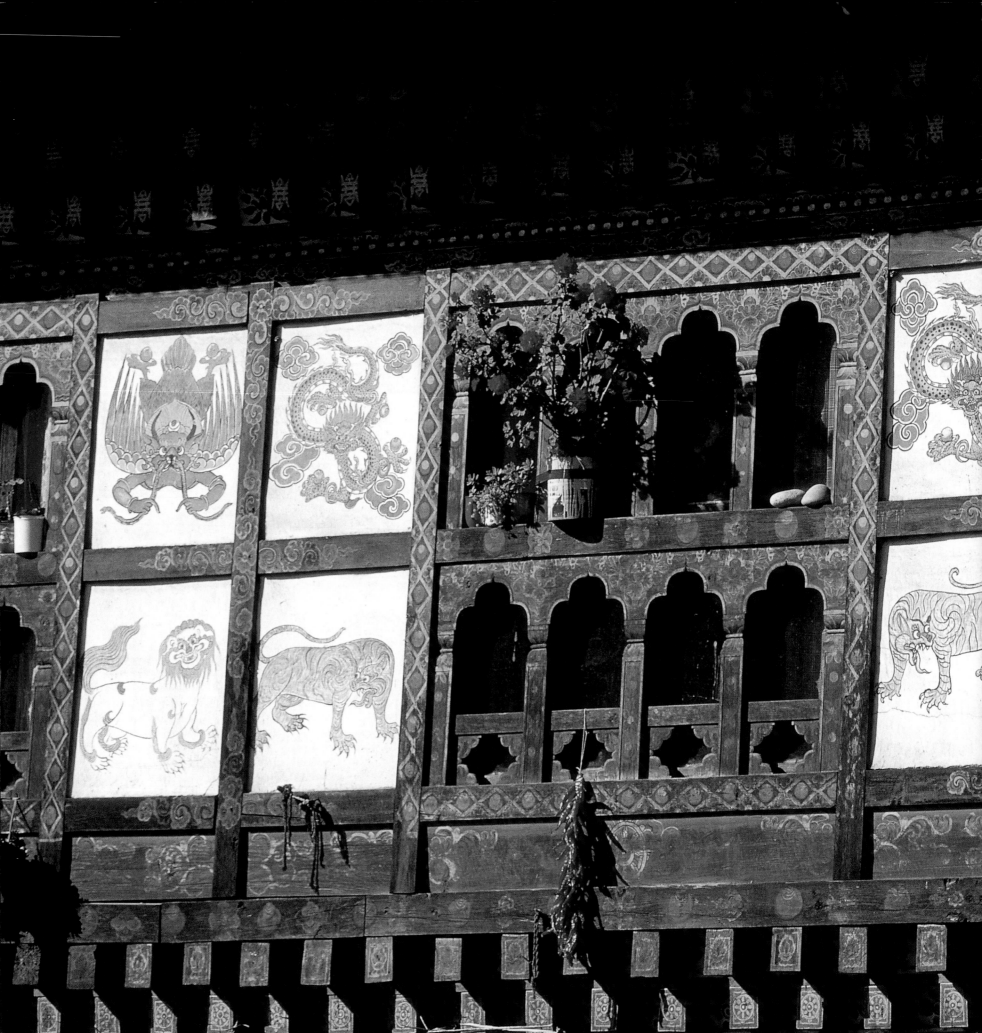

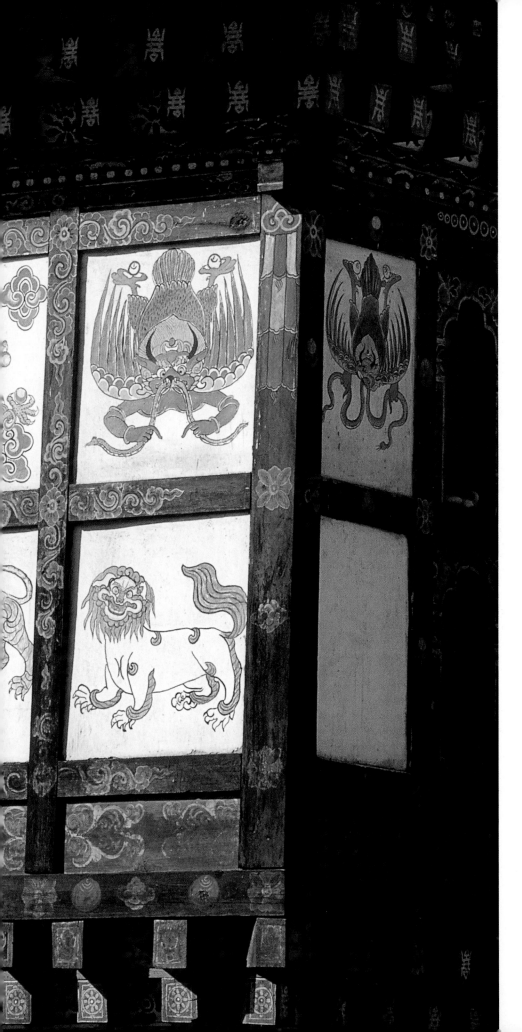

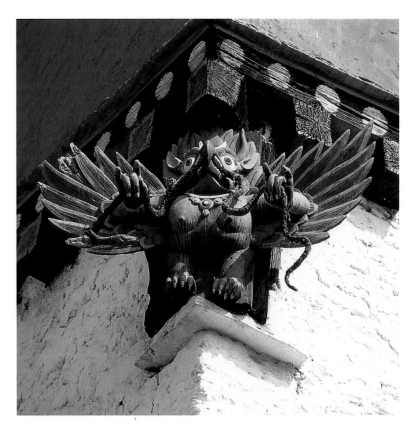

Left: Animals are frequently represented in the decorative paintings on the walls of Bhutanese houses. They may be real (tigers, deer, etc.) or taken from Buddhist mythology (dragons, snow lions, etc.). The mythical *garuda*, with its powerful eagle's beak and terrible horns, also appears frequently on the walls of houses and numerous temples, as at Simtokha *dzong* (*above*).

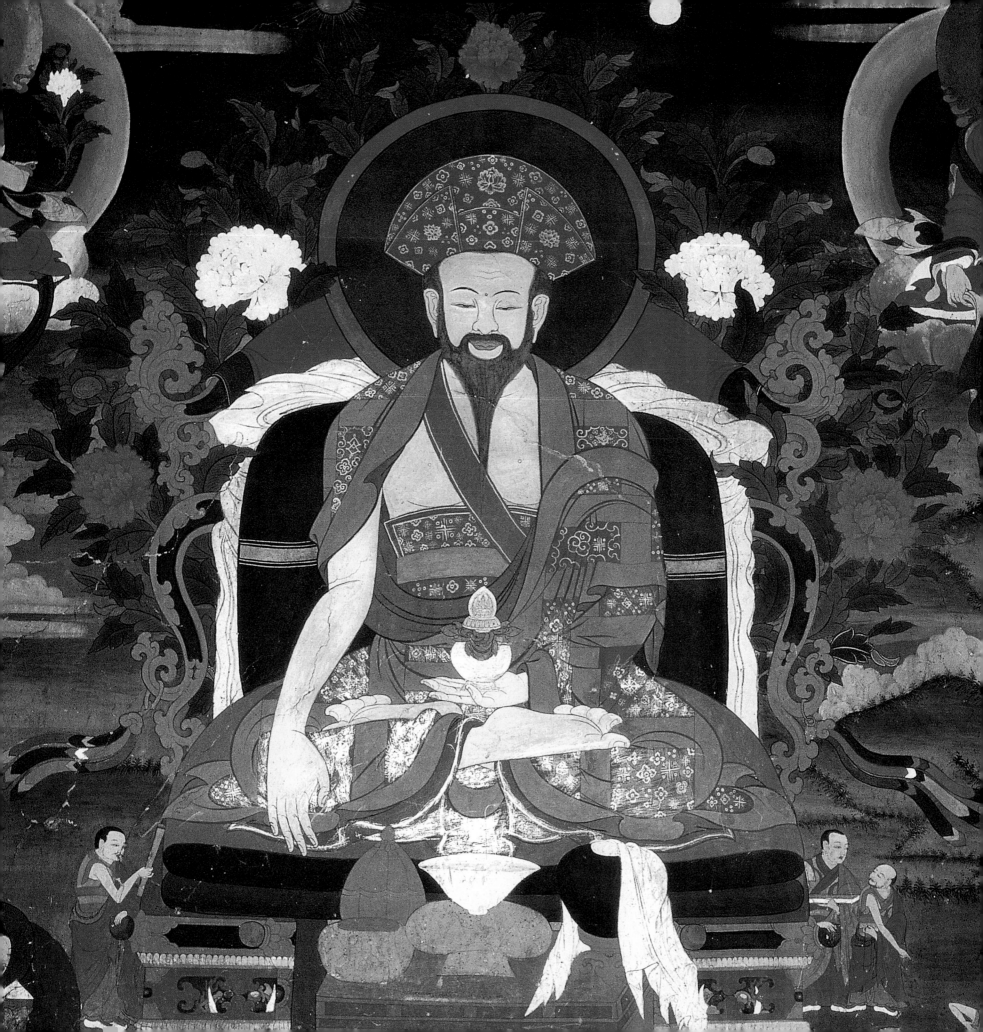

THE GREAT PUNAKHA PROCESSION

3

In the cool of the early morning, a multicoloured crowd throngs towards the *dzong*, seat of the district's civil and religious administration. Normally calm and serene, the old fortress is a buzzing hive of activity this morning. Men and women, young and old, monks and lay people are all laughing and jostling under the great white walls to reach the wooden staircase that leads into the *dzong*. The atmosphere is one of joy as strange soldiers dressed in red and black mingle with the crowd. All these figures seem to come straight from some country festival painted by Brueghel.

This shared outburst of frenzy and joy is apparent because they have come to take part in the great Punakha procession. Each year on the ninth day of the first month, this recounts one of the most famous chapters in Bhutan's history, the story of a battle, or rather a cunning victory, that the Bhutanese won against the Tibetans more than 300 years ago.

To prepare the day, long rituals are performed at the *dromchoe* ceremony dedicated to Yeshe Gompo, the "Great Black One", Bhutan's protective divinity. In the inner courtyard of the *dzong*, the masked dances will help to purify the ground and protect the region from demonic spirits. Once these rituals are over, everyone rushes outside to watch the *serda*, a superb and solemn procession. Monks and lamas wearing the great red head-dress of the official school of Bhutan leave the enclose of the *dzong* to the sound of trumpets and drums. Flags, banners and standards form a long colourful line, like a great ribbon flapping in the winter breeze. On either side of the procession, the crowd rushes forward to receive a blessing from the religious men who now make their way towards the river. There, in the first half of the 17th century, their ancestors performed the very same ceremony.

At the beginning of 1639, the Tibetans had crossed the mountains. Undeterred by the snow and ice blocking the high passes, their army had made its way down into the foothills and had now reached the gates of Punakha. Already their helmets and armour glinted at the edge of the nearby woods. They had come to take back the small statue that Ngawang Namgyel, Bhutan's religious leader, had carried away from Tibet several years before, and they were prepared to use force. This statuette, known as Rangjung Kharsapani, represented the Buddha of Compassion. Tradition said it had appeared miraculously from a vertebra of Tansgpa Gyare,

founder of the *drukpa kagyu* school, at the moment of his cremation. Possessing it gave power over all the *drukpas*.

Convinced of their superior numbers and weapons, the Tibetans prepared to attack the *dzong*. However, the besieged Bhutanese were to be saved by a double trick. Using a secret door at the back of the fortress, and hence out of sight of the Tibetans, they organised an uninterrupted line of men that came back into the *dzong*, thus giving a false idea of their strength. Somewhat taken aback, their assailants withdrew to the far side of the river. Ngawang Namgyel had been waiting for this opportunity. He gathered all the monks and warriors together and ordered them outside, where they were to form a great procession and head slowly towards the river. Bringing up the rear was the *Shabdrung* himself, grave and solemn, carrying in his hands a small casket that the Tibetans took to be the sought-after relic, assuming that the holy man was about to return it to them. All eyes were fixed on the procession. As the cortege reached the river, it stopped. Then, Ngawang Namgyel raised his arms and threw the casket into the icy waters swirling beneath. Horrified by this, dozens of Tibetans hurled themselves into the river to try and save it. But they were wearing heavy armour and as none of them could swim, they all drowned. No-one imagined that the precious statuette was still concealed in the dark recesses of some temple!

Nowadays, a handful of oranges symbolises the precious relic that the *Je Khenpo*, Bhutan's religious leader, in his turn throws into the river. A few reckless fellows disrobe on the banks and jump into the clear water as it carries away the oranges, thus recalling the poor Tibetans as they drowned – to the delight of the crowd.

The return towards the *dzong* is rowdy and joyous. Shouts of victory are heard all around. This historic day ends with great libations, in which *chang* flows freely.

Then, as evening falls, everyone returns home, heads filled with visions of colour and movement. The religious chants and the war cries of the great Punakha festival fade into the surrounding mists, and peace returns to the solitary, majestic *dzong*. And as the monks go back to their meditations, in the distance, towards the plains and the jungle, the river carries away the last echo of the victory celebrated by the mountain people.

Left: Shabdrung Ngawang Namgyel, who unified Bhutan in the first half of the 17th century.

Following spread: Built in 1637, Punakha *dzong* is the setting for the Great Procession each year.

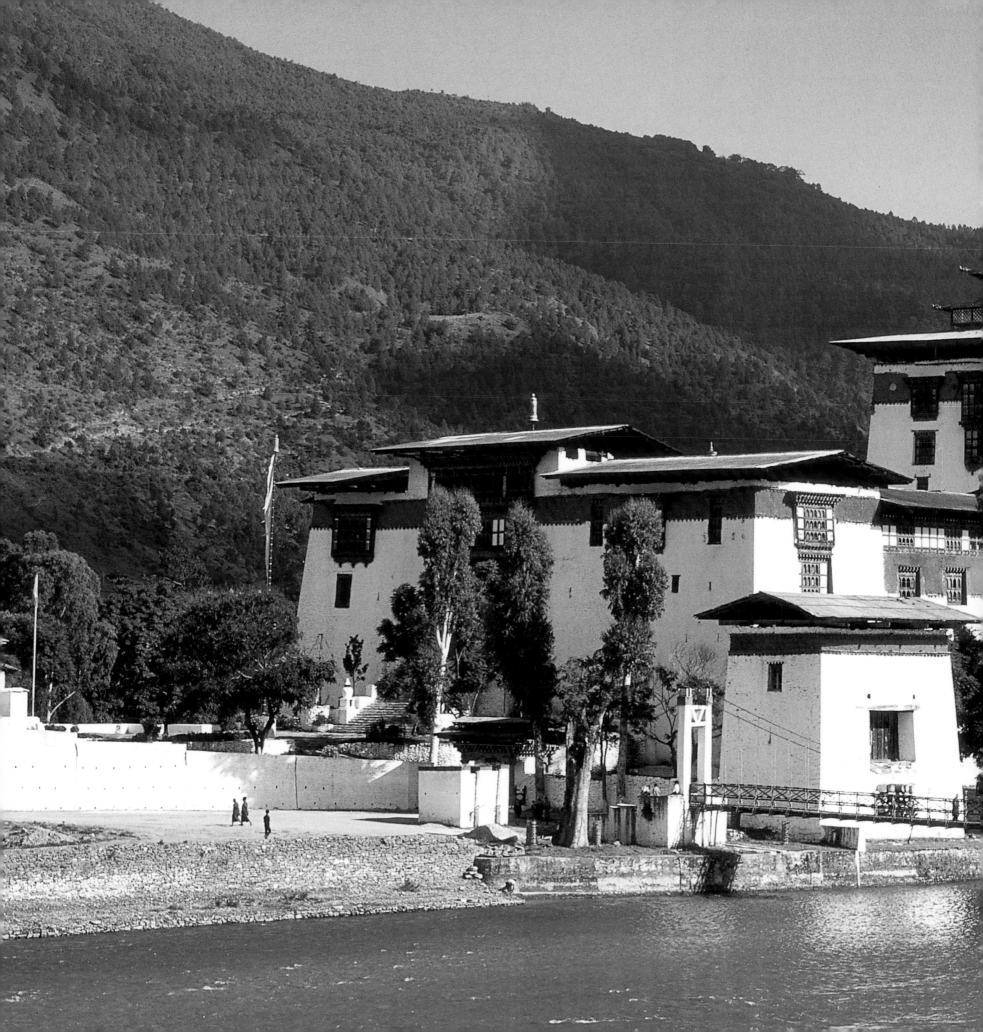

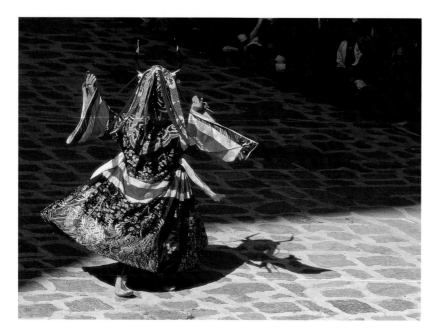

Before the Great Procession takes place at Punakha in the first month of the lunar year, several days are devoted to the _dromchoe_, during which deeply symbolic dances and purification rites are held. The dance of the Fearsome Divinities, _tungam cham (right)_, involves a ritual sacrifice whereby the enemies of the Doctrine are destroyed. Through this gesture, the dancers rid the world of demons and evil spirits; they also eliminate inner enemies such as the ego, obstacles and mental darkness that prevent each individual from achieving Enlightenment.

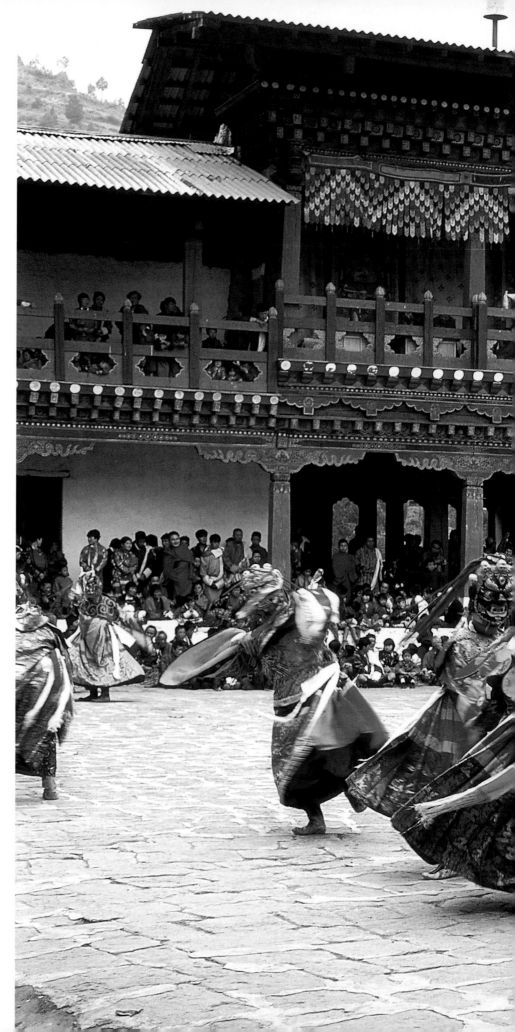

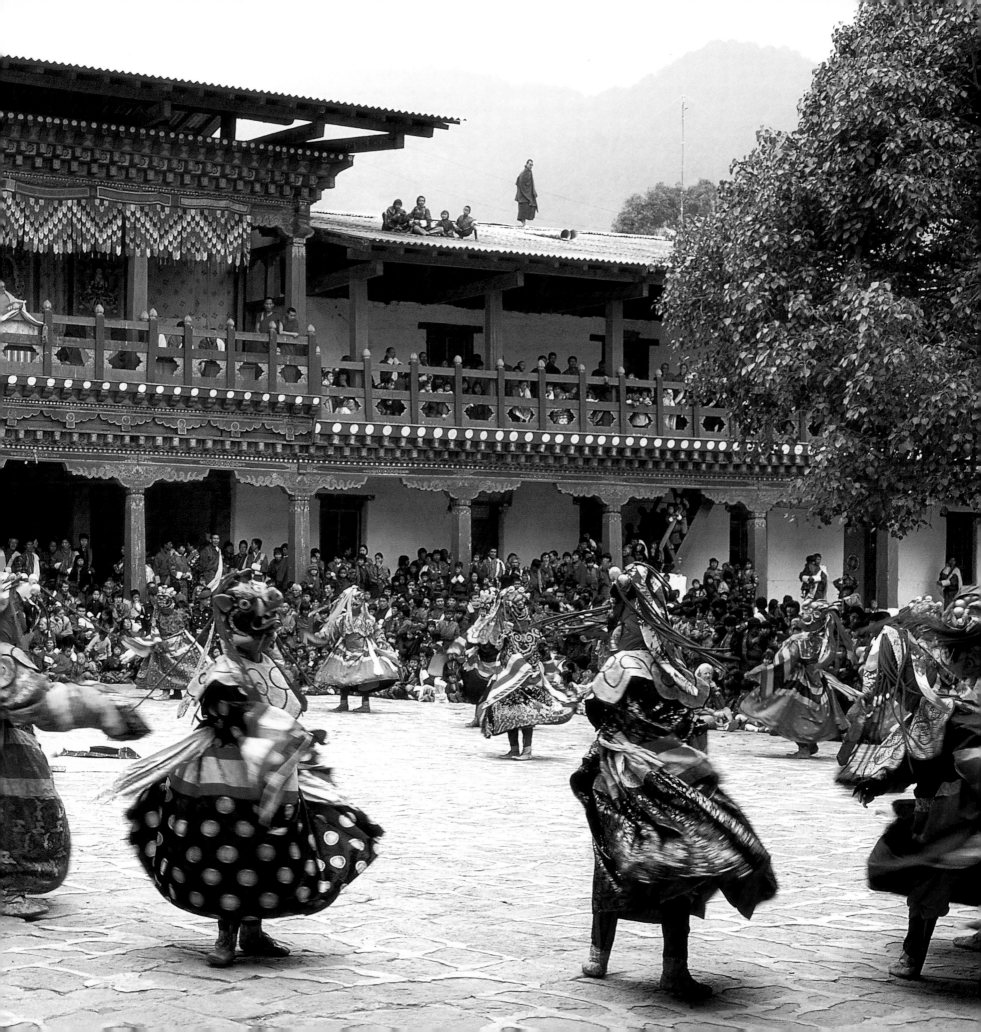

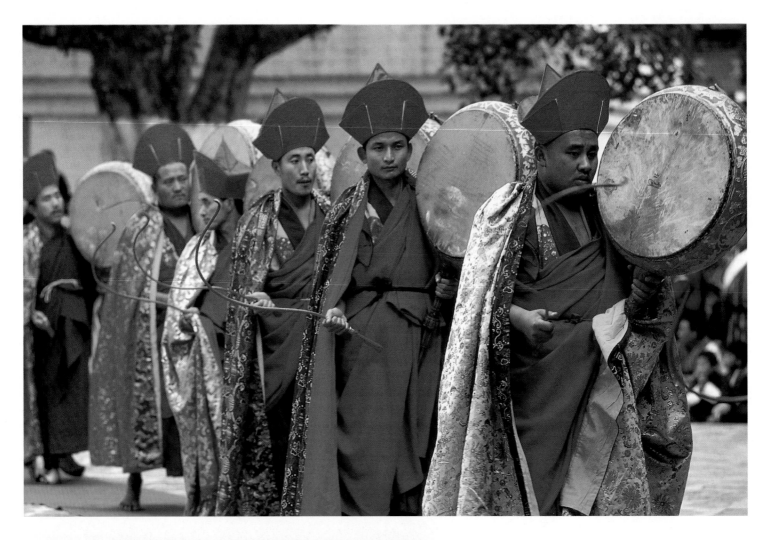

Above and top-right: Having overcome all obstacles, the dancers use their drums to proclaim the victory of Knowledge that leads to Deliverance.

Left and bottom-right: These remarkably modern-looking paintings at the entrance to Punakha *dzong* combine geometric designs and lines of poetry honouring the *Shabdrung*.

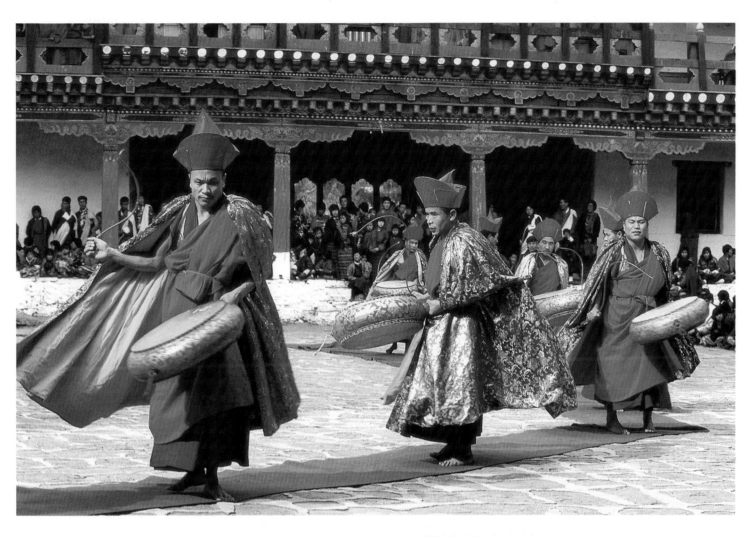

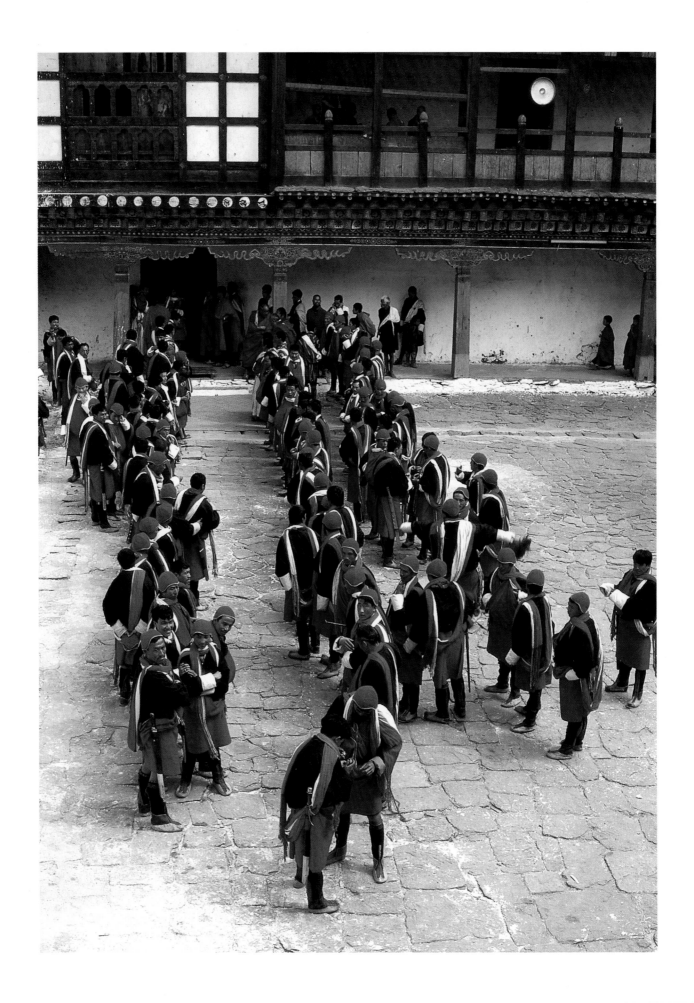

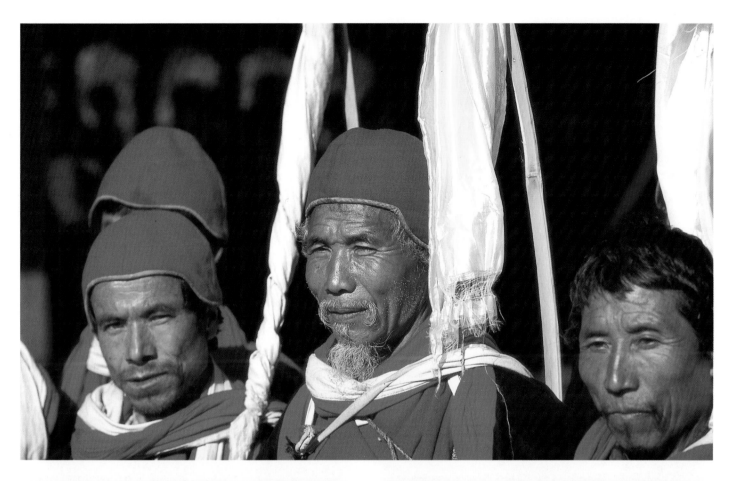

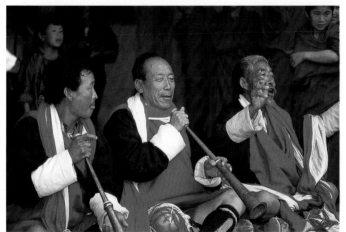

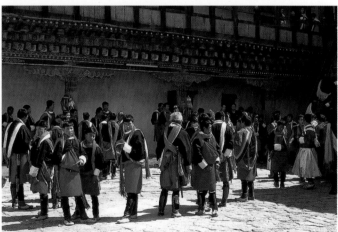

Dressed in red and black, the *pazaps* represent the soldiers of Ngawang Namgyel's army.

Following spread: On the day of the Great Procession, the generals (*zinpōn*) dress in their finest clothes made of coloured silk and proud helmets decorated with flags.

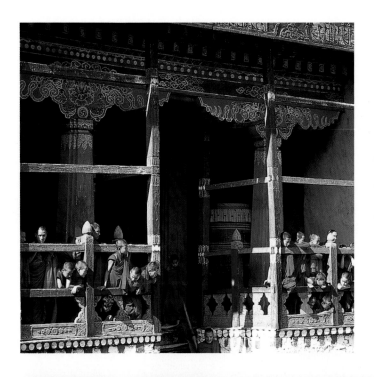

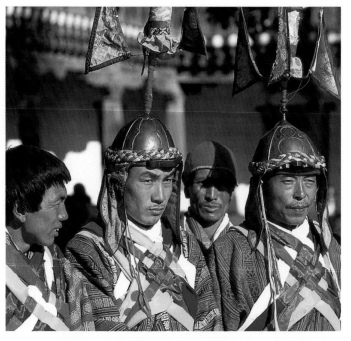

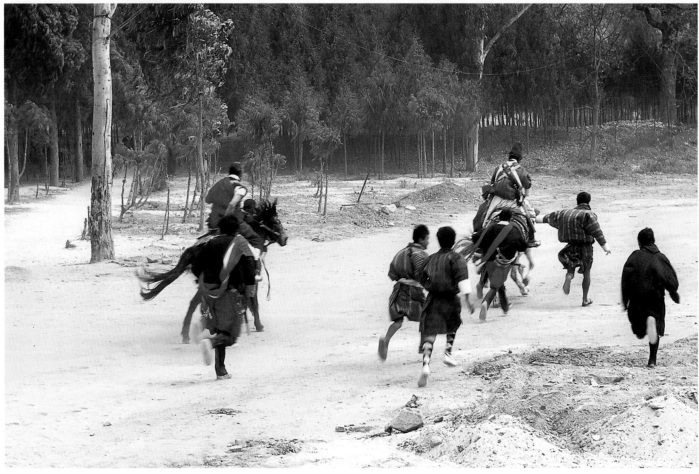

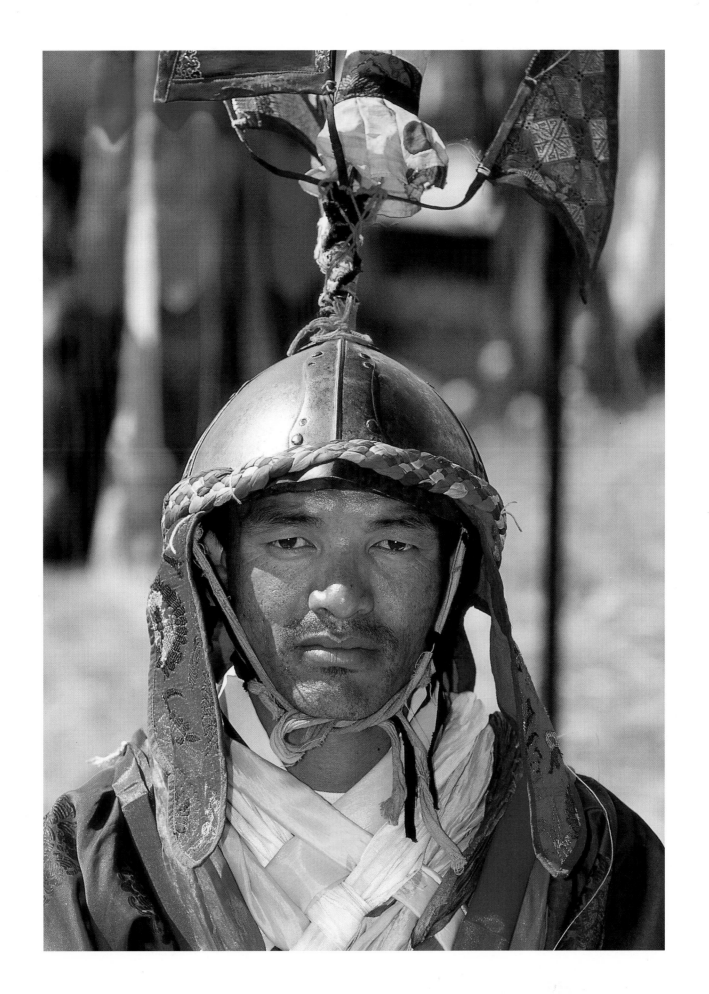

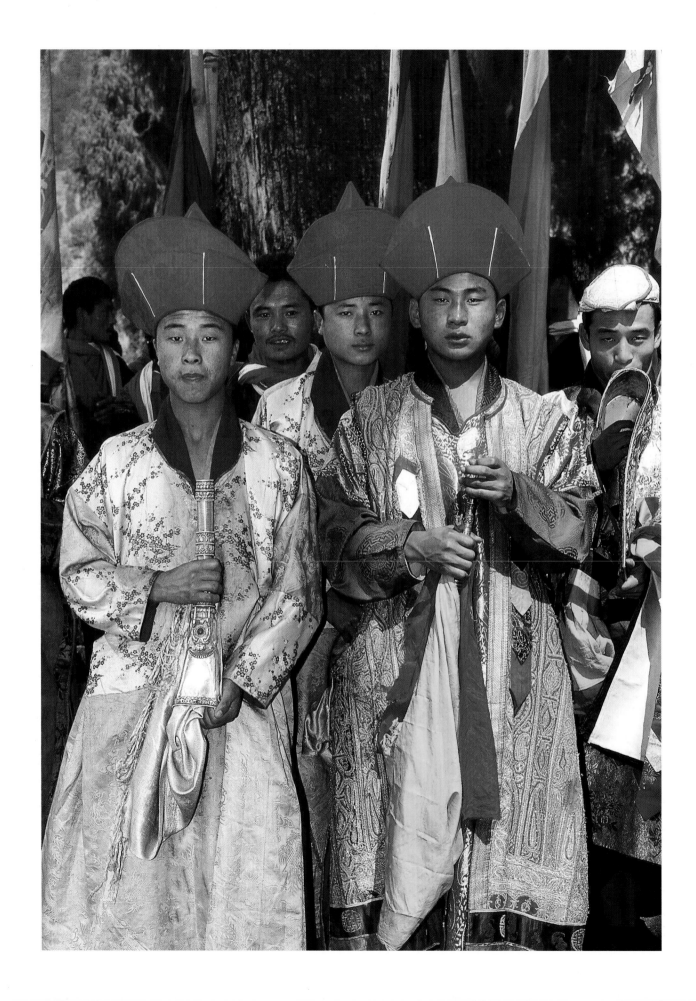

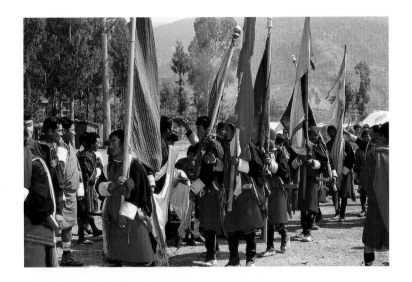

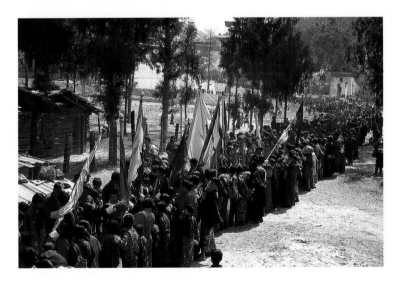

The *serda* is a magnificent solemn procession and the most spectacular part of the ceremonies held at Punakha. All the monks and lamas, wearing the great red head-dress of the *drukpa kagyu* order, leave the *dzong* to the sound of trumpets and drums. On either side, the crowd rushes forwards to receive a blessing from the religious men. In clouds of juniper and incense smoke, the procession heads towards the river, where Ngawang Namgyel conducted the same ceremony more than 300 years ago.

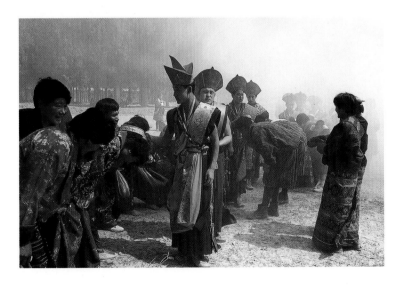

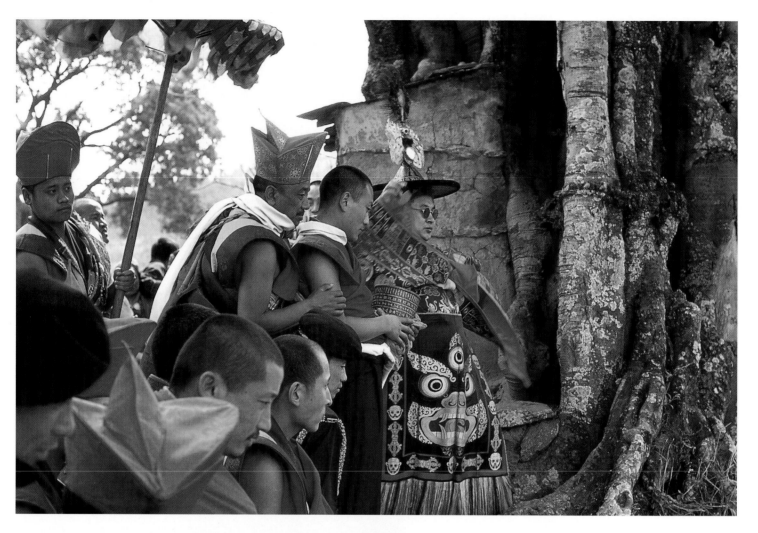

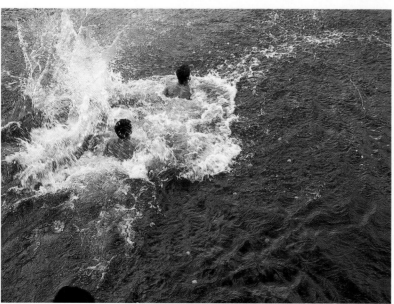

Nowadays, a handful of oranges symbolises the precious relic that the *Je Khenpo*, Bhutan's religious leader, throws into the river. A few reckless fellows disrobe on the banks and jump into the freezing water to try and collect them.

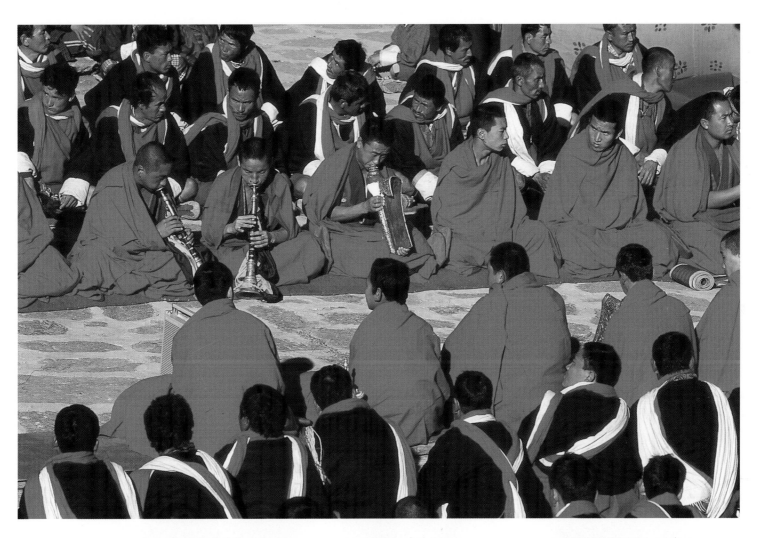

The Punakha ceremonies
end with offerings of *chang*
and a ritual which takes
place opposite the immense
thongdroel representing
Ngawang Namgyel.

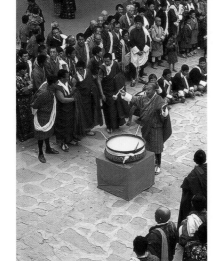

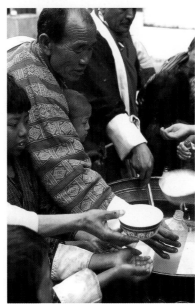

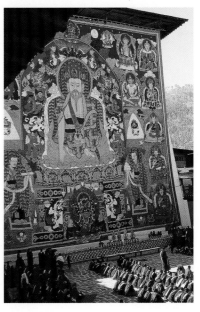

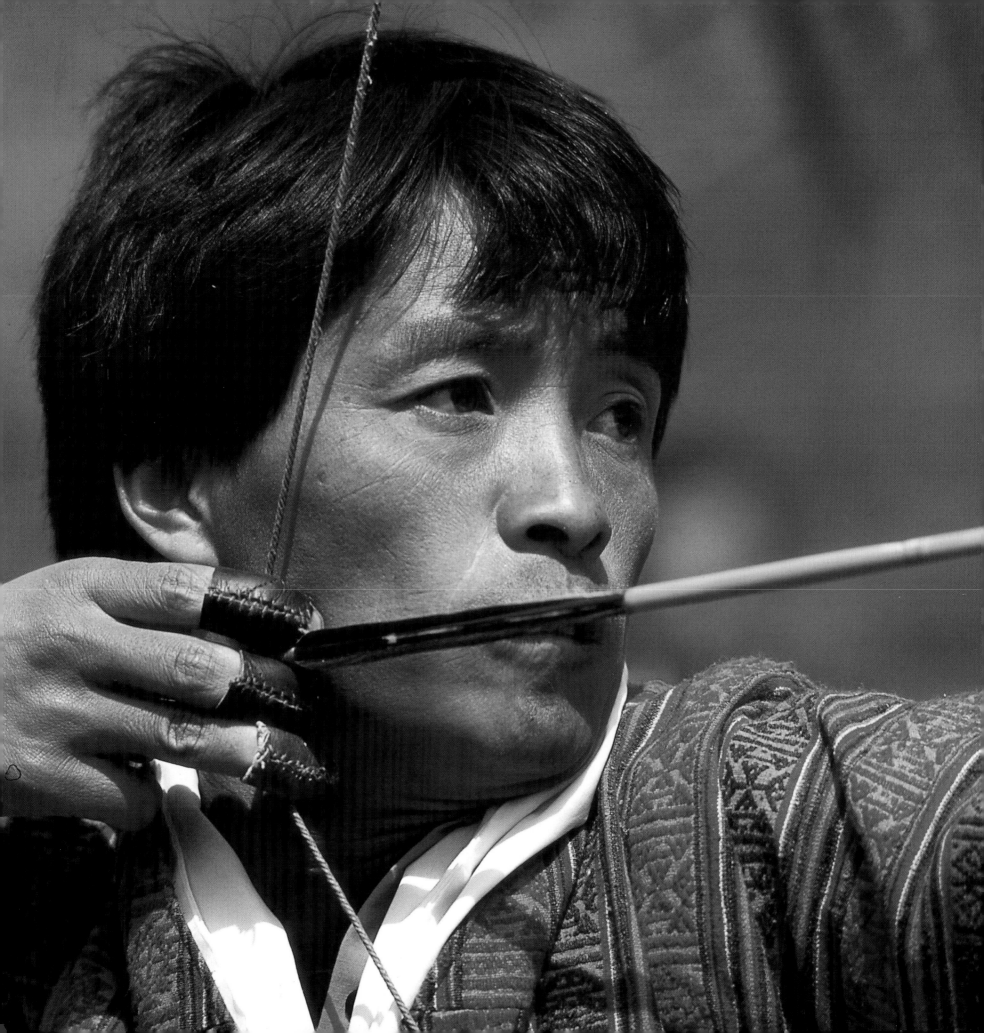

BHUTANESE SOCIETY

Strongly influenced by Buddhism and its tradition of tolerance, modern Bhutanese society has been built up over the years in a harmonious manner, avoiding the confrontations of castes and cultures that often afflict many of the countries of Asia. However, complex ethnic and linguistic structures could have worked against the creation of this society.

In the earliest years of our era, the indigenous people, of whose origins nothing is known, seem to have been joined by tribes from the Indian plain and foothills of the Himalaya. Successive waves of Tibetans followed between the 7th and 17th centuries, indelibly marking Bhutanese society with the influence of the Land of Snow. These Tibetans included the legendary prince Tsangma, the brother and enemy of the dreaded King Langdarma, who persecuted Buddhism. He settled in Bhutan in the 9th century. Lastly, Nepalese immigrants began to arrive in Bhutan at the end of the 19th century and during the first half of the 20th. These successive migrations have produced the three main ethnic groups that form modern Bhutan's population.

The *Sharchops* or "people of the east" are of Indo-Mongoloid origin and seem to belong to the oldest groups living in Bhutan. Their religious traditions are extremely lively, and sometimes elements of the *bön* cult can still be detected. The eastern part of the country is inhabited by many *gomchens* of the *nyingma* school. Unlike the official clergy, these lay priests do not live in a monastic community but with their families. The people in the east speak *tsangla*, which is more commonly called *sharchopkha*.

The *Ngalongs* are of Tibetan origin and live in the west of Bhutan. Their forbears included the great religious teachers of the 14th and 15th centuries. Disciples of the *drukpa kagyu* school, they played an important role in the administration of Bhutan from the 17th century onwards. They speak *dzongkha*, which is now the official language of the entire country.

The *Lhotsampas* live mostly in the villages in the south of Bhutan, along the frontier with India. They are mainly Hindu and speak Nepalese. As in India and Nepal, they are organised into castes and ethnic subgroups: *Gurungs, Limbus, Raïs*, etc.

In addition to the three main ethnic groups, there are many minorities, forming a great mosaic of traditions and cultures. The *Khyengpas* inhabit the Trongsa and Zhemgang regions of central Bhutan. They are people of the forest, and know all its secrets. The *Brokpas* are semi-nomadic shepherds who live in the Merak and Sakteng regions. The *Doyas* occupy a few villages in the districts of Ha and Samtse, where their distinctive traditions feature special funeral rites. Lastly, the *Lepchas*, who came from Sikkim, are scattered throughout the western part of the country.

Although small towns are now beginning to appear, Bhutan is still essentially a rural country. Farmers and stock-breeders account for almost 85% of the total population. The rural people all live in attractive villages built on the banks of rivers or on the gentle slopes of hills overlooking patchworks of terraced fields.

With the country's economic development and improvements in the road network, however, many people are now turning towards business enterprises. Shops and boutiques offering Bhutanese and Indian goods are springing up in all the larger towns. Various businesses also import high-tech goods, including communications technology and computers from the West. These tradesmen now form a new social class, consisting mainly of young go-getters who are totally committed to Bhutan's future. Lastly, the expanding civil service works on behalf of the Government, in the various ministries located in the capital or in administrative departments spread throughout the country.

Bhutanese society is extremely egalitarian and as such has no rigid class structure. Anyone can rise through the ranks of the civil service or private sector. Bhutanese women enjoy equivalent rights to men, taking an active part in the affairs of the country and sometimes holding high positions in government departments. Family ties, which are often very old, cut across social boundaries and help in mixing the political, religious and economic spheres, thus reinforcing the cohesion of society. Whatever their status, all Bhutanese are extremely respectful of the monarchy.

Archery was used for centuries in warfare, but it is now Bhutan's national sport.

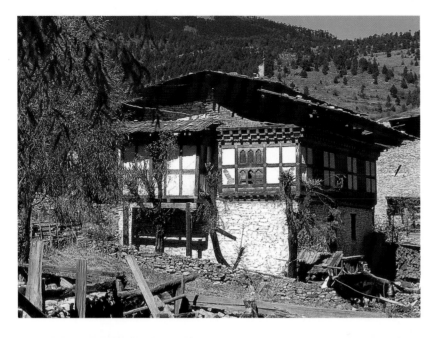

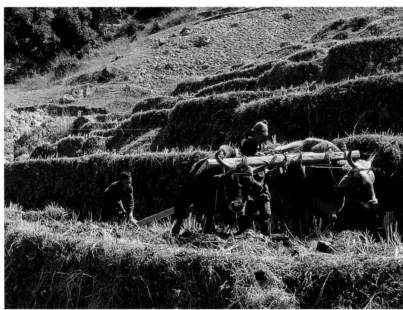

The great majority of Bhutan's people are farmers and animal breeders. Rice is grown in many regions, sometimes at very high altitudes, and is the country's staple food.

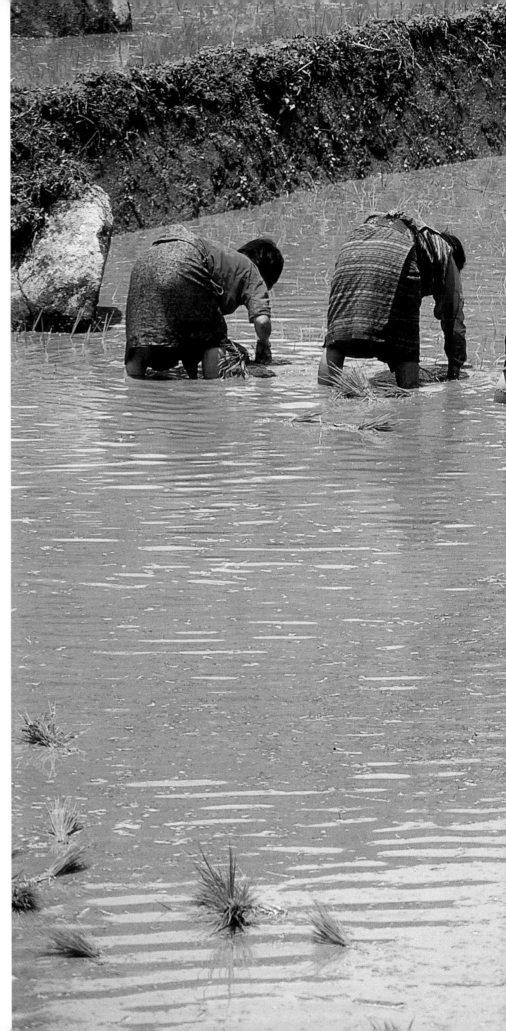

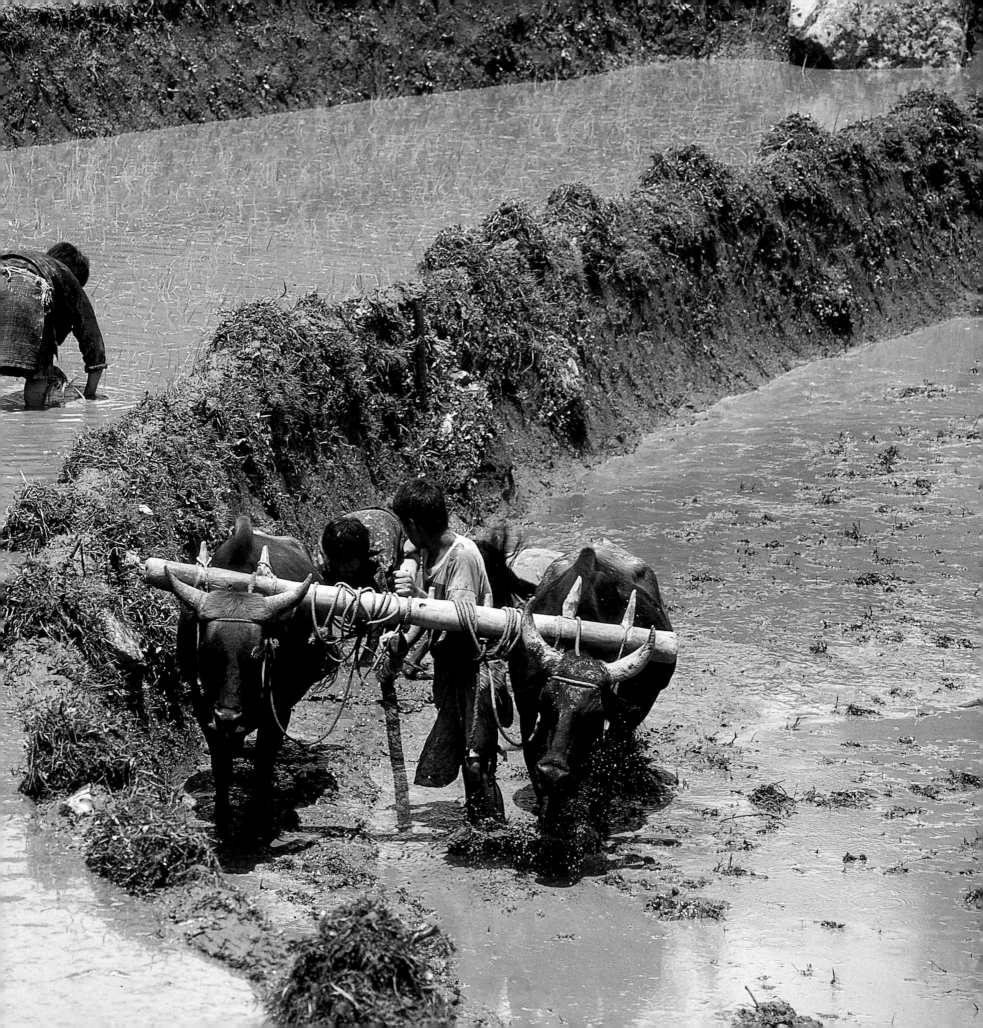

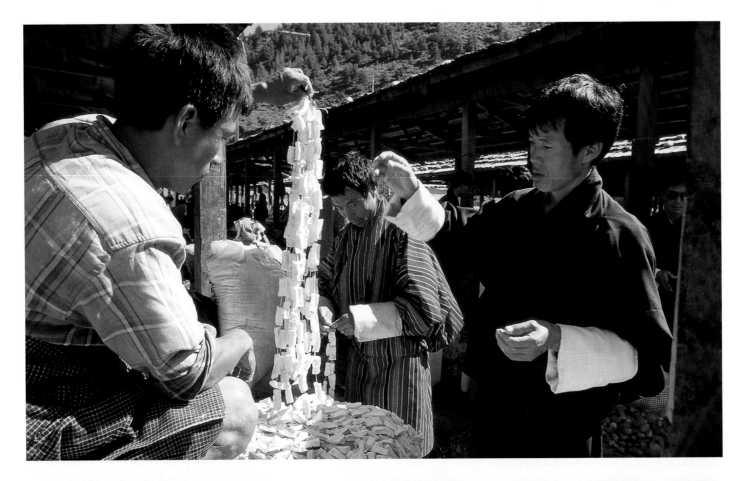

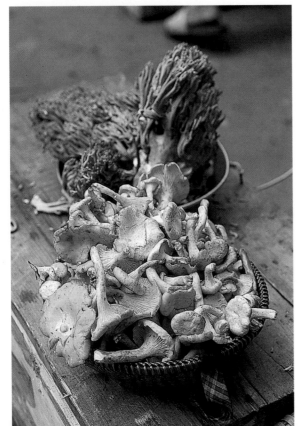

The bustling, colourful vegetable market in Thimphu offers all sorts of produce from the four corners of the kingdom. The local people buy little squares of dry cheese and excellent mushrooms or areca nuts that are used, with a betel leaf and lime, to prepare the famous *doma*. They also buy peppers, beans, cabbages, potatoes, onions and fern shoots to include in curries.

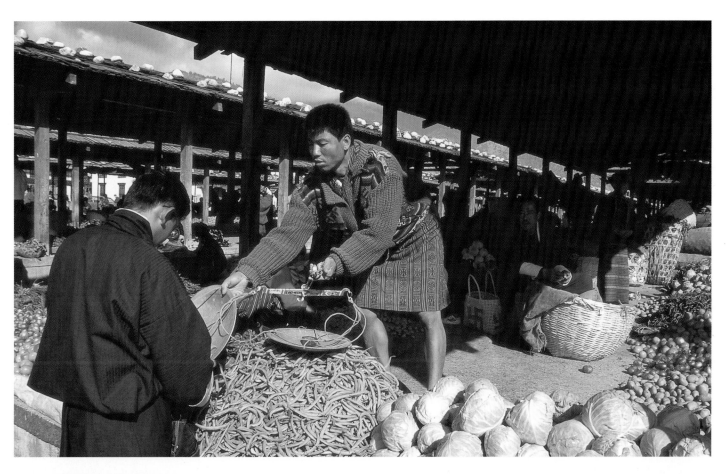

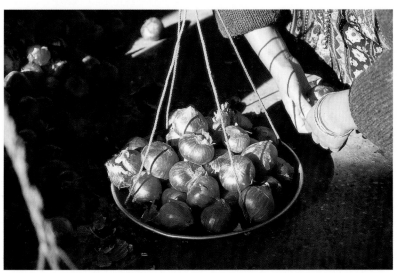

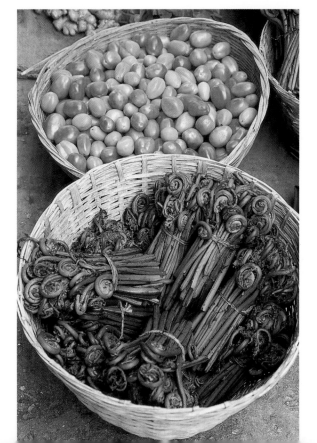

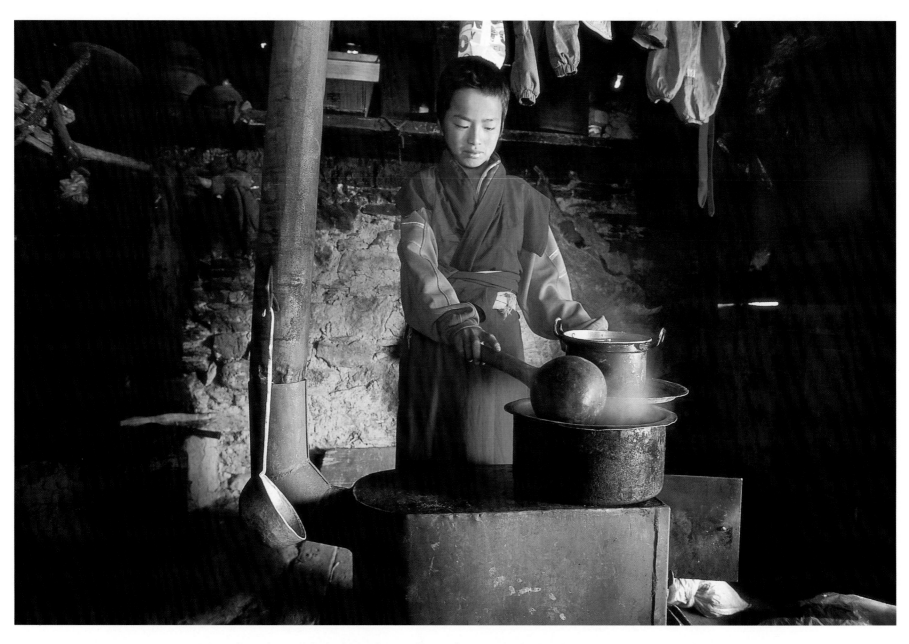

Water is always kept on the boil to make tea, Bhutan's favourite drink. The Bhutanese make two sorts of tea: *ngadja*, which is sweetened and boiled with milk, similar to Indian tea, and *sudja*, Tibetan-style buttered, salted tea. It is usually served with *zao*, toasted rice, which is eaten dry or dipped into the tea.

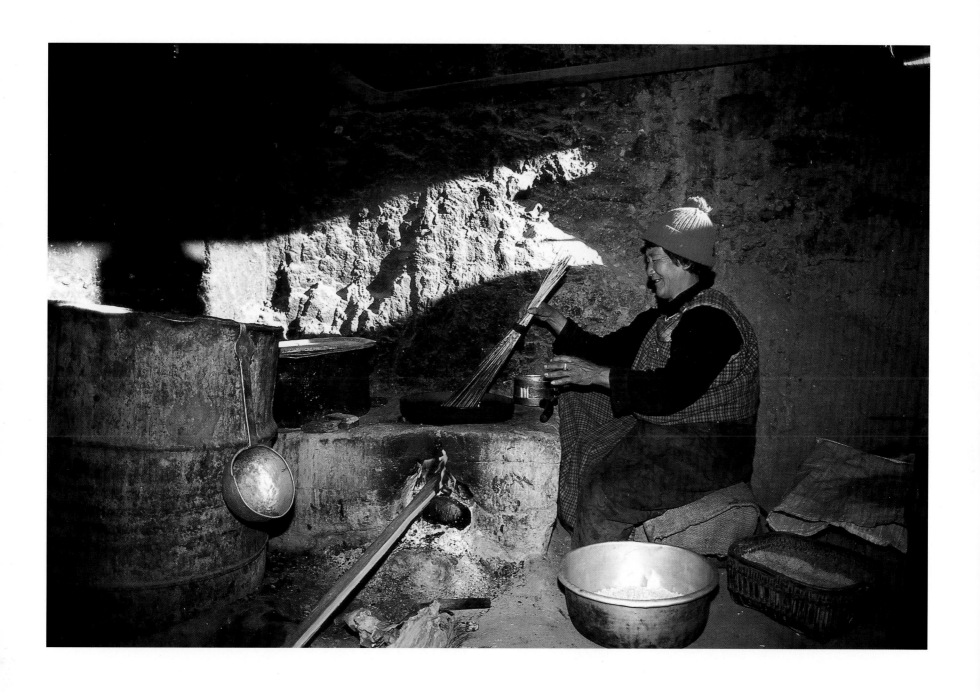

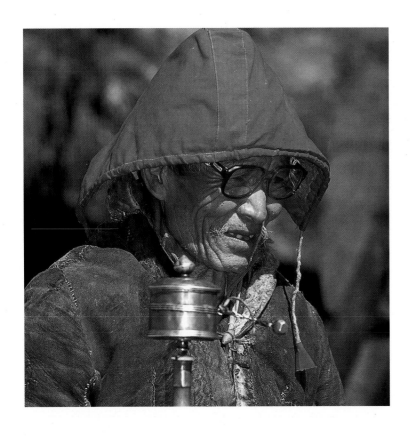

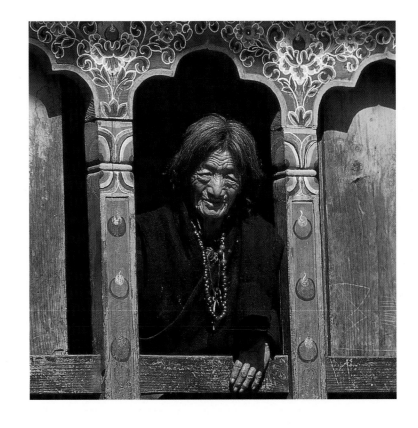

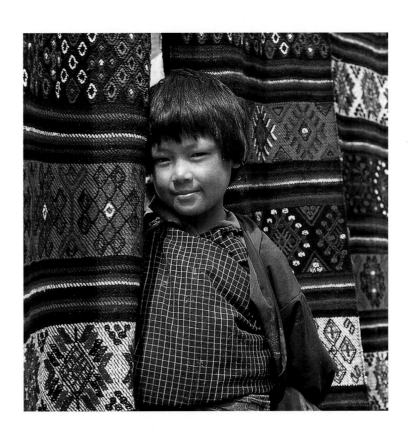

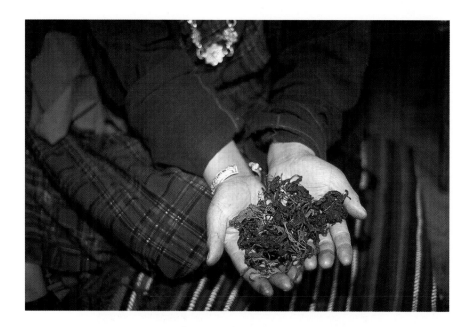

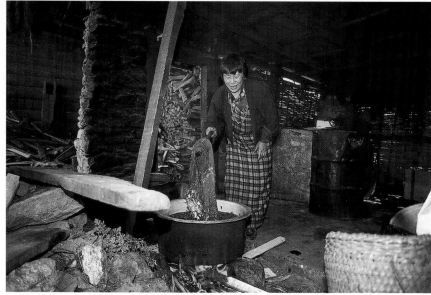

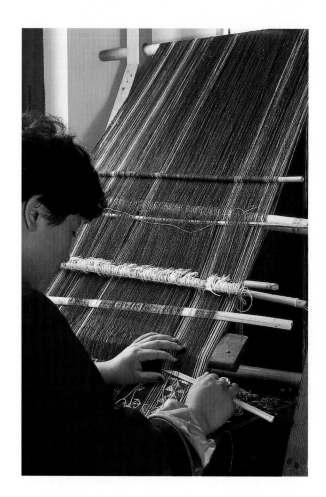

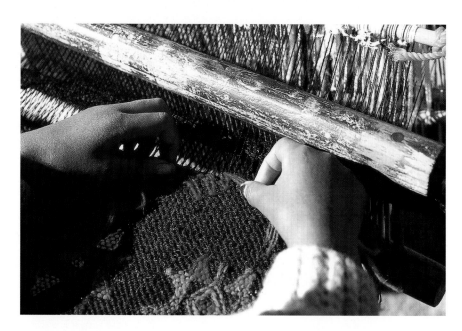

Bhutan is famous for its textiles, and many regions have their own particular speciality: raw silk in the east, brocades from Kurtoe and woollen cloth from Bumthang. The dyes are usually made from plants or minerals by the weavers themselves. Everything is done manually, from dyeing the skeins to weaving the cloth itself.

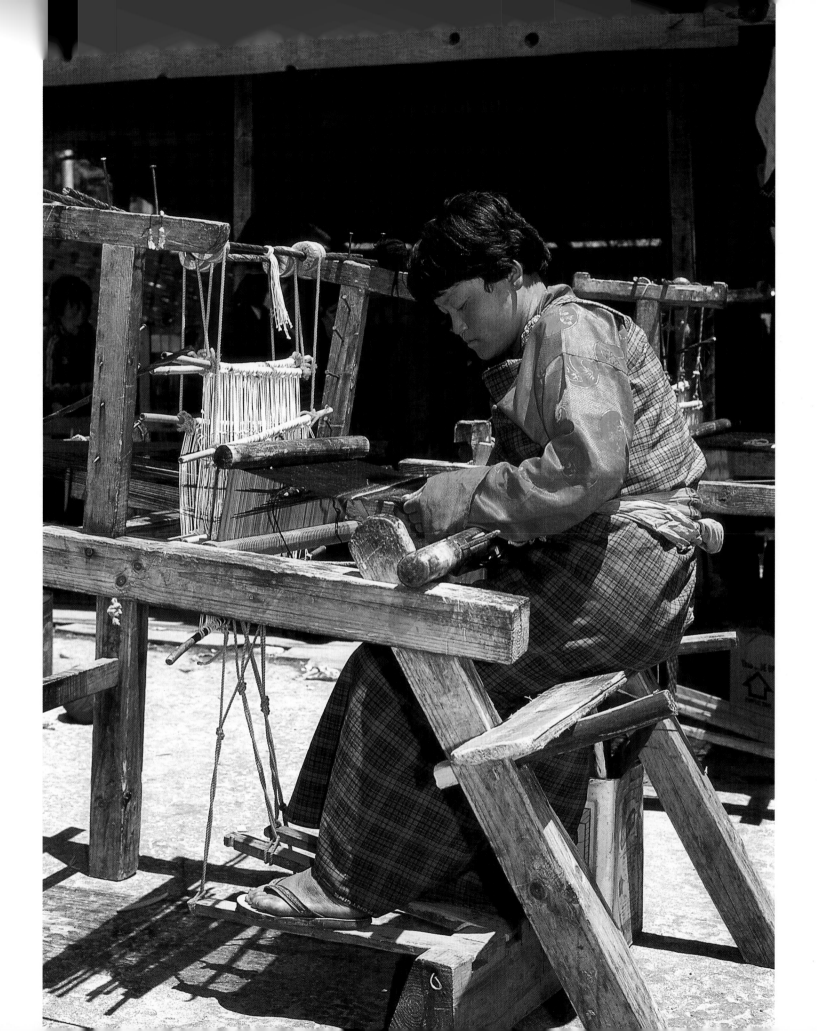

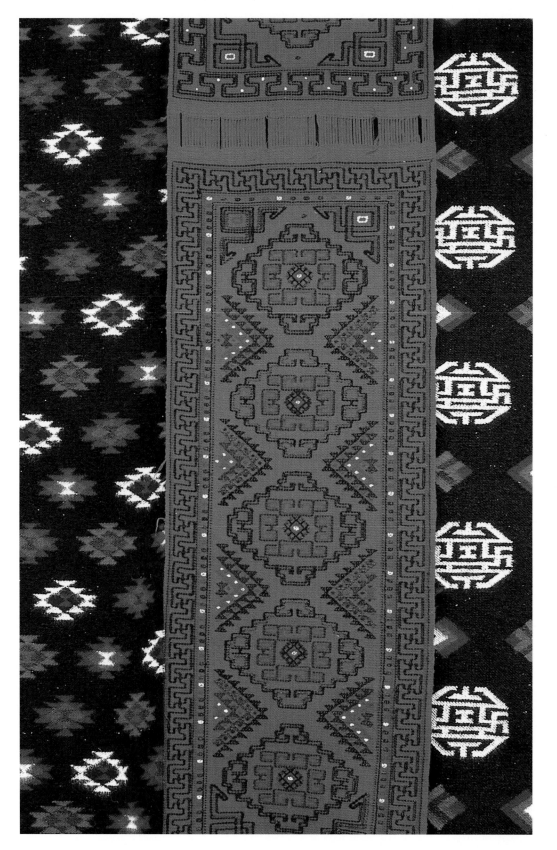

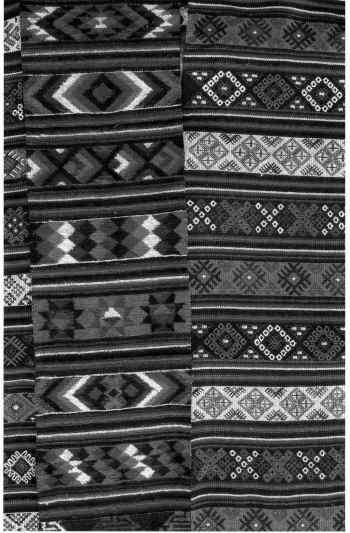

The woollen cloth from Bumthang, known as *yathra*, is used to make jackets and blankets. Superb *yathras* are woven in the village of Zugne in the Chume valley, one of the four valleys in Bumthang.

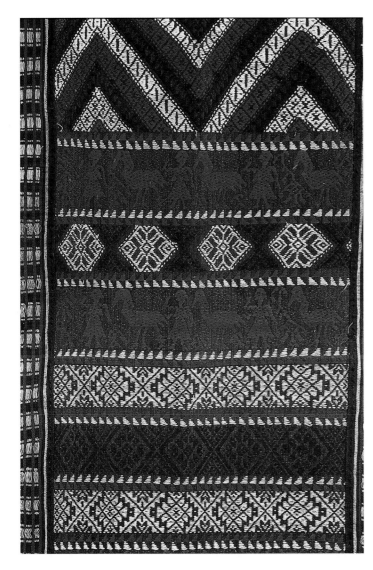

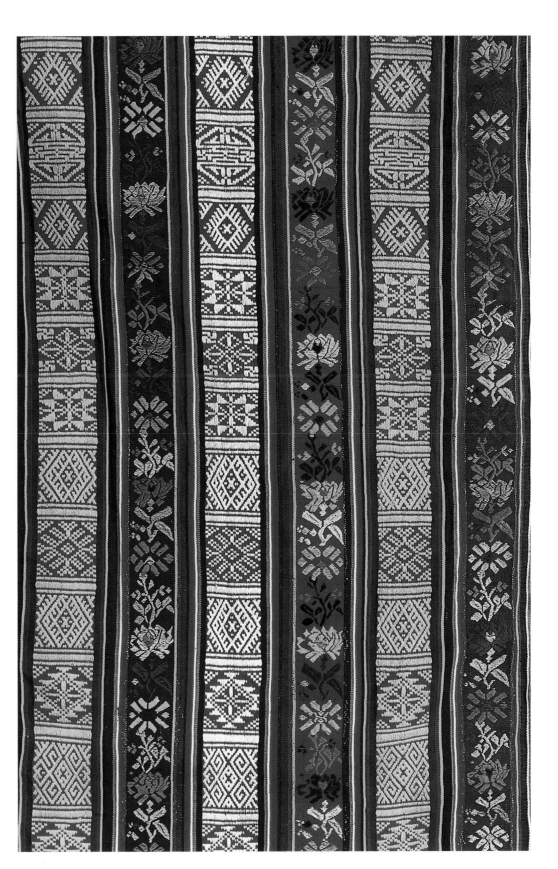

Chagsi pangkheb (above), used as a ceremonial hand towel. *Aikapur (right)* made of raw silk from eastern Bhutan, used for a high-quality *gho*.

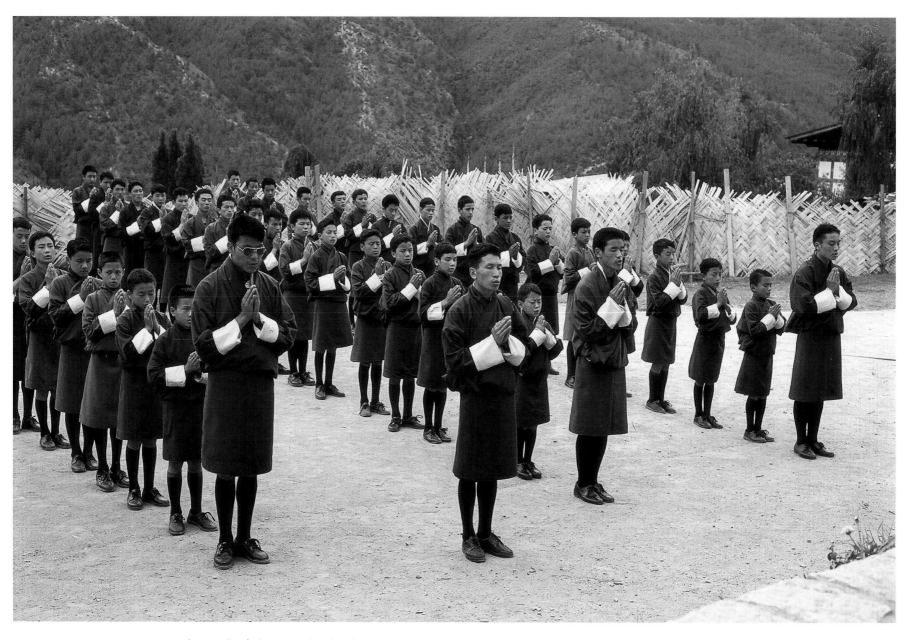

The people of Bhutan are deeply religious; school begins each morning with an assembly during which a prayer is sung. The children must wear the national costume, the *gho* for boys and the *kira* for girls. The colours vary from one school to another. Education is compulsory and free.

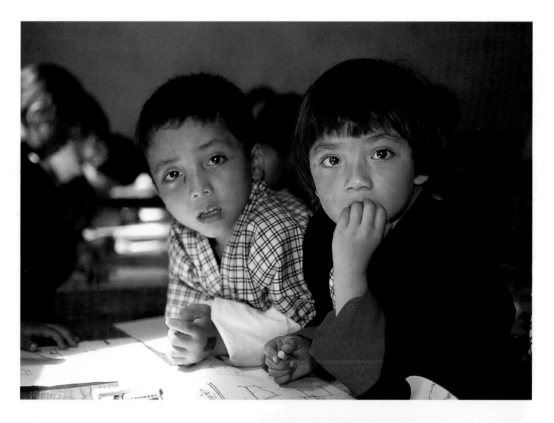

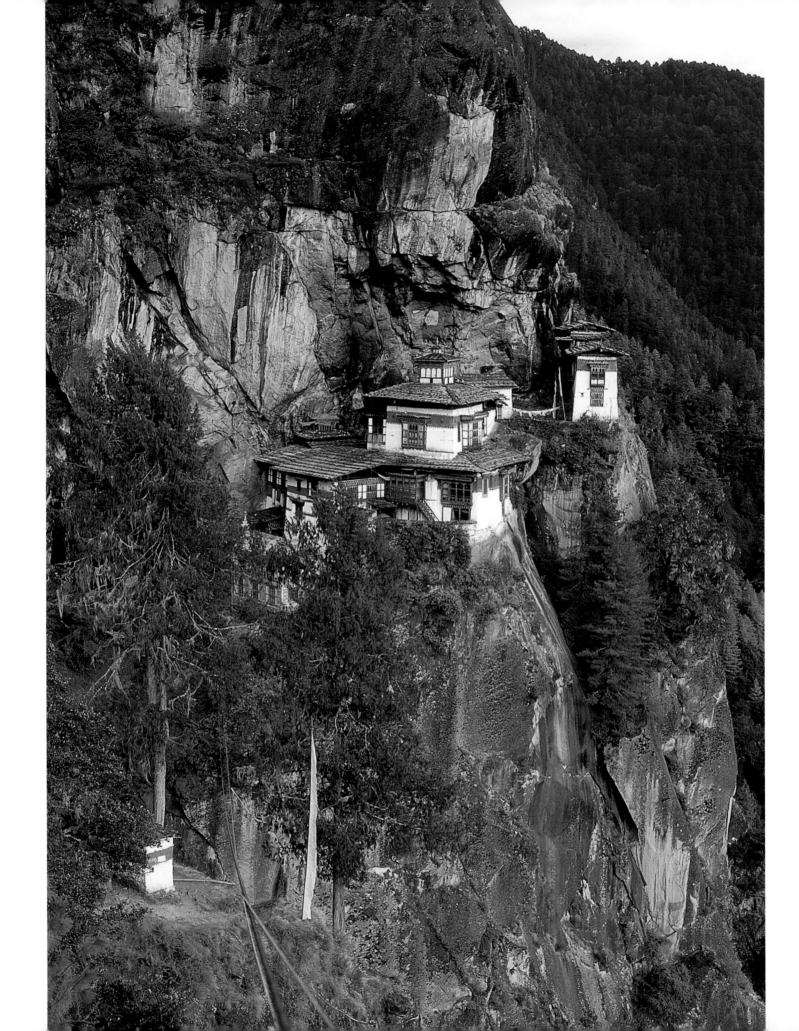

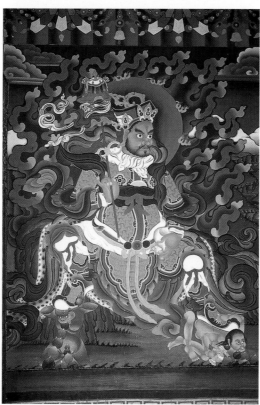

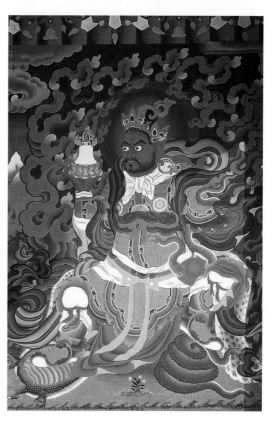

Left: The Bhutanese express their devotion by making regular visits to the country's main temples, such as Taktsang in the Paro valley. This is one of the holiest places in Bhutan, as Guru Rinpoche is said to have meditated here in the 8th century.

Right: Paintings representing the guardians of the four directions are found at the entrance to most monasteries.

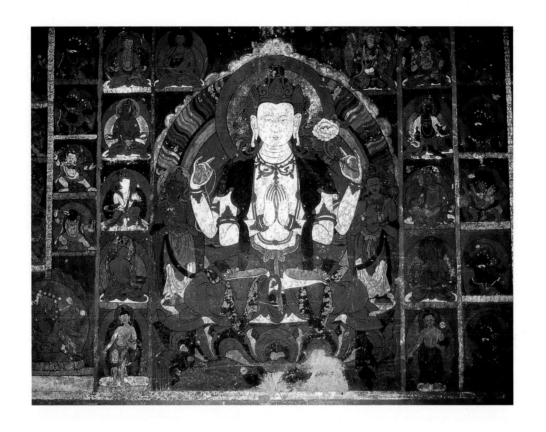

Left: Tamshing monastery in Bumthang, founded in 1501, contains paintings dating from the time of its construction, such as these representations of Chenrezig, the divinity of compassion, and of Yeshe Tshogyal, the wife of Guru Rinpoche.

Right: Next to the classical religious figures are paintings of local divinities. These guardian spirits belong to beliefs that predate the introduction of Buddhism, like this water divinity near Tango monastery.

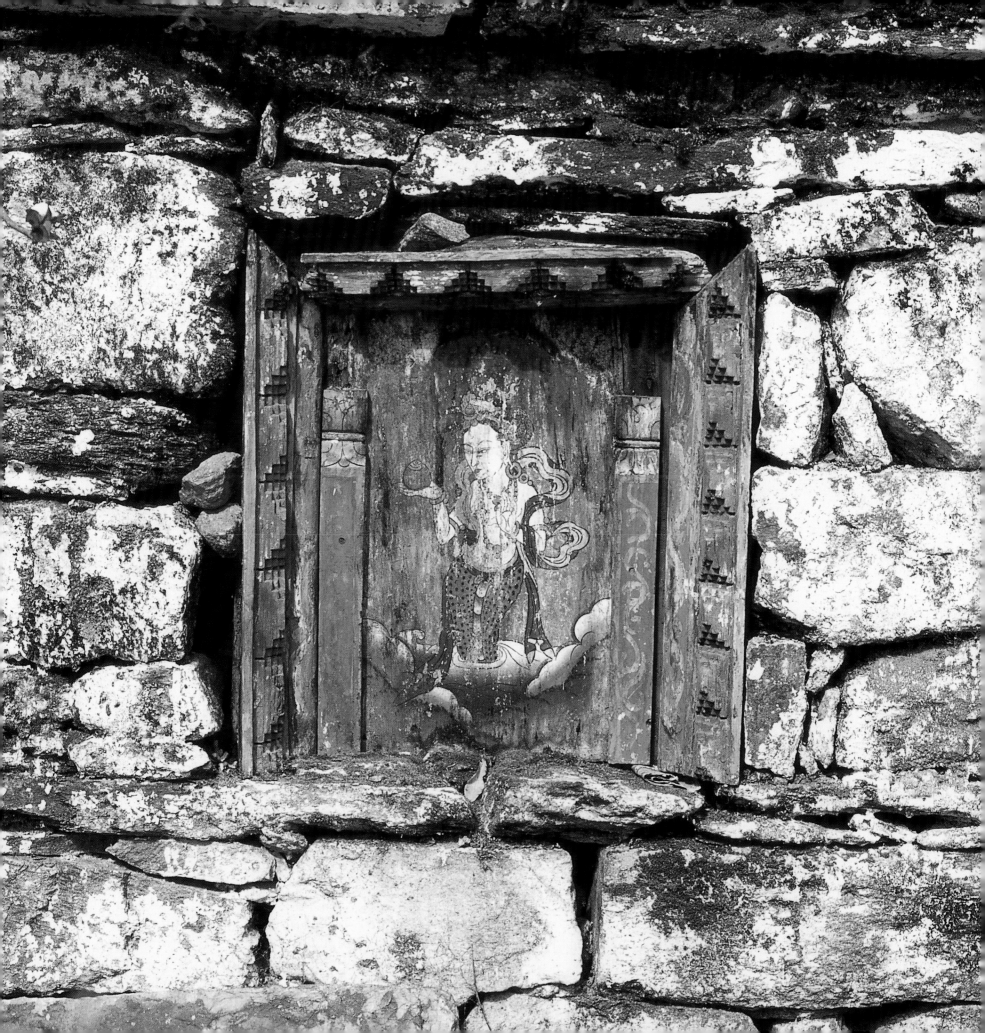

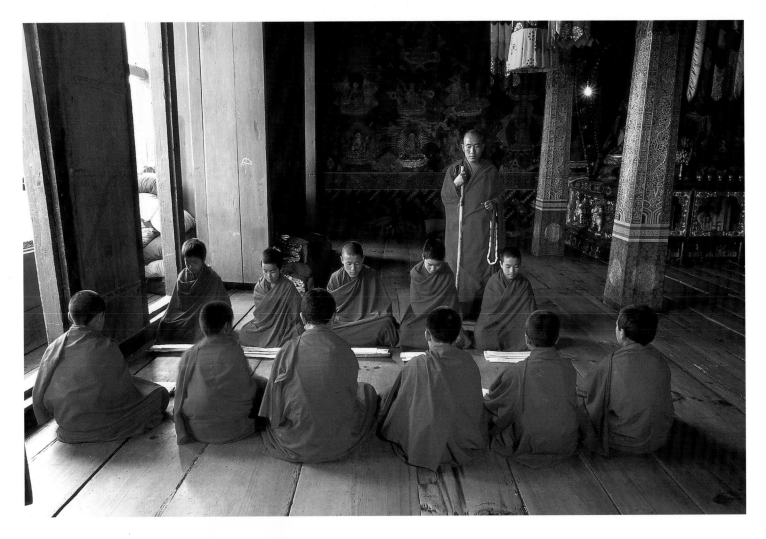

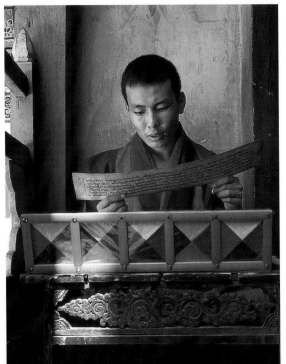

Monks studying in temples in Bumthang and Thimphu. In a country so deeply influenced by religious belief, tradition requires a boy from each family to enter a monastery.

Right: Gangtey monastery in the Black Mountains. Gangtey, which belongs to the *nyingmapa* tradition, was founded in 1613 by Pema Thinley, grandson of the great *tertön* Pemalingpa.

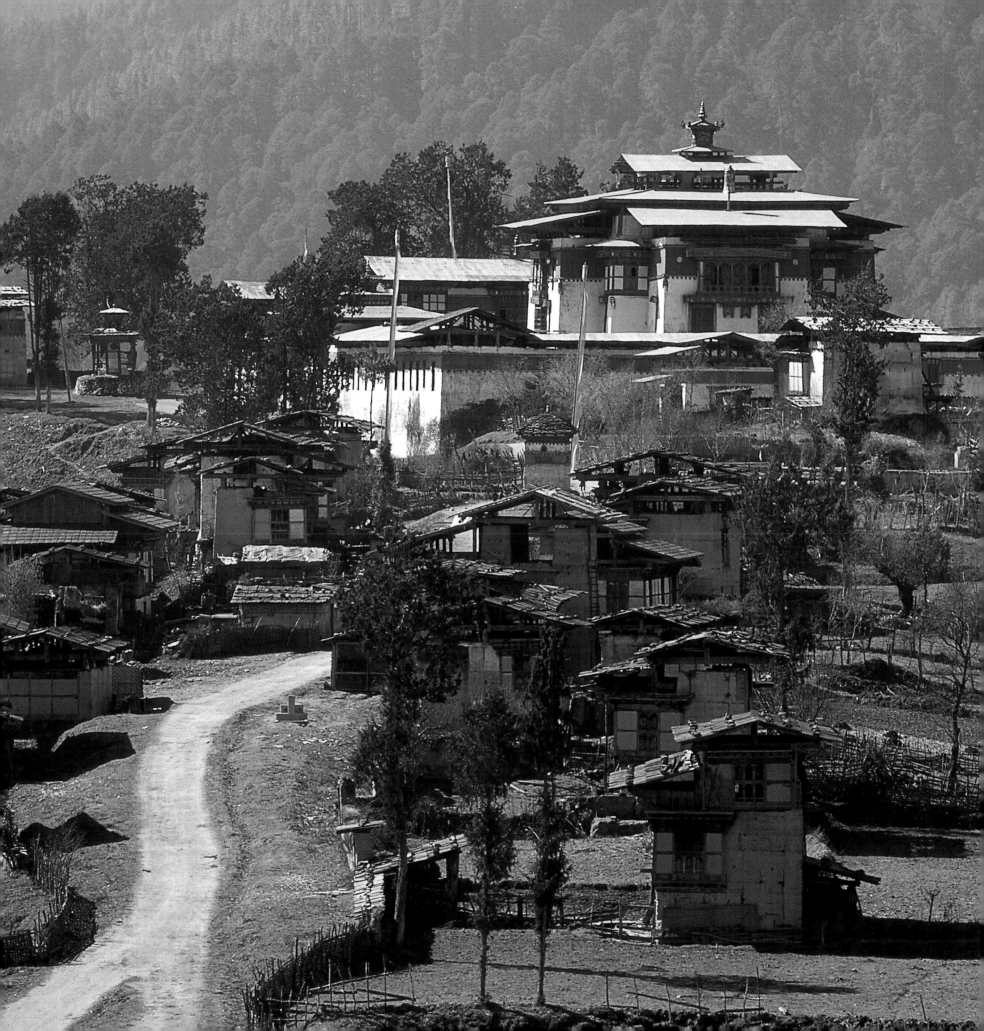

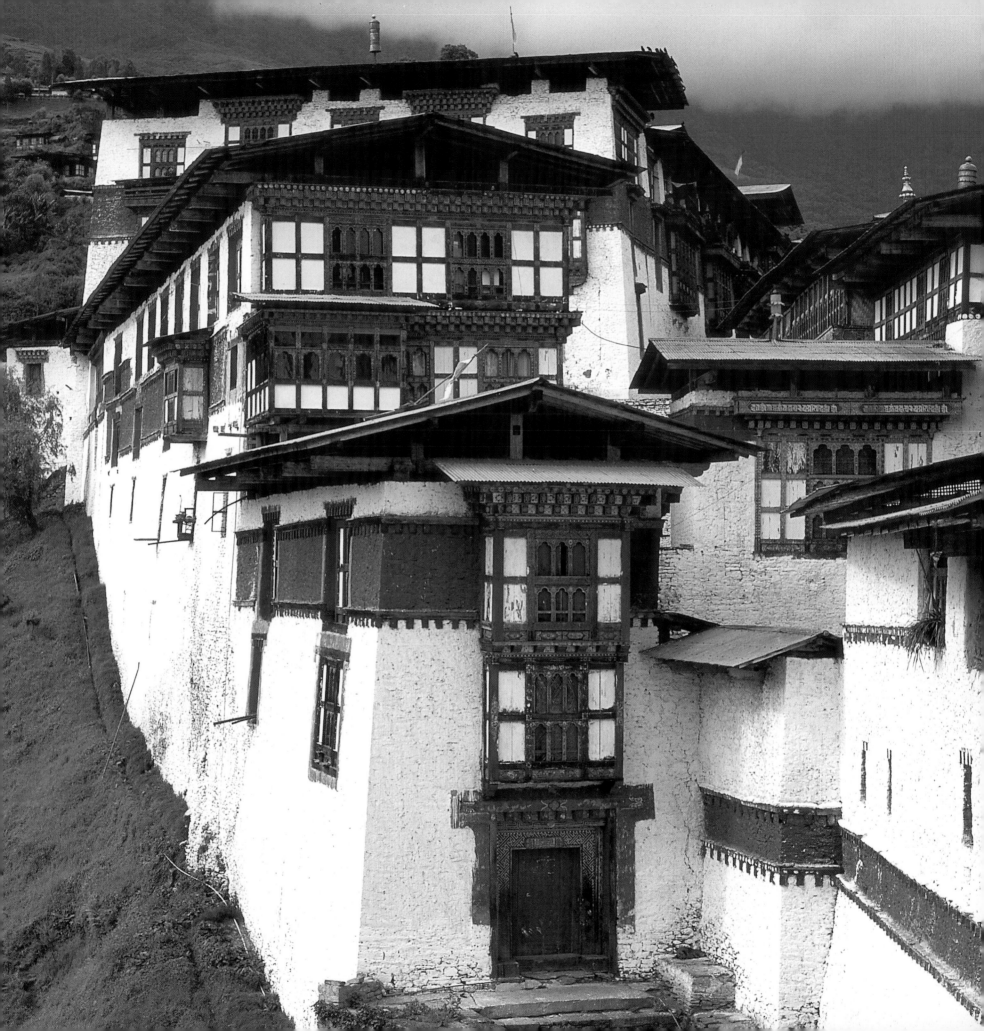

Bhutan's *dzongs* represent the civil and religious authorities in each province. The structure is entered by a narrow gate in the thick outer wall. Originally, the *dzongs* were also defensive structures designed to withstand sieges, which could sometimes last for long periods. For example, water was brought by buried pipes from the nearest springs. The great lords were often at war with one another, and capturing a *dzong* could often decide the outcome of a battle.

Inside, two- and three-storey structures are built against the impressive outer walls. They form one or more courtyards paved with large stone slabs. These courtyards, named *gom* (upper) and *wom* (lower), are reminders that the buildings needed to have various levels in order to follow the ground relief. The monastic community's quarters are traditionally on the upper floors, while the lower part houses the administrative offices. The courtyards are separated by a massive keep-like tower called *utse*, which rises well above the other buildings and houses temples and chapels. Most of the buildings around the courtyards are half-timbered, with galleries, balconies and arcades. Behind these richly decorated wooden structures are other temples, the monks' cells and kitchens, and the quarters occupied by the civil authorities.

Life begins early in the morning inside the *dzong*, well before the civil servants arrive. The monks and lamas perform various rituals in the large assembly halls. Each temple has its own keeper who is responsible for supervision and maintenance, and for making the daily offerings of water, incense and butter lamps to the divinities represented on the altar. After the morning rituals, most of a monk's day is devoted to study and meditation.

Unlike Christianity, Buddhism makes no distinction between regular and secular clergy. With the exception of hermits and ascetics seeking to meditate alone in some isolated cave, most of Bhutan's monks are in regular contact with the outside world. The monks who live inside the *dzong* may therefore go outside, for private ceremonies in a village or house, to visit their family or friends, or to go to the market from time to time.

Certain *dzongs* also comprise monastic schools and boys sometimes attend from the age of 5 or 6. They learn to read, write, count and gradually to study the sacred texts that they have to memorise. Traditionally, each Bhutanese family placed one son in a monastery. Until the 1960s, this was indeed the only way of getting an education in Bhutan.

The *dzongs* house the administrative offices in each district. Bhutan is divided into 20 districts at the present time. They are placed under the authority of a governor, the *dzongda*, who answers to the Minister of Home Affairs. All the administrative departments needed to run the province are to be found in the *dzong*: agriculture, finance, roads, economic development and so on. At the judicial level, a judge called *thrimpön* presides over a court responsible for ensuring proper application of the law, in which the spirit of Buddhism is always present as it has been since the time of Ngawang Namgyel's Law Code.

Inside the *dzongs*, the Bhutanese must wear the *kabney*, a long silk or cotton scarf that is draped over their traditional garb. In addition to its ceremonial importance, the colour of the scarf indicates the rank of the person wearing it. Most people wear a white *kabney*, while senior State officials, governors, judges, heads of department and so on wear a red one and carry a sword, the symbols of their function and hierarchical status. Ministers wear orange *kabneys*. Only the King wears a yellow one. Lastly, a blue *kabney* indicates that the wearer is an elected representative of the people, that is to say a member of the Royal Council or national assembly. Things are simpler for women. Whatever their rank, they wear a narrow strip of material called a *rachu* over the left shoulder, with no distinctive colouring.

In addition to their use for protocol, these ceremonial scarves worn over *ghos* or *kiras* made of rich materials are a delight to the eye, especially at the time of the religious festivals, when the courtyards of the *dzongs* are transformed into a dazzling palette of colour.

The southwestern side of Trongsa *dzong* with the old entrance gate on the track from western Bhutan.

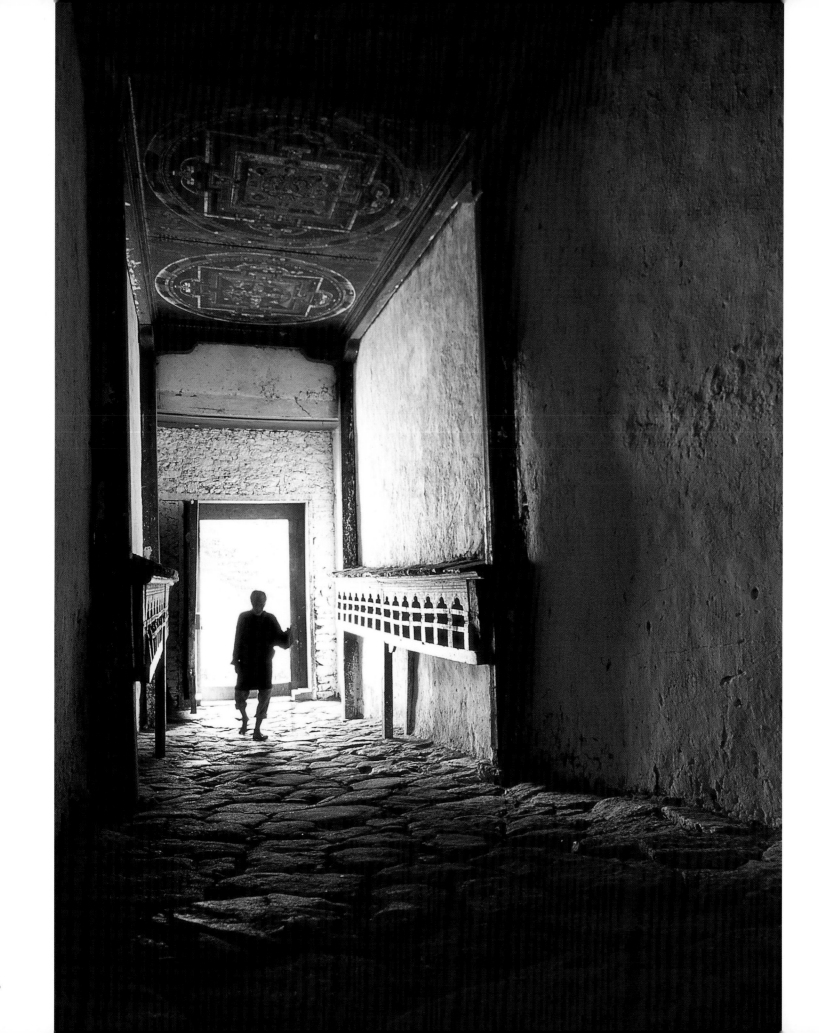

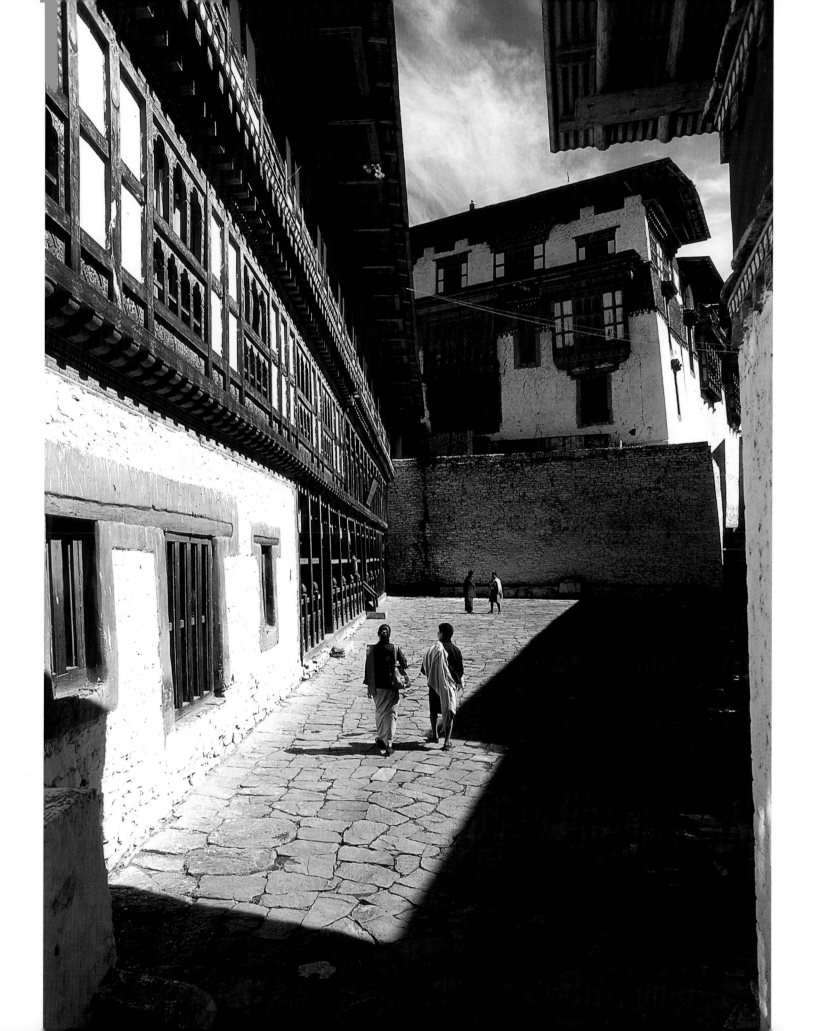

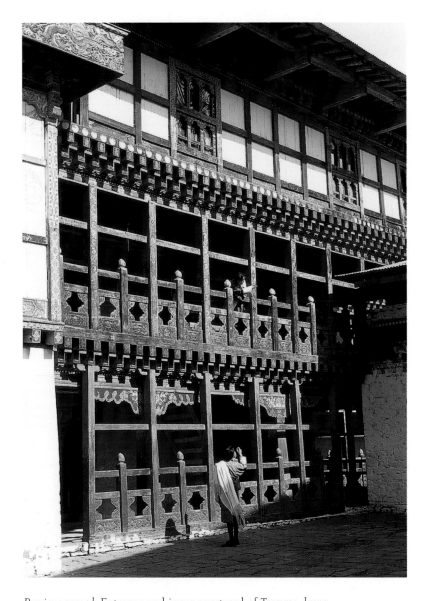

Previous spread: Entrance and inner courtyard of Trongsa *dzong*.

Above and right: Arcades, galleries and balconies are typical features of the buildings inside a *dzong*. Behind them are the monks' quarters and administrative offices.

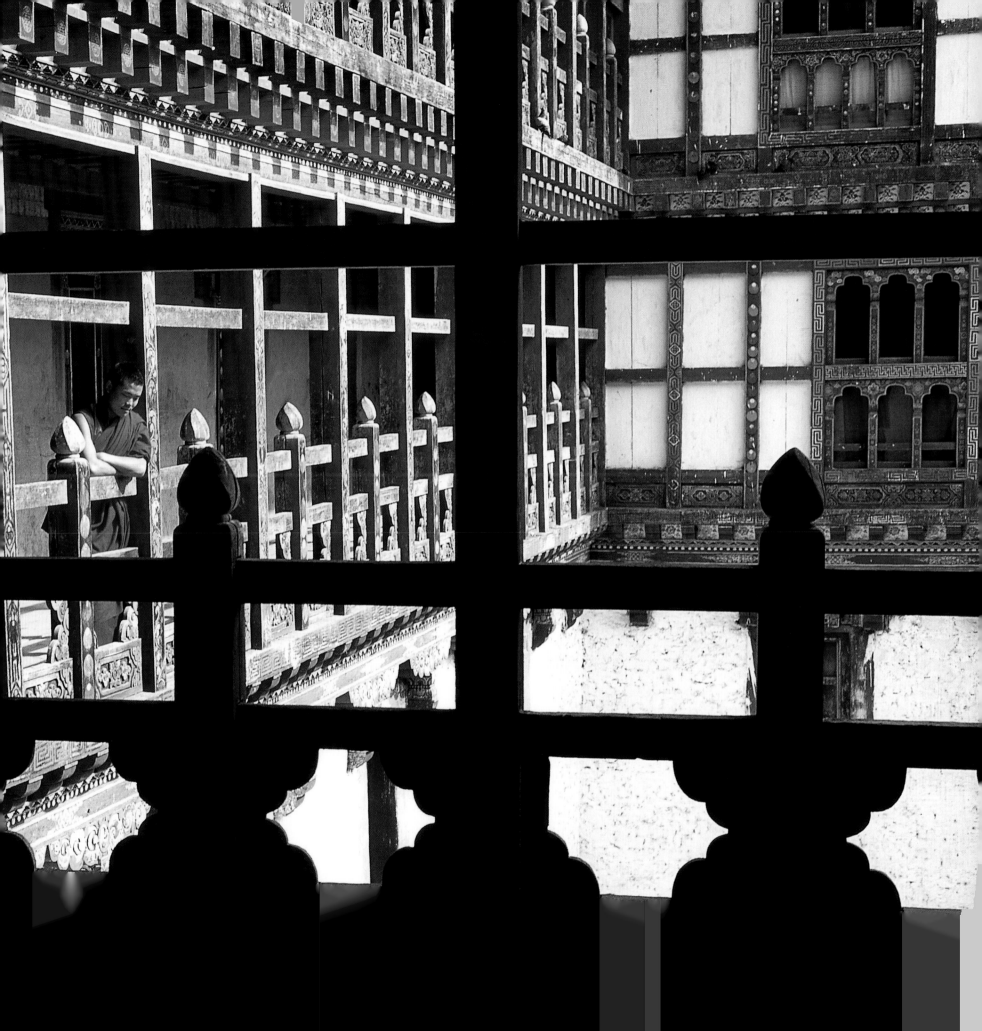

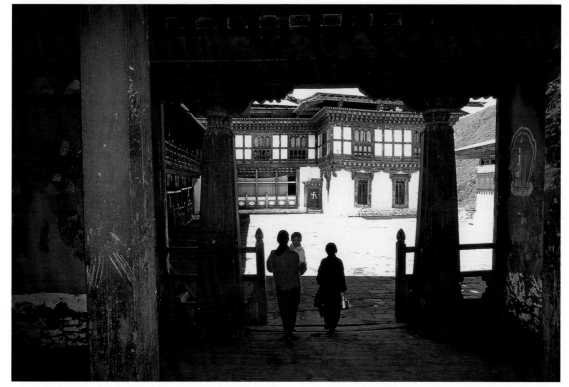

Originally built for political and strategic reasons, *dzongs* are still occupied by the civil and religious authorities of each province. Under the supervision of the *dzongda*, civil servants work in the various administrative departments: agriculture, finance, transport, economic development, etc. They often receive visits from ordinary citizens.

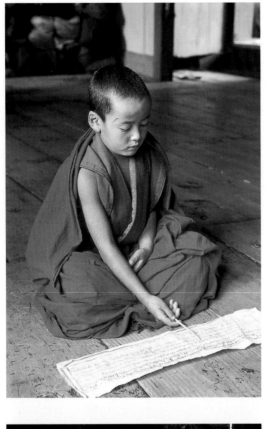

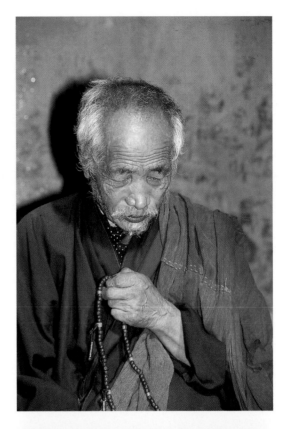

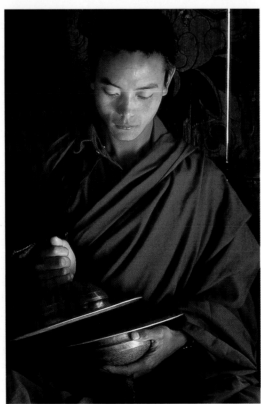

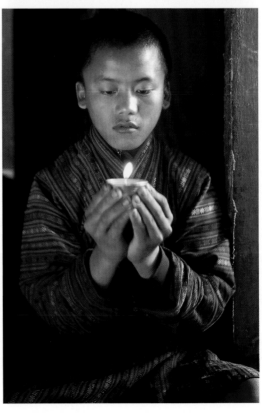

As the monastic community is sometimes very large, numbering several hundred monks, the *dzong* is also a place of study, prayer and meditation.

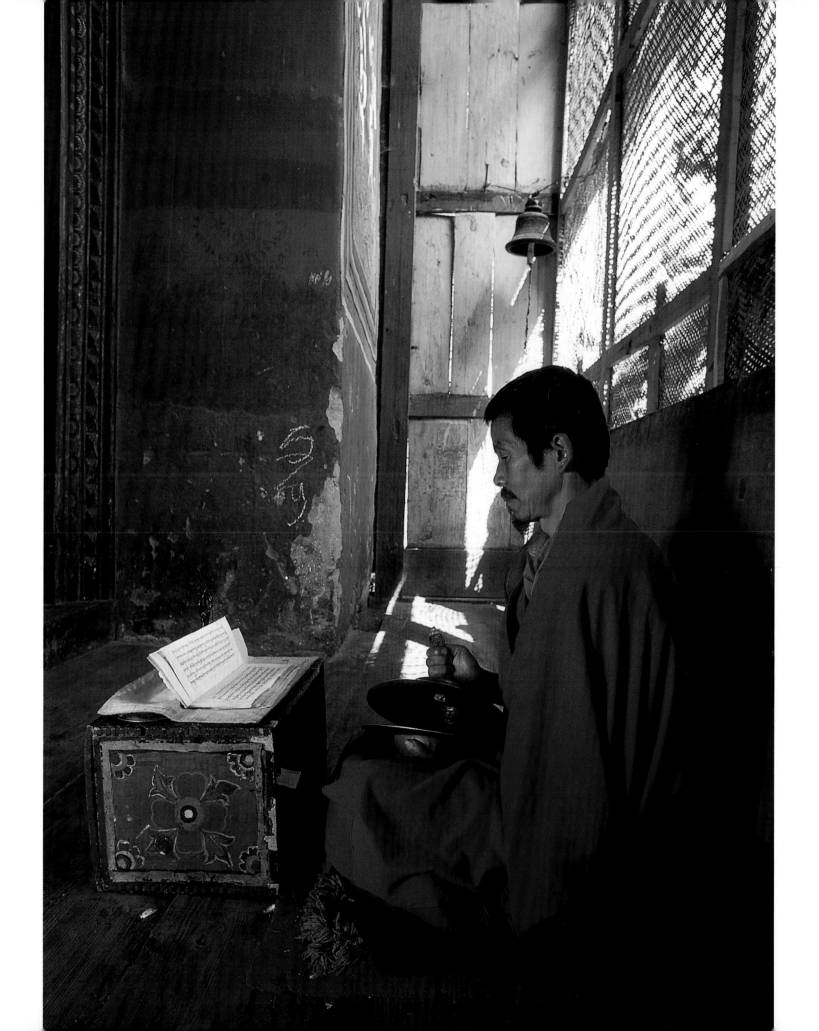

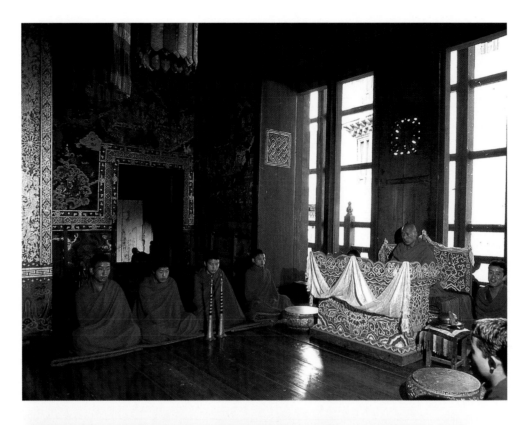

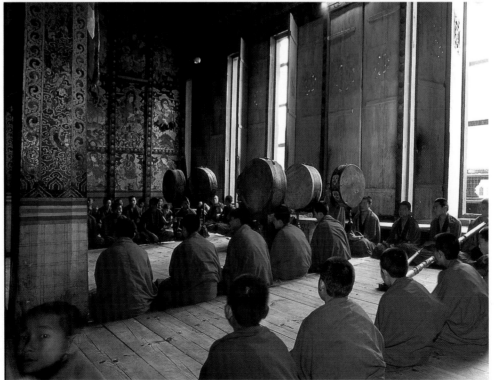

Whenever the monastic community comes together in a *dzong* for special rituals, as at Dorje Jigje *lhakhang* in Trongsa *(above and right)* and Thimphu *(left)*, one monk is assigned to each temple for the daily offerings of water, butter lamps and incense.

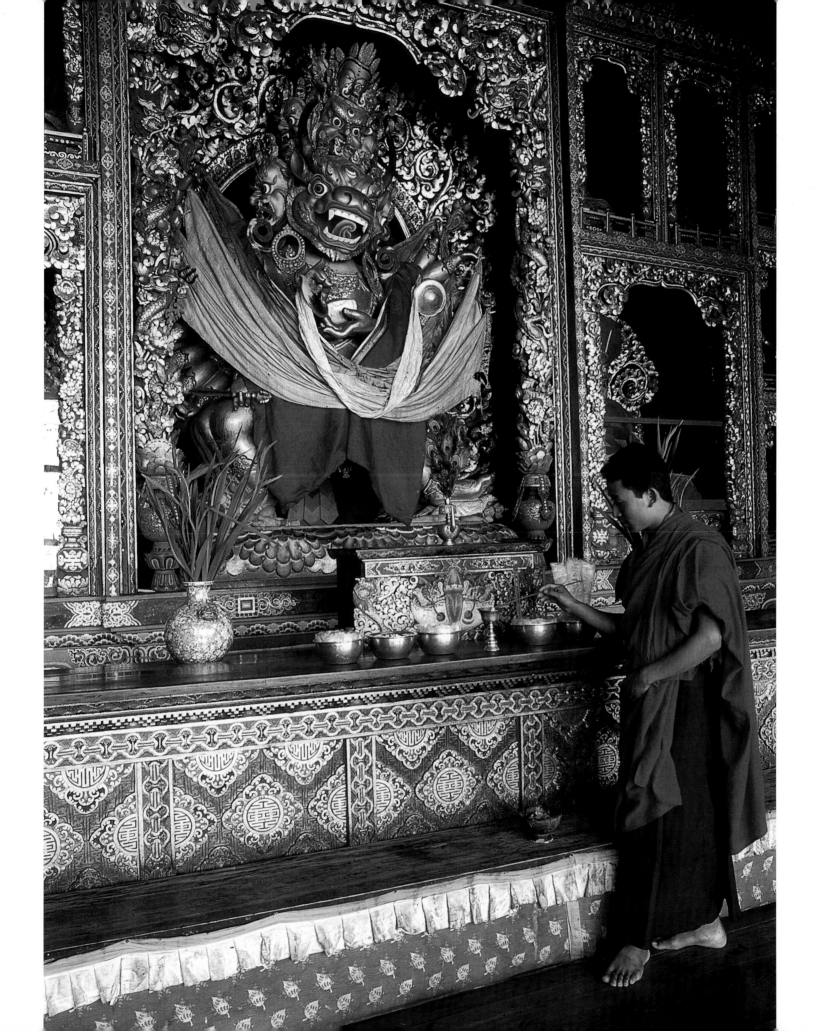

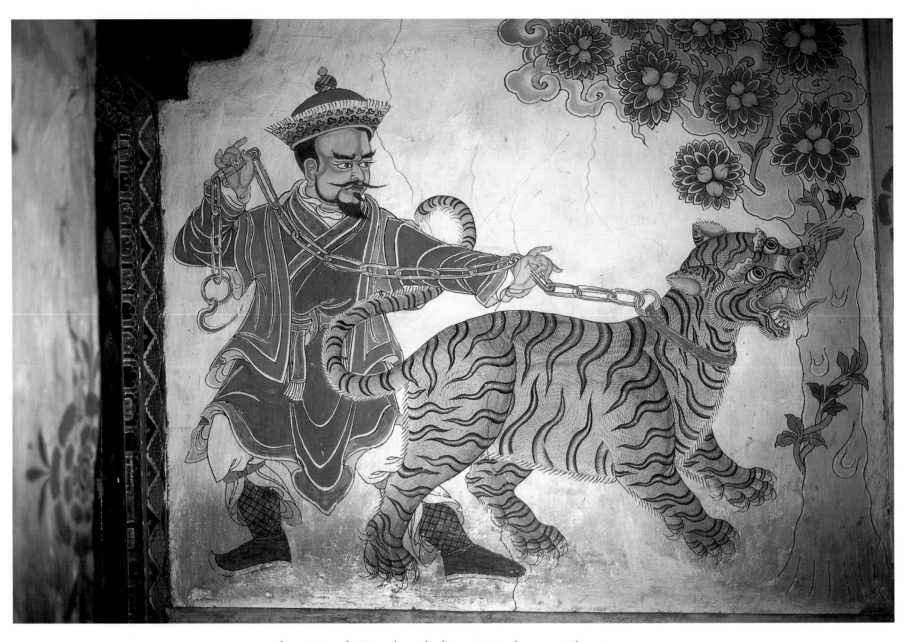

The painting of a Mongol man leading a tiger is often seen at the entrance
of a house, temple or *dzong*, to protect it from fire.

Shabki Zimchung *lhakhang*, Trongsa *dzong*.

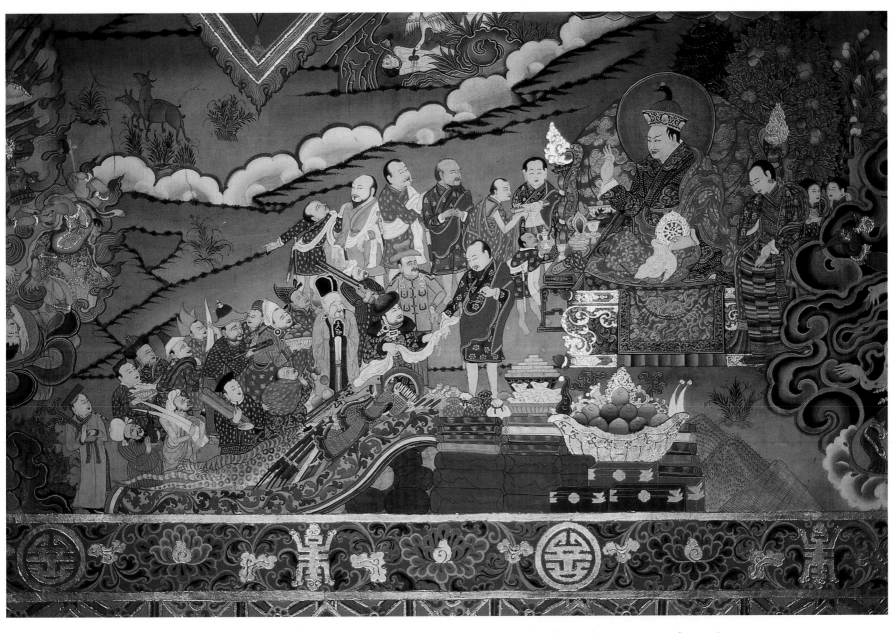

Painting showing the first King of Bhutan, Ugyen Wangchuck, during the construction of a temple dedicated to Dorje Jigje in Trongsa *dzong*. Chinese, Tibetan, Nepalese and Indian are bringing offerings for the building of this new temple.

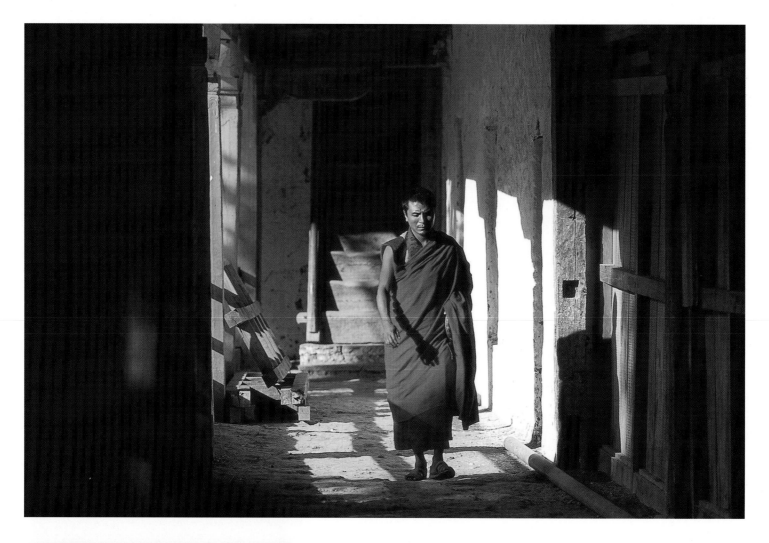

In addition to their main activities of study and prayer, the monks have their own day-to-day occupations. They can keep abreast of the latest happenings in the kingdom by reading Bhutan's weekly newspaper *Kuensel*.

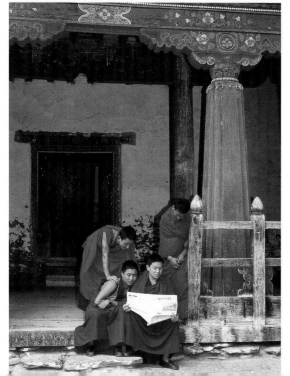

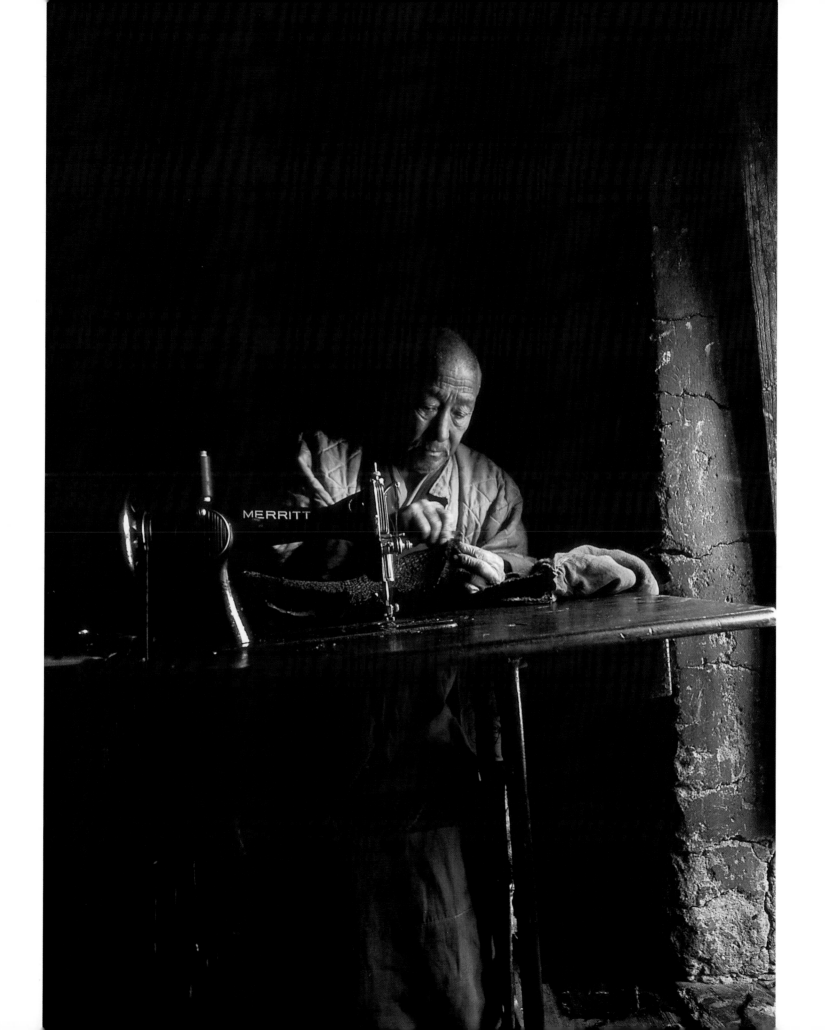

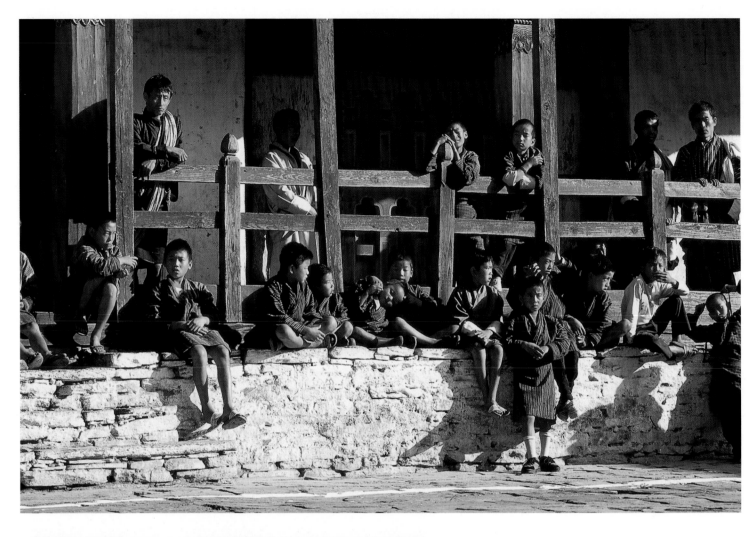

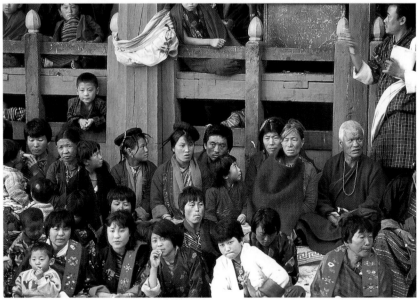

Trongsa, like most of the *dzongs* and monasteries in Bhutan, organises a *tsechu* once a year in honour of Guru Rinpoche. These colourful festivals, featuring dances and rituals, are the main religious events of the year and draws huge crowds from even the remotest villages.

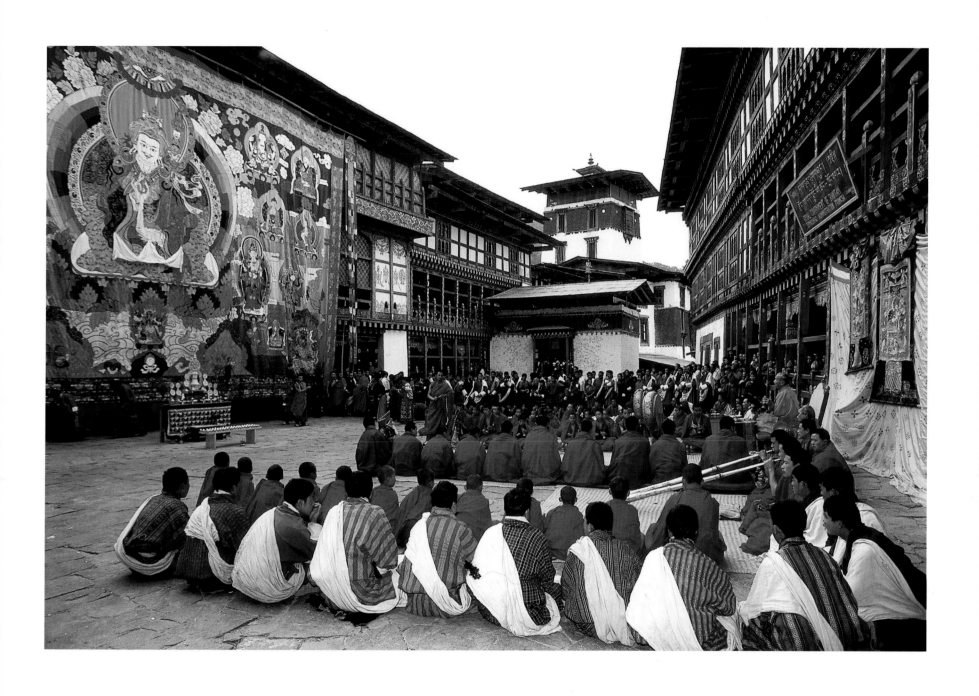

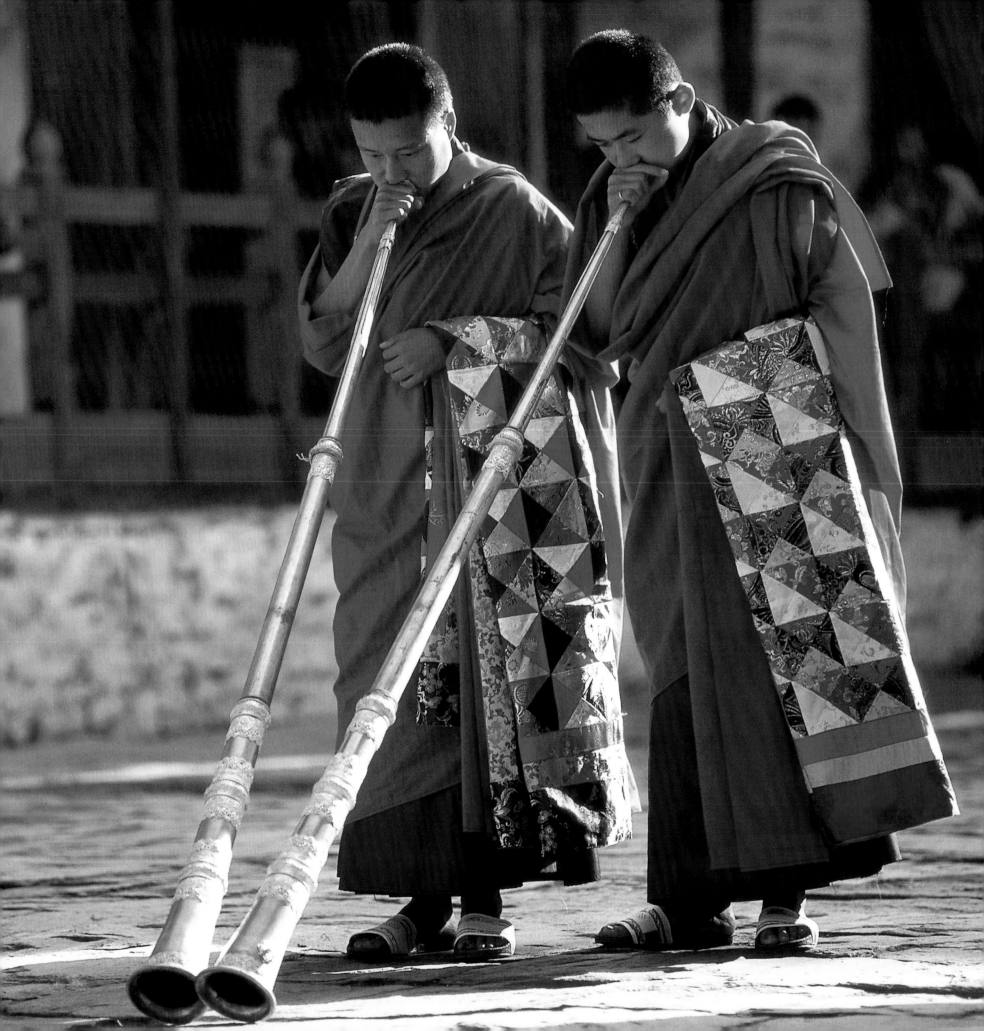

DANCES WITH THE GODS

The *tsechus* are undoubtedly the most famous of the many religious festivals held in Bhutan. They are given in honour of Guru Rinpoche and consist of dances by masked performers. *Tsechus* are held once a year in all the great monasteries throughout the country and attract crowds that have sometimes travelled from the most remote villages. In a swirl of colour and noise, the gods and demons of Buddhist mythology come to life. These colourful ceremonies, both religious theatre and exorcism ritual, are the most striking testimonies to the deep-rooted faith of Bhutan's society.

The dances follow one another for several days to the sound of trumpets, drums and cymbals. The dancers, who are nearly always masked, turn and leap under the fascinated gaze of the onlookers thronging the balconies and vast courtyard. Everyone is spell-bound by the shimmering brocades and peaceful or fearsome appearance of the masks. And at the heart of this thrilling spectacle appear Padmasambhava the Precious Master, Milarepa the Sweet Poet and Shinje Choegyel, the God of Death, who judges the dead and frightens the living with his scales of divine justice.

In the days preceding these spectacles, ritual offerings are made in the secrecy of the temples, some of which are hundreds of years old. Monks and lamas recite the appropriate texts to invoke the divinities that they will represent during the *tsechu*. After being imbued with sacred power, they simply have to put on the great masks and multicoloured clothes to incarnate the gods.

The masked dances are a way of giving lively instruction in the religious philosophy of Buddhism and making the many sacred texts accessible to the uninitiated. Relating the activity of the great saints of Buddhism, they recall the importance of virtuous behaviour and thus play an extremely important didactic role.

But in addition to edifying the onlooker, the dances are also magical. Originally, or so the story goes, Guru Rinpoche was begged to come to Bumthang to cure King Sindharaja who was dying. He took on various appearances and performed a series of dances to subjugate the evil spirits that were tormenting the king and his land. Today's dancers perpetuate this tradition, and in turn purify the ground, destroy demons and evil spirits, and repel famines, epidemics and wars. Dances accompanied by drums then proclaim the victory of Knowledge, which leads to Deliverance. Because the purification ceremony also drives out inner enemies, the ego, obstacles and obscurity that are so deeply rooted in each being and prevent us from achieving Enlightenment.

From their earliest years the young monks learn this language of dance, which is to become a physical liturgy during the *tsechu*. After Guru Rinpoche, the great saints of Buddhism such as Pemalingma and Ngawang Namgyel defined the steps, the position of the hands and feet, the rotation of the upper body and so on for all time to come. Turn, jump from one foot to the other, lean backwards, spin to the right, to the left. . . each step and gesture is codified and has its own symbolic meaning. To have a "sacred" dimension, the dance must be performed with great accuracy and concentration. The young monks undergo a long apprenticeship involving years of practice.

These masked dance festivals are also an ideal opportunity for meeting people and socialising. They enable relatives, who are sometimes separated by long distances on foot through the mountains, to see each other and rebuild old friendships. Young girls put on their best clothes and parade around as the boys look on eagerly. Families come to conclude marriage arrangements. For a few days, everyone takes advantage of these special occasions, far from their work in the fields or their household tasks.

The *tsechus* usually end with the presentation of the *thongdroel*, an immense patchwork as much as 15 or 20 metres wide, representing the image of Guru Rinpoche. It is unfurled on one of the walls of the *dzong*. In the tantric doctrine of Deliverance by sight, he who has looked on the *thongdroel* once in his life will derive a blessing from it, and this will surely lead him towards the state of Buddha.

The sound of long trumpets, *dungchen*, announces the entrance of the dancers.

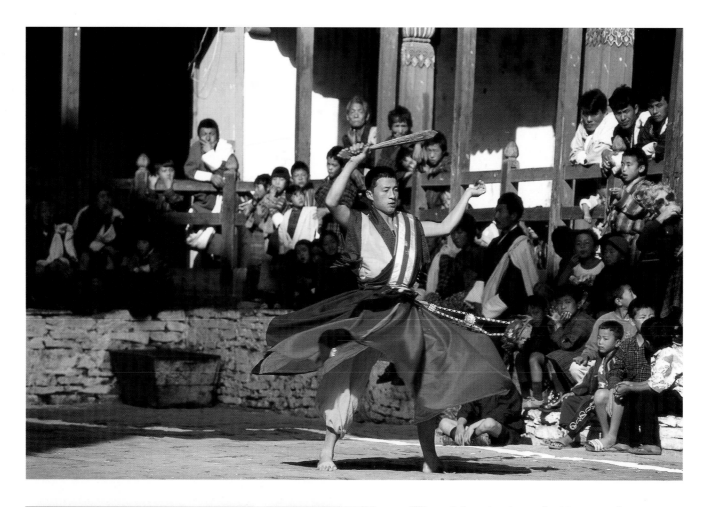

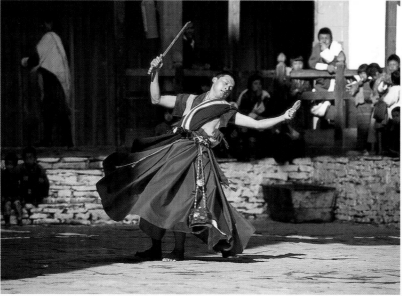

Rehearsing dances for Mongar *tsechu*.

Before the *tsechu* begins, a whole day is spent practising and checking final details to make sure that everything is ready to honour the gods. The dancers have already rehearsed the strictly codified steps for days on end and now, under the vigilant gaze of the head of the monastery, they perform these astonishing danced liturgies. The inner courtyard of the *dzong* becomes a sacred area on these occasions, and each dancer becomes the emanation of a divinity, the human form transformed into the divine.

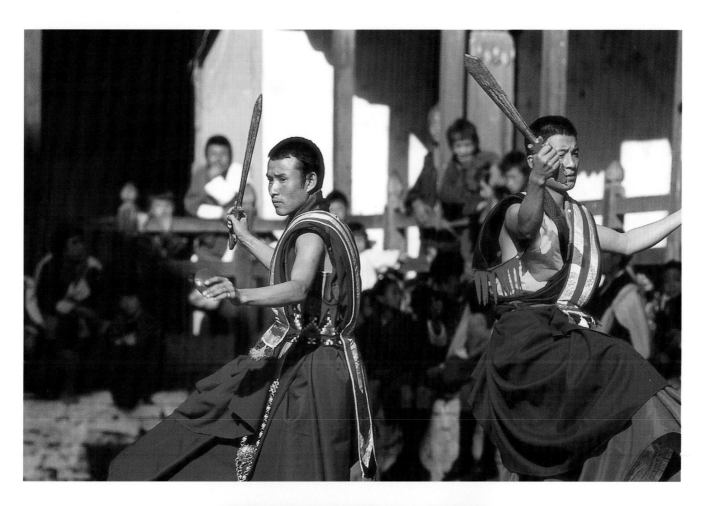

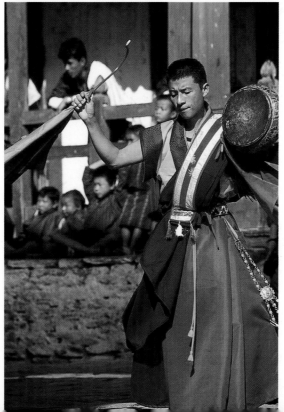

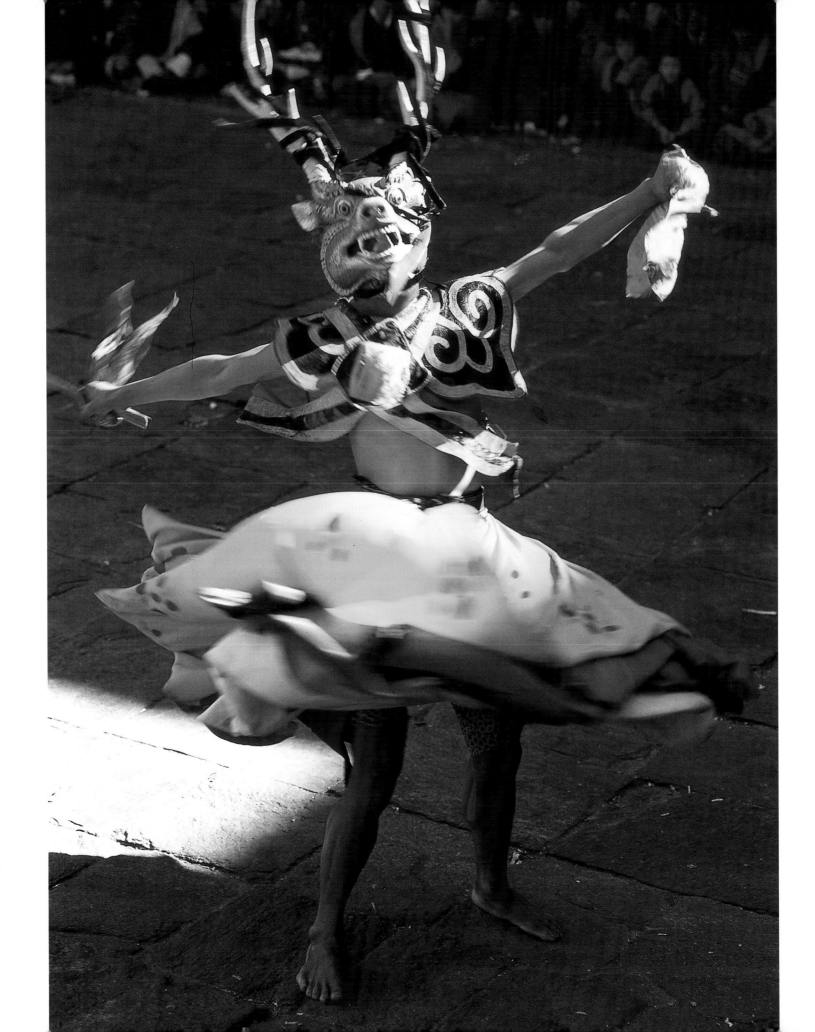

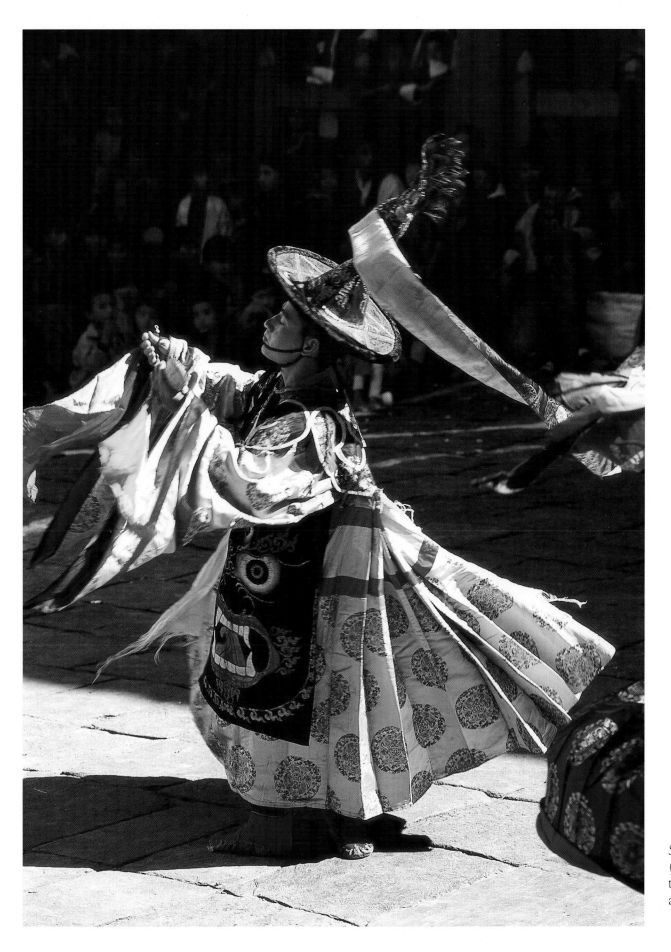

Shacham, the stag dance
(*far-left*), and *shanag*,
the black hat dance (*left*)
at the Trashigang festival.

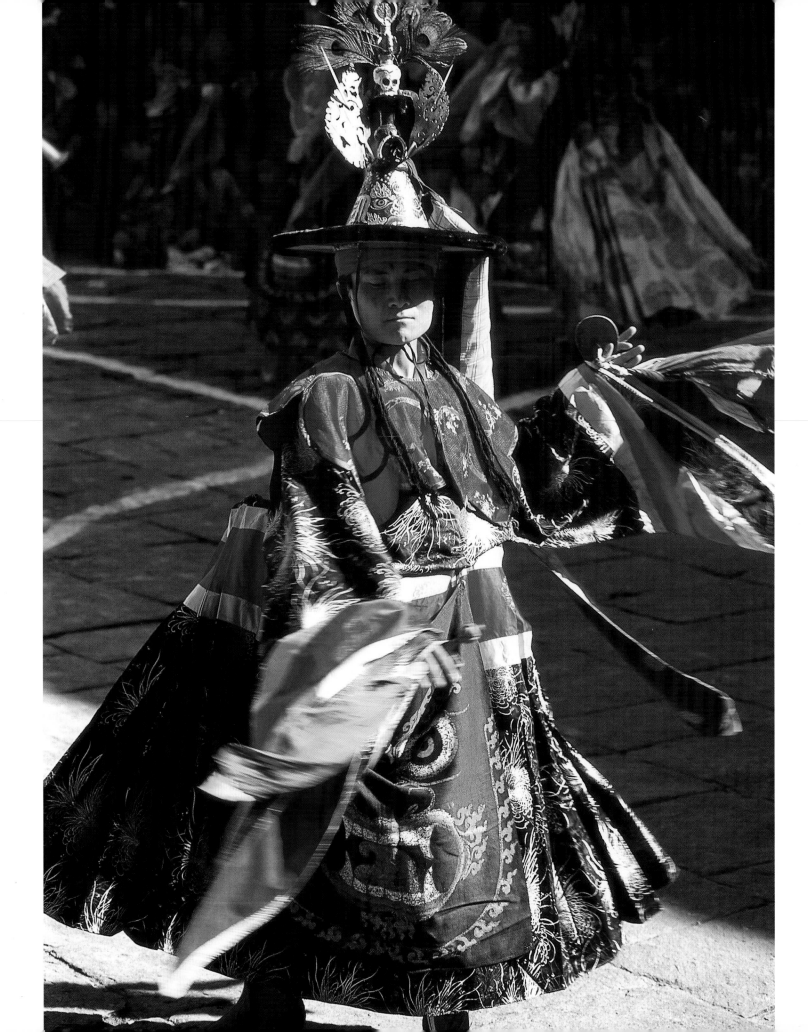

The black hat dance, *shanag*, tells the tale of King Langdarma, who reigned in Tibet in the 9th century. This tyrant persecuted the Buddhist faith and massacred its followers. A brave monk disguised as a *bön* priest and dressed in black obtained an audience at Langdarma's court. As he approached the king, he drew a bow and arrow from his sleeve and killed him. The dance in fact celebrates the destruction of all enemies of the Doctrine, both inner and outer, which prevent an individual from achieving Enlightenment. Evil spirits are subdued, defeated, imprisoned within a circle, and eliminated.

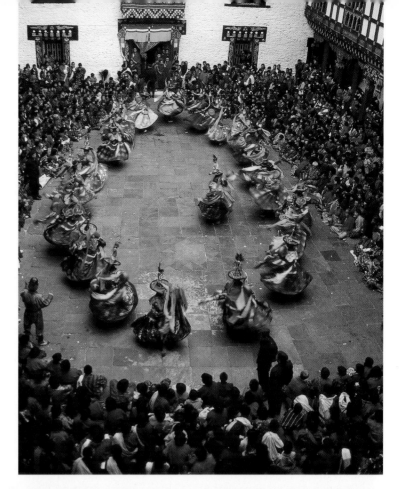

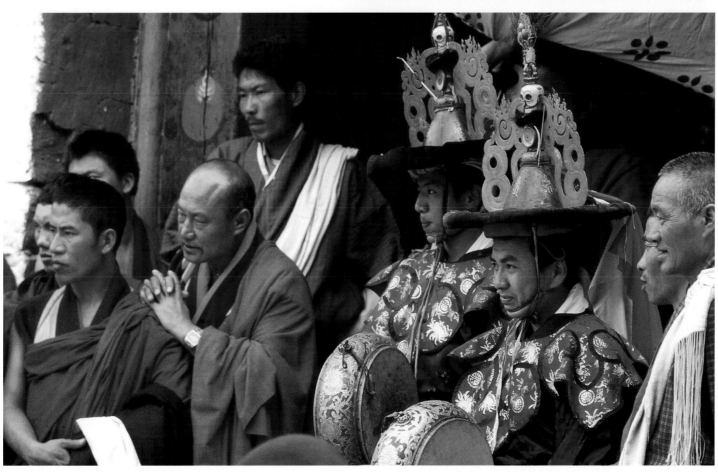

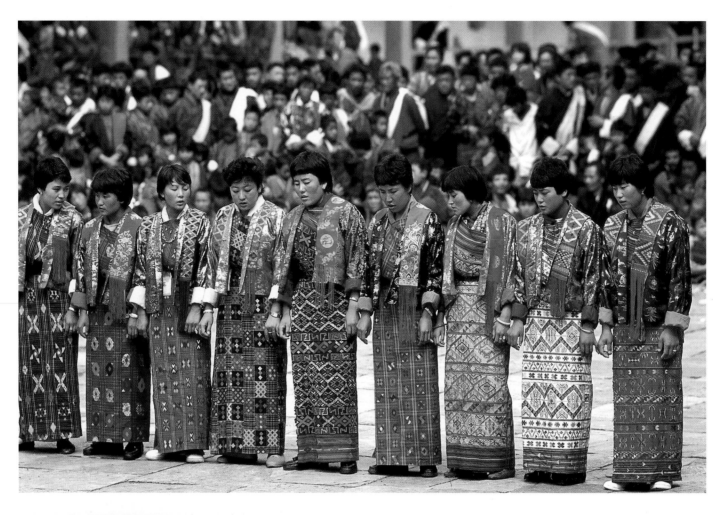

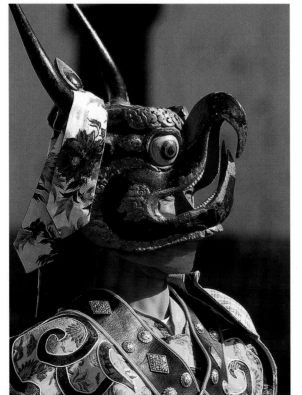

Above: Popular songs and dances performed by young girls provide an interlude to the masked dances. Wangdue Phodrang *tsechu*.

Left and right: The drum dance from Dramitse, *Dramitse ngacham*, is one of the most famous in Bhutan. The dancers represent incarnations of the celestial beings of Guru Rinpoche's paradise, as seen by Kunga Gyaltshen, a descendant of Pemalingpa, in a vision in the 16th century. Beating their drums, the dancers celebrate the victory of religion. Thimphu *tsechu*.

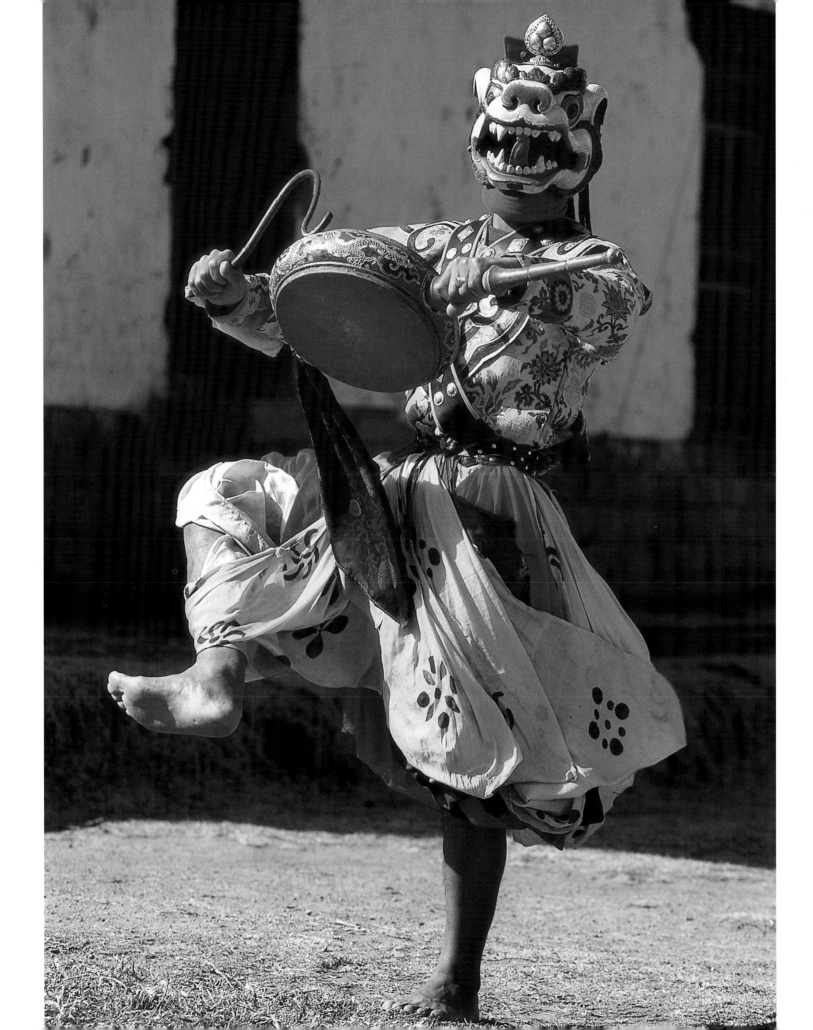

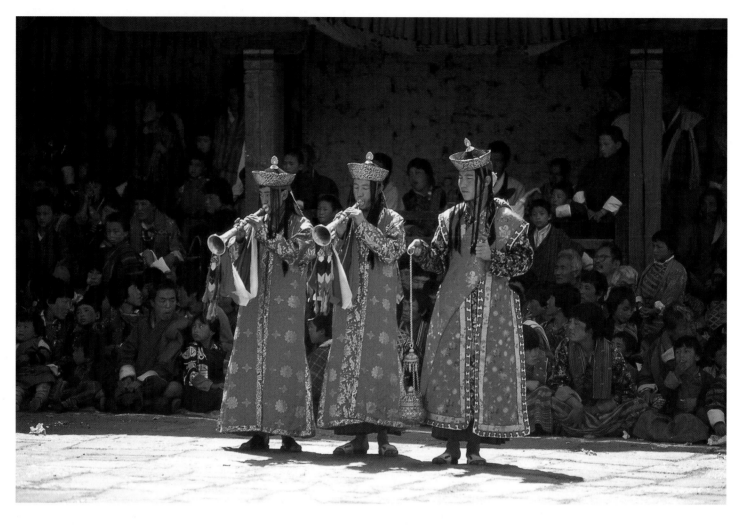

Crowds gathered at the *tsechu* at Paro, as the musicians announce the entrance of the dancers.

Shacham, the stag dance, dance of the *ging* and *tsholing*, and *gingsum*, dance of the three kings of Ging.

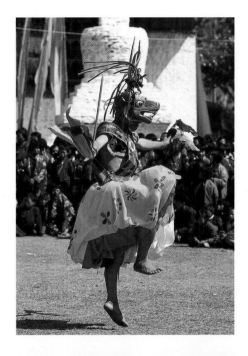

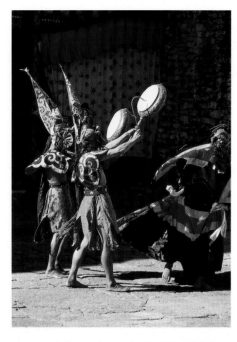

(top-right) Beating their drums, the *ging* chase the *tsholing* from the dance floor. This dance was performed for the first time by Guru Rinpoche in order to subdue the demons that were preventing the construction of a monastery at Samye in Tibet. But rather than eliminating them, Guru Rinpoche turned them into servants of the Doctrine, and finally obtained their help in building the monastery. During the dance, the *ging* strike the onlookers' heads with their curved sticks to drive out any impurities. The people then whistle to chase away the demons and evil spirits.

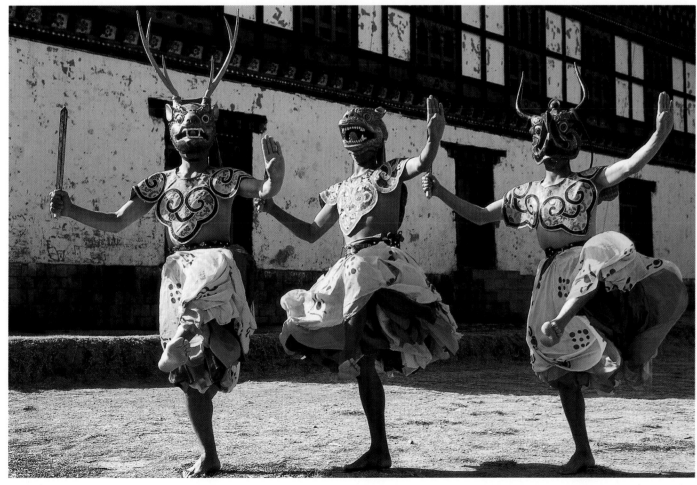

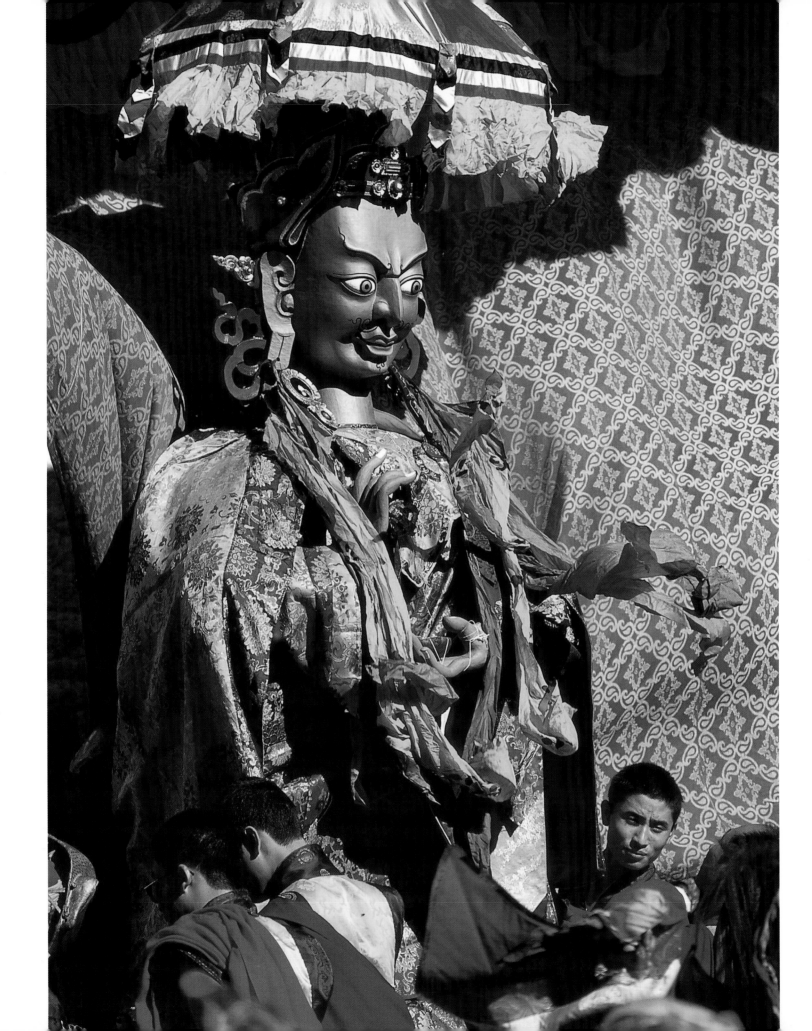

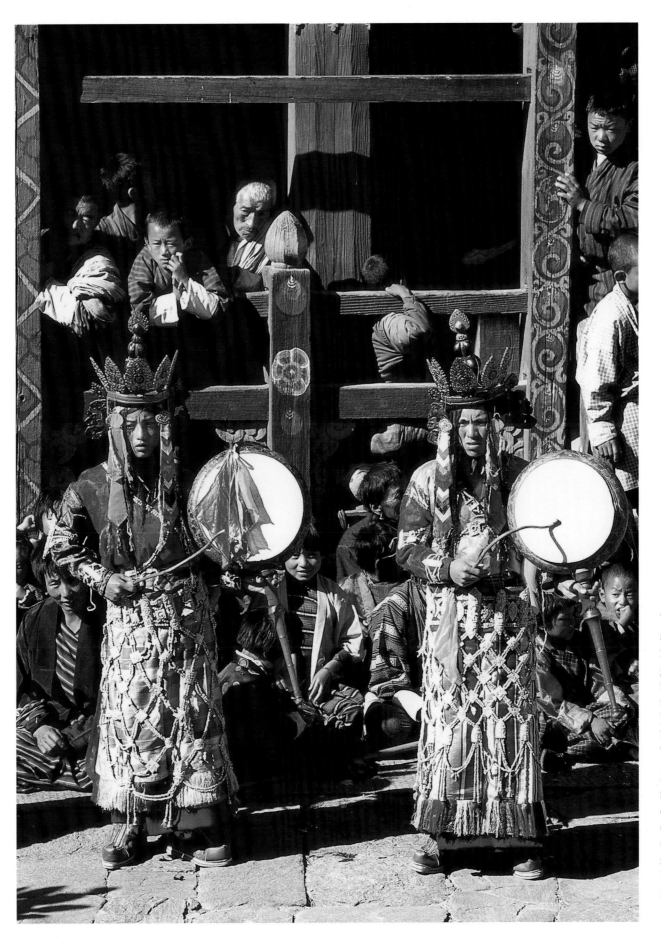

The dance of the *ging* and *tsholing* (*previous page*) is intended to purify the ground before the evocation of *Guru Tshengye*, the Dance of the Eight Manifestations of Guru Rinpoche (*far-left*). Trashigang festival.

Left: Dance of the sixteen divinities *rigma chudrug*, celestial beings covered with bone ornaments who come to sing the praises of Guru Rinpoche. Trongsa festival.

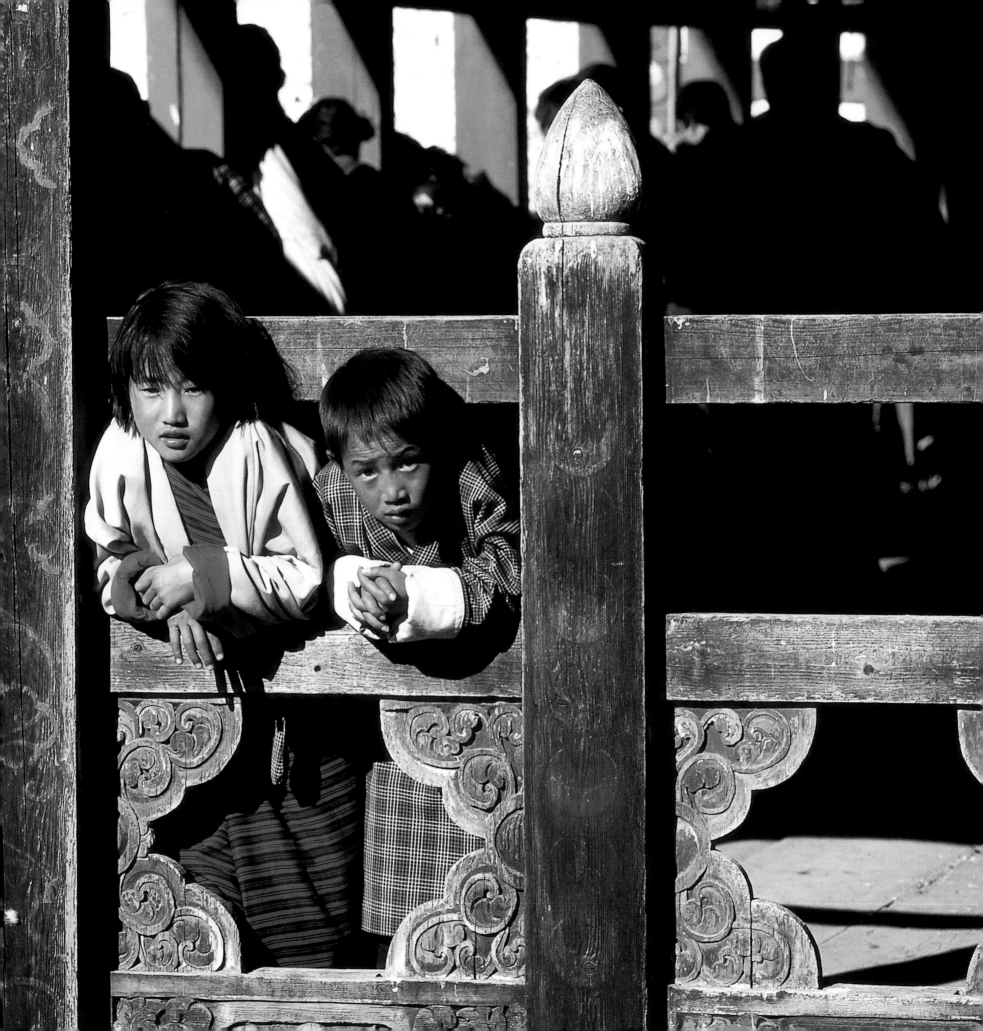

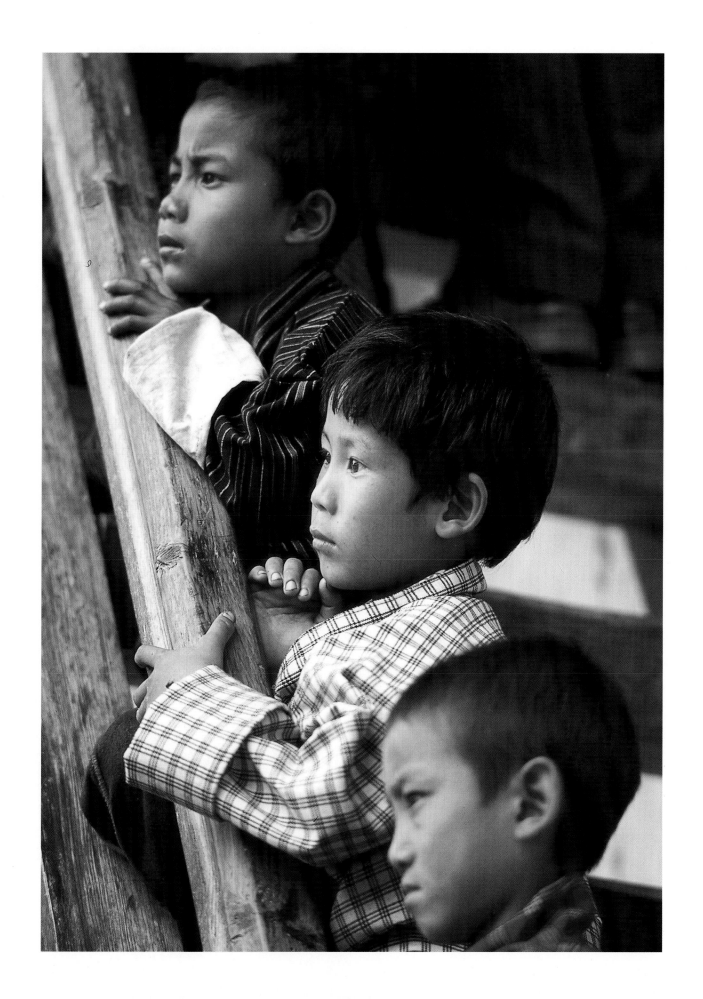

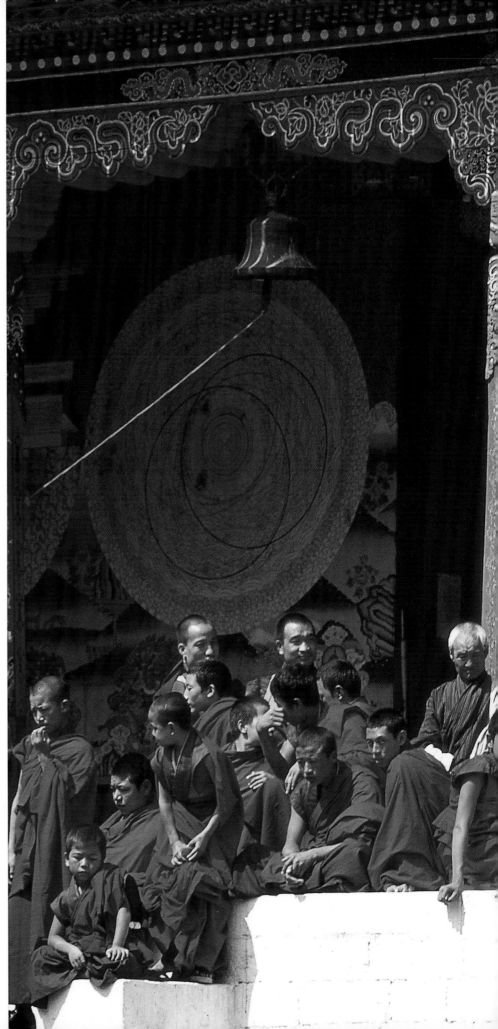

Previous spread: Youngsters watching the *tsechu.*

Top and right: Monks watching the *tsechu* at Thimphu.

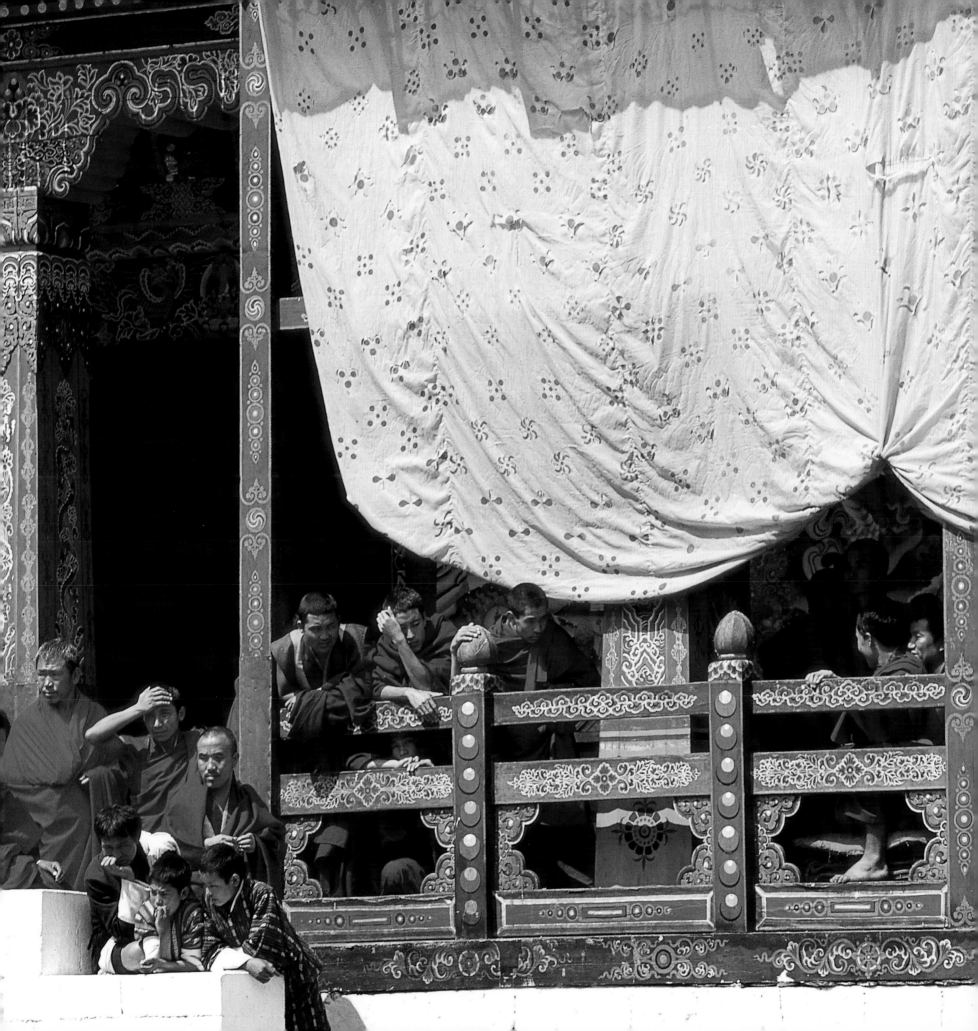

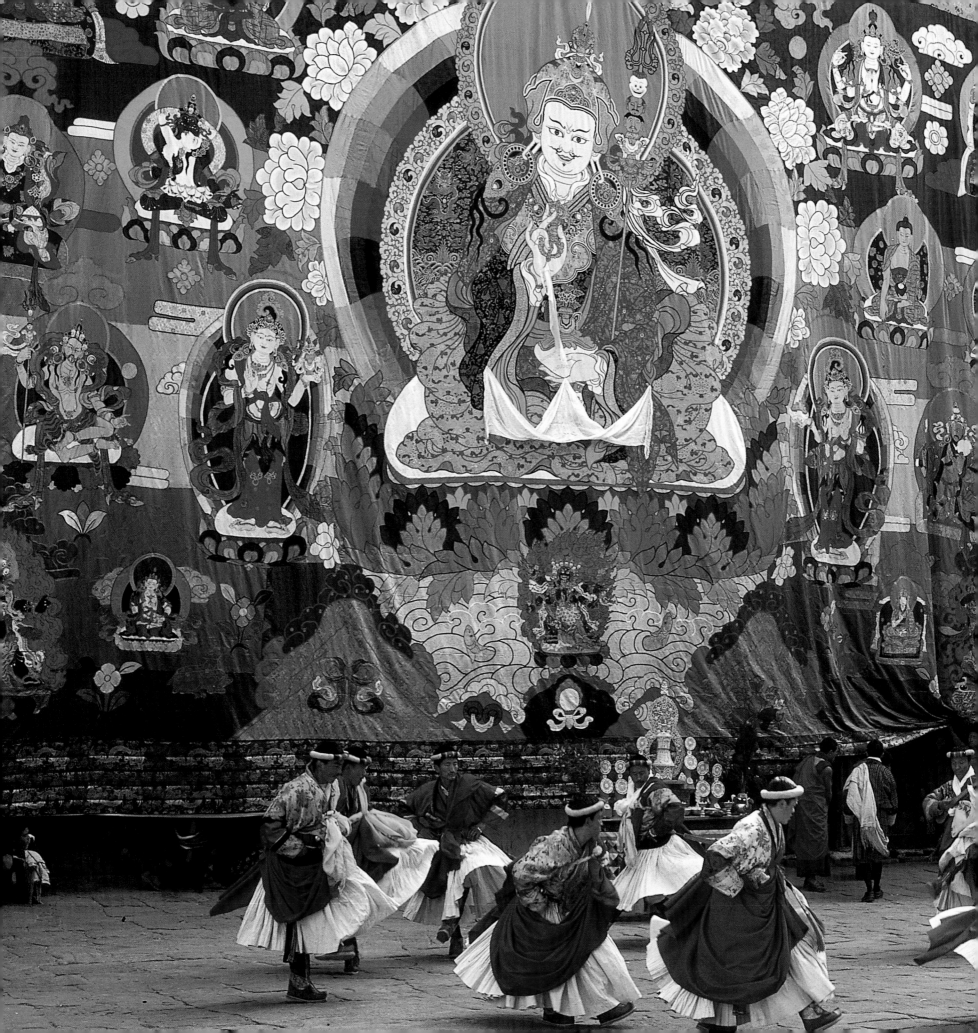

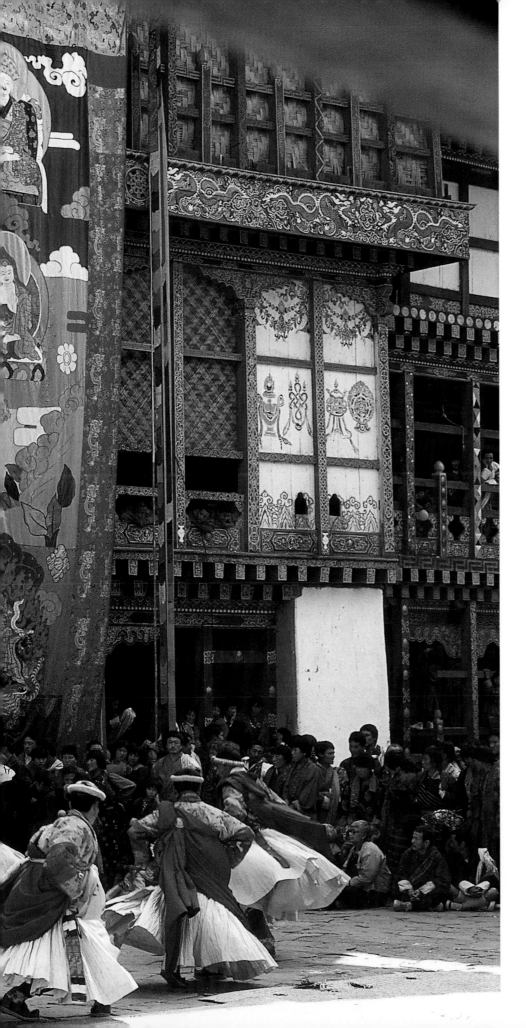

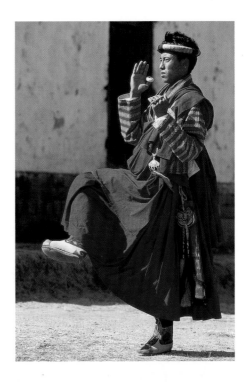

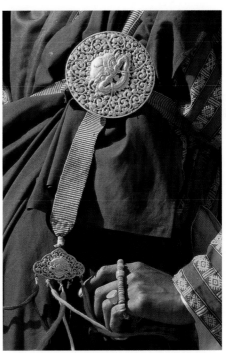

Chöshey is a dance that commemorates the pilgrimage by Tsangpa Gyare, founder of the *drukpa kagyu* school, to the Tsari mountains in eastern Tibet. The dancers wear the costumes of knights connected with the *drukpa* order. *Chösey* performed at Trongsa festival (*left*) and at Thimphu (*above*).

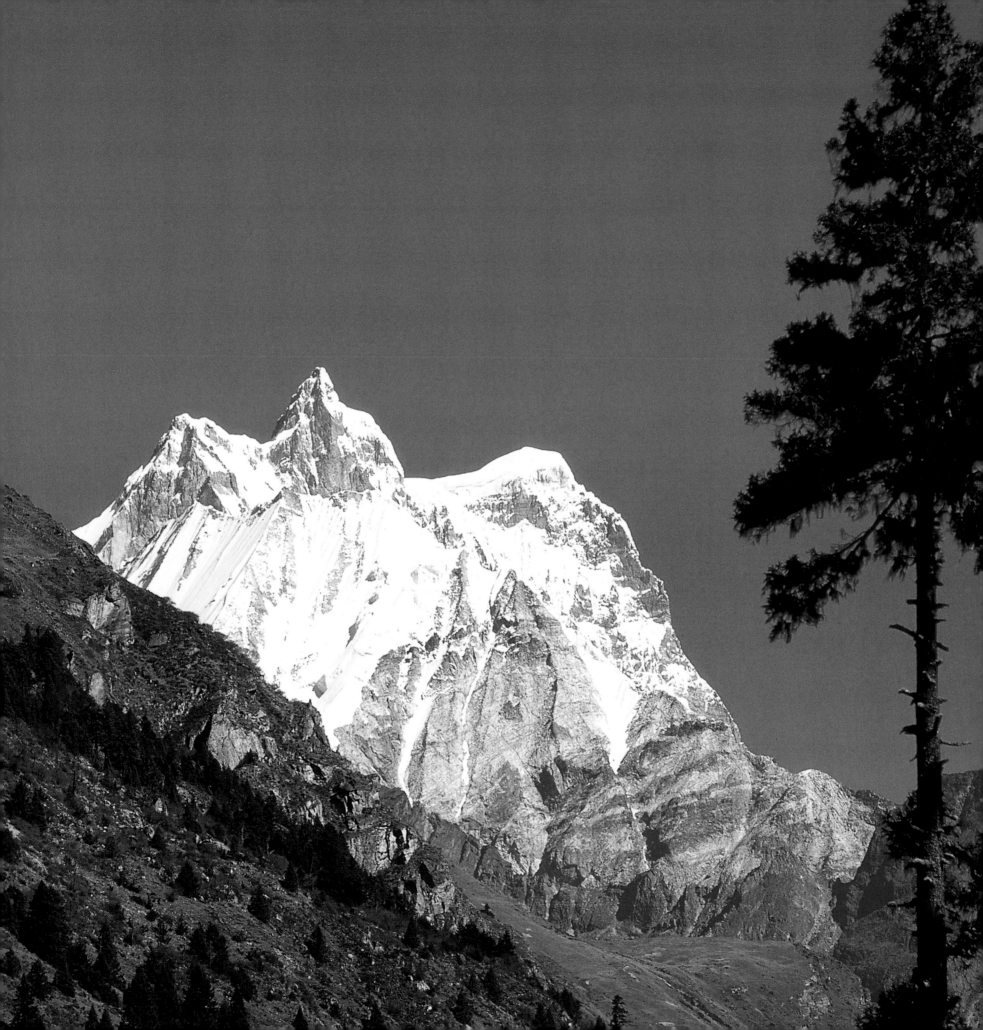

KINGDOMS OF THE NORTH

Crossing high passes after many days of walking, the path reaches the Kingdoms of the North, where the forest disappears and the mountain pasture and glaciers begin. These are the most remote, wild and inhospitable regions of the country, where the climate is harsh and the winters endless. And yet, in ancient times, these isolated spots were the favourite destination of people coming from Tibet. Men and women learnt to live in this stark, uncompromising environment.

Their lifestyle and customs are those of mountain folk. They raise yaks, turning to farming for just a short period in the summer when it is warm enough for the barley and black wheat to grow. This is also the time when some of them depart with their herds in search of better pasture, living in black tents made of yak hair. In the winter, these hardy people devote themselves to handicrafts or go and live in the villages lower down the mountainside where the climate is not so harsh. They can then do a little trading with the villagers from the surrounding areas.

To the north of Punakha and Gasa stretches the high valley of Laya, with its stone houses scattered among the fields on a small plateau at a height of almost 4000 metres. The villagers, who came here from Tibet centuries ago, have retained their own customs and dress. The women in particular wear a quaint conical hat made of bamboo. At a very early age, they proudly start to sport this distinctive head-dress, which, along with their silver, coral and turquoise jewellery, clearly shows that they belong to the clan.

But the remotest and most inaccessible regions are those of Lunana. It takes many days' walking, with several passes at more than 5000 metres to be crossed, before one reaches Chözo Dzong and Thangza. This is home to the hardiest people in Bhutan. Their sometimes barbarous appearance gives some indication of the difficulty of living in this spot at the end of the earth.

These high valleys offer the awe-inspiring spectacle of grandiose mountain ranges perpetually covered in snow and ice. Changing colour at different times of the day, sometimes even appearing to change shape, the great peaks are a truly captivating sight.

These ranges, running for about 300 km, form the eastern end of the Himalaya. Most of the summits have never been climbed and the existing maps are not fully accurate. Bhutan's mountains fall into seven main groups which form a watershed, with the exception of the river Kuri Chu, which rises in Tibet and cuts through the mountains of eastern Bhutan.

Running from west to east, the first range is that of Jomolhari (7320 m), comprising three main summits rising above the Tibetan valley of Chumbi. Running northwards from here is Kangchenta (6800 m) with its extremely steep sides covered in ice. At the northern end of the Laya valley are two imposing summits forming the Masang Kang massif (7200 m).

The Lunana ranges then run for more than 50 km, forming the northern border with Tibet. Huge glaciers descend from summits rising to more than 7000 m, ending in numerous glacial lakes of infinitely varied colours. These high summits dominate the Tarina valley, through which runs the river Pho Chu, and the Chözo Dzong and Thangza valley. Four main peaks, all over 7000 m, form this long chain: Theri Kang, Jejekangphu, Kangphu Kang and the Table Mountains.

To the east of the high Lunana valleys and starting above the Gonto la pass, a difficult route at more than 5500 m running to nearby Tibet, long glacial ridges lead to the summit of Kangkar Punsum, the highest peak in Bhutan at 7541 m.

Lastly, in the extreme east of the country, two massifs terminate the long stretch of the Himalaya in Bhutan. These are Chura Kang (6650 m) that ends abruptly with the deep cut of the Kuri Chu valley, and Garula Kang (6500 m), the easternmost massif in Bhutan.

The elegant peaks of Masang Kang (7200 m), the holy mountain of the Layap, dominate the upper Laya valley.

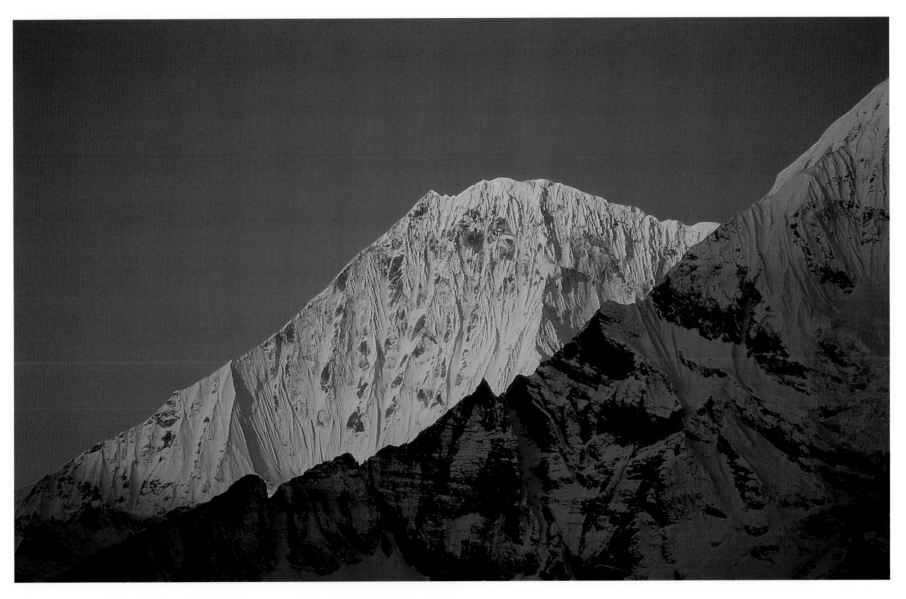

From time immemorial, semi-nomadic yak-herders have lived at the foot of these mountains, some of which are over 7000 metres high.

Left: Lakpa, a young yak-herder from the village of Lingzhi.

Above: The north-east face of Jitchu Drake (6794 m) seen at sunrise from the track to Chebisa.

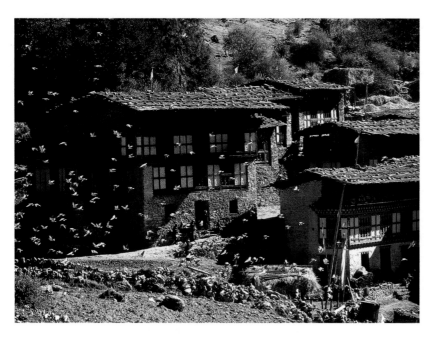

The village of Laya is situated on a small plateau at almost 4000 metres, at the edge of the forest and high pasture. The stone houses are grouped into little hamlets, with people and animals living under the same roof. A steep wooden staircase, or sometimes just a simple ladder, leads from the ground floor cattle shed to the first floor living quarters.

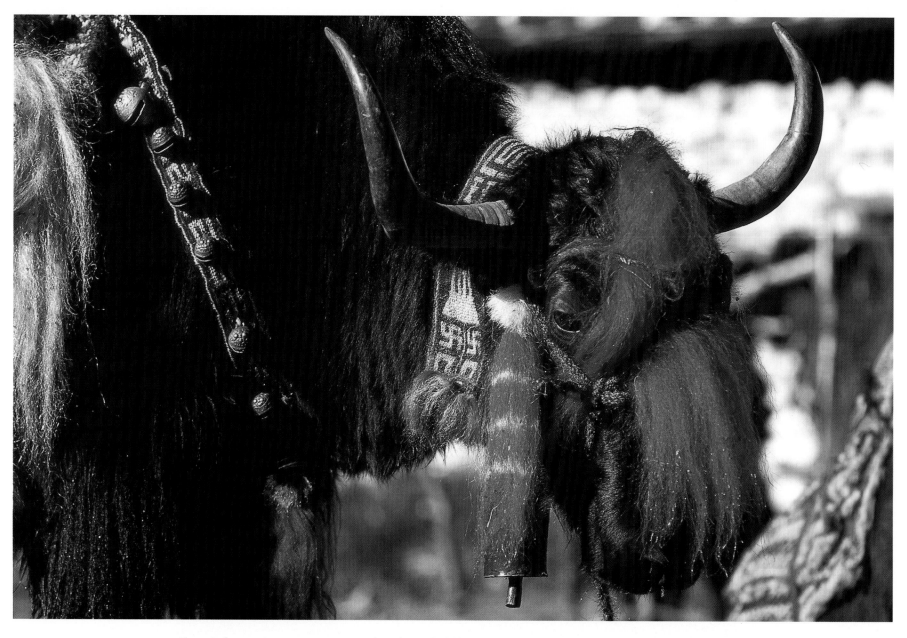

Above: Before mustering into a caravan, the yaks are bedecked with red pom-poms placed on their ears, between their horns or on their tails. These vermilion adornments serve to identify each person's property.

Right: Snuggling two or three together under thick yak-hair blankets, the yakmen do not hesitate to sleep outdoors in temperatures of -10°C or even -15°C. By morning, a thick layer of frost covers both men and livestock.

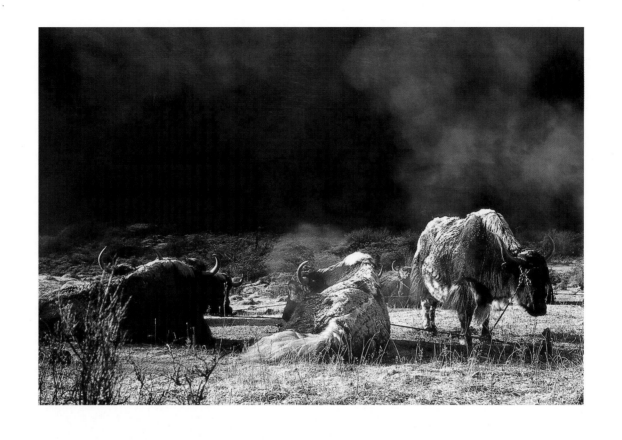

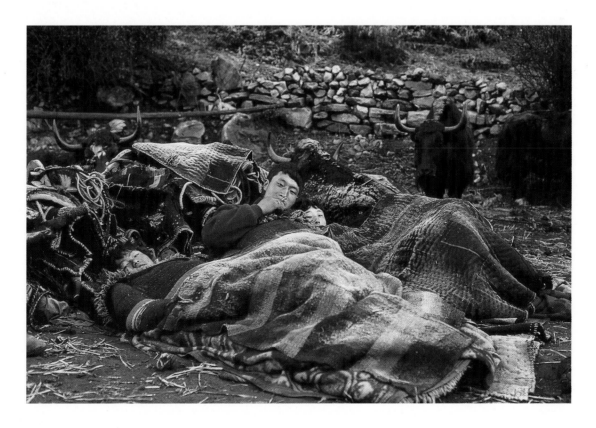

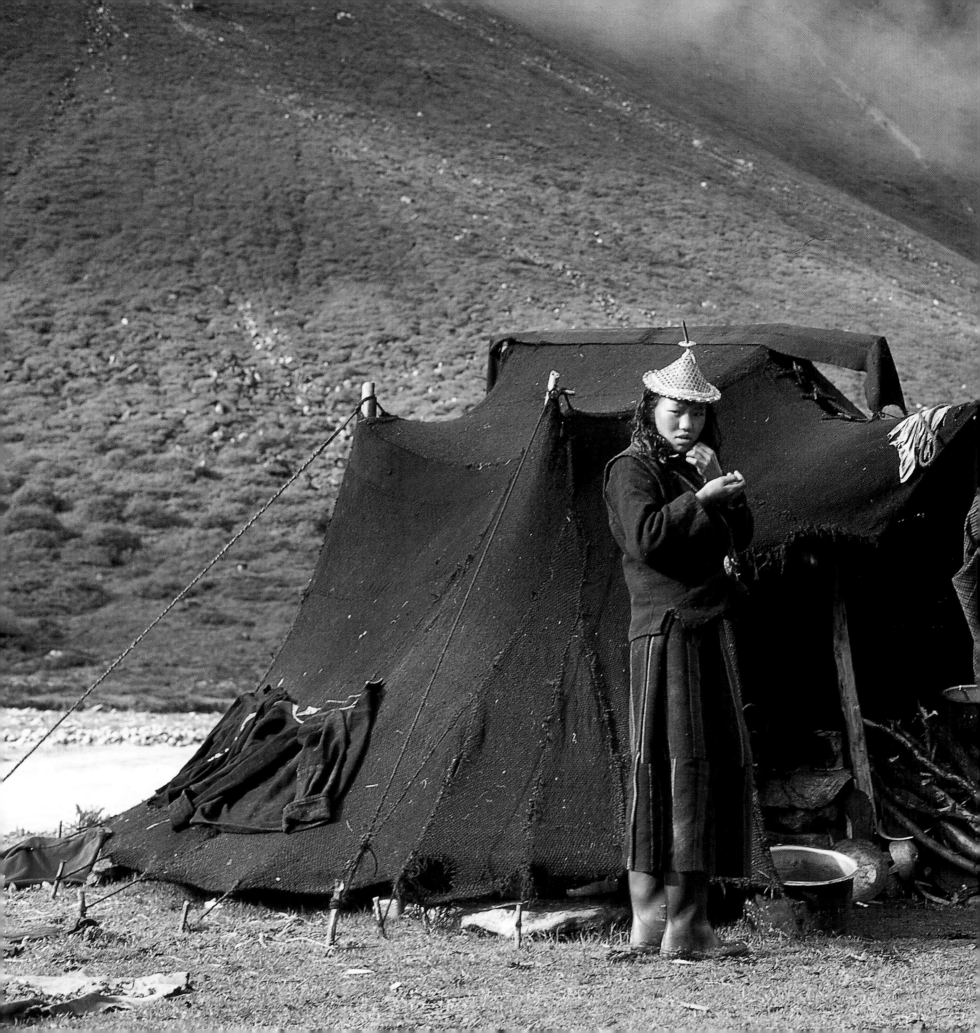

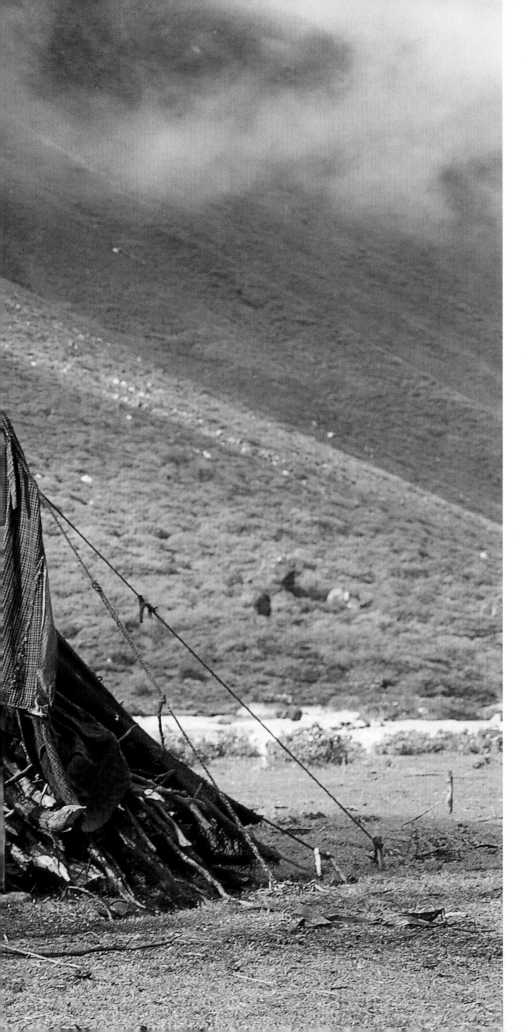

Above: Daily life in Laya. Preparing buttered tea, and morning ablutions.

Left: In the summer, the inhabitants of Laya take their herds up to the high pastures, where they live for several months in black tents made of yak hair.

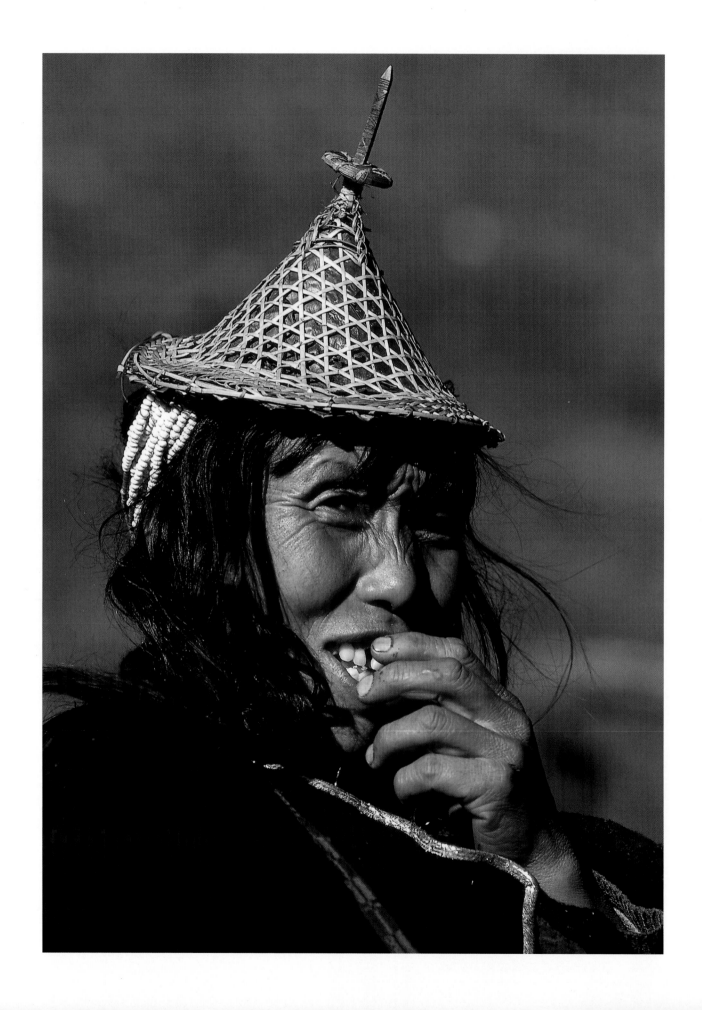

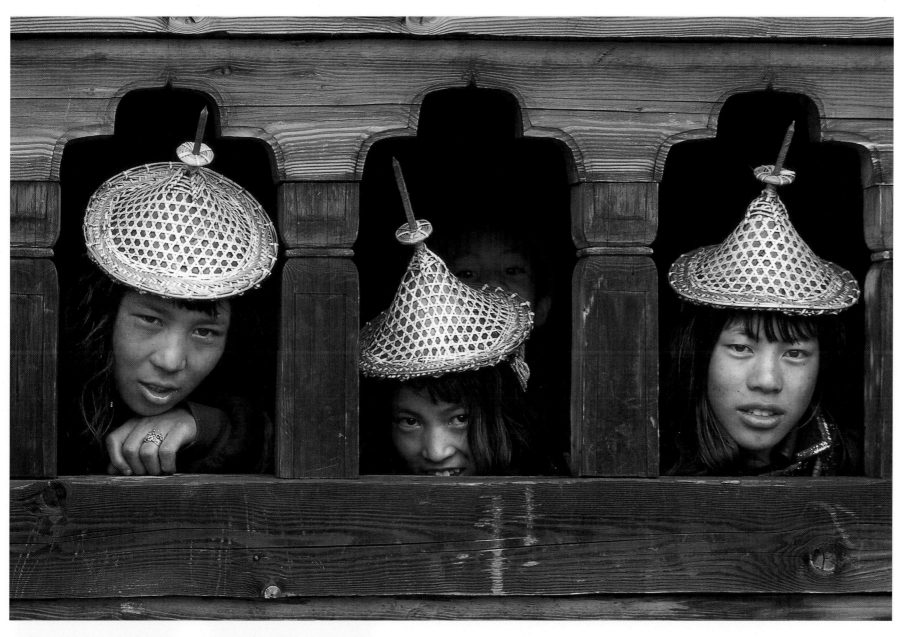

The inhabitants of Laya came from Tibet many centuries ago, but they have kept their own customs and costumes. The young girls and women wear conical hats made of bamboo. At a very early age, they proudly start to sport this distinctive head-dress, which, along with their many pieces of jewellery, often mixed with spoons and silver coins, clearly shows that they belong to the clan.

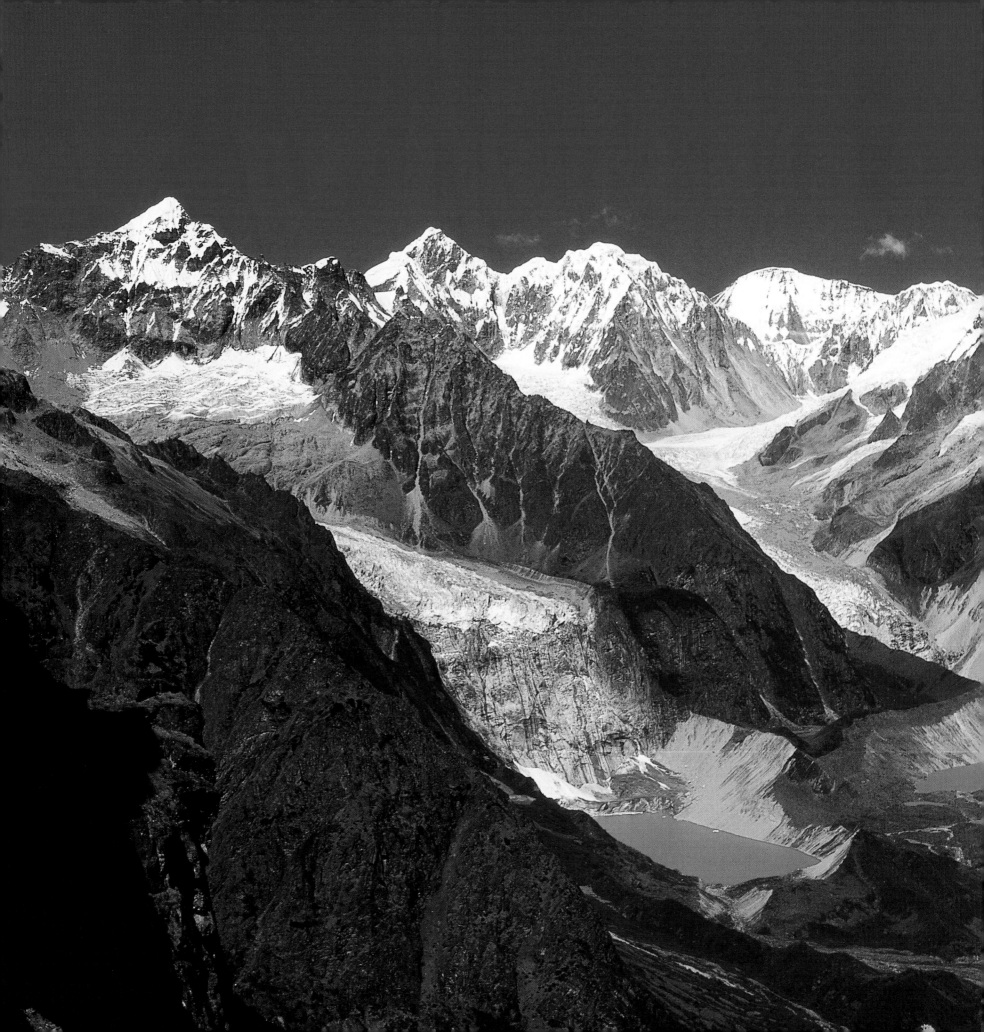

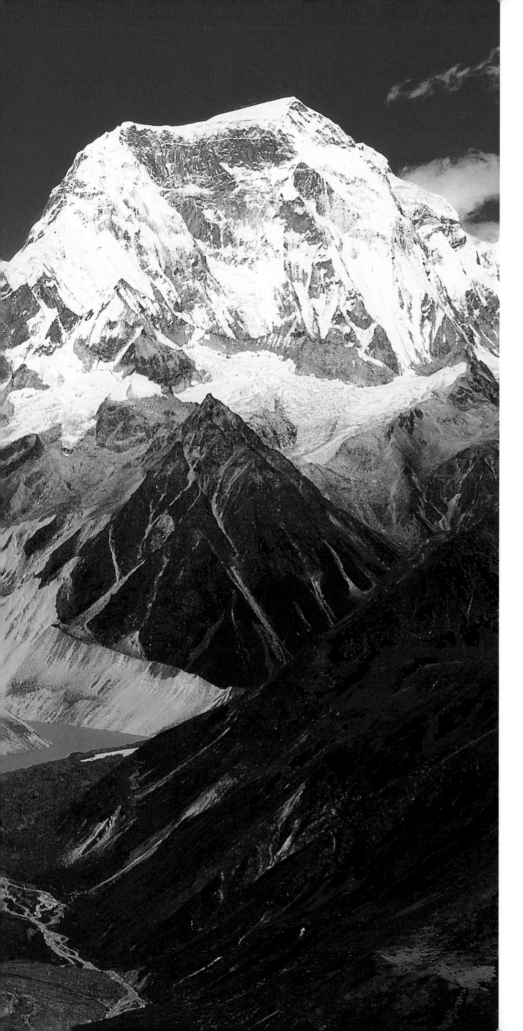

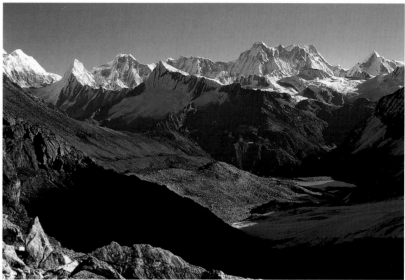

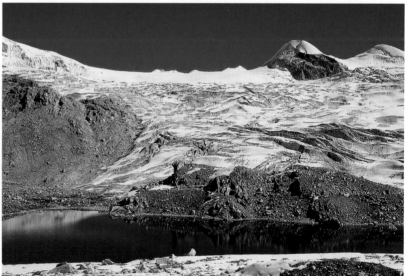

At 5100 metres, the Karakachu la is one of the rare tracks giving access to the remote villages of Lunana. Everything is on a vast scale in this grandiose landscape of peaks and glaciers: Theri Kang (*left*) and Jejekangphu Kang (*top*), are two summits rising to more than 7000 metres.

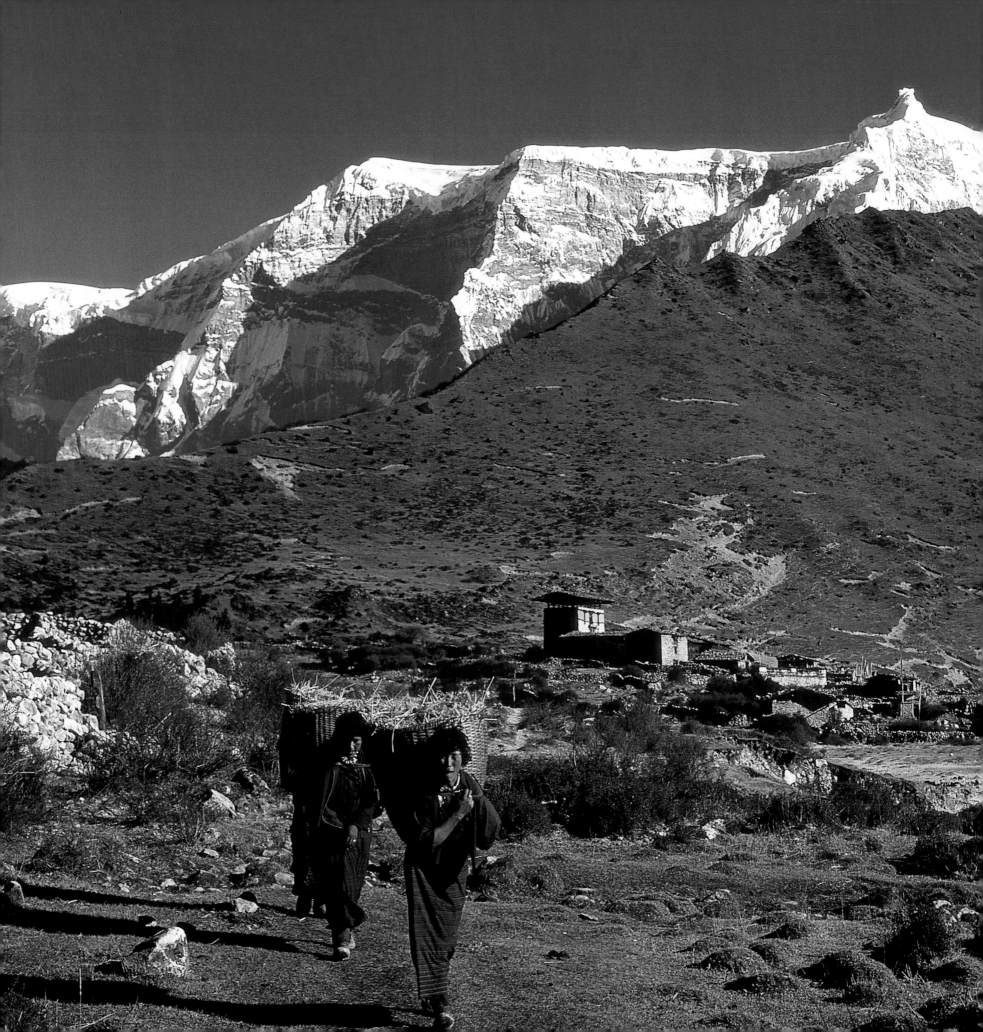

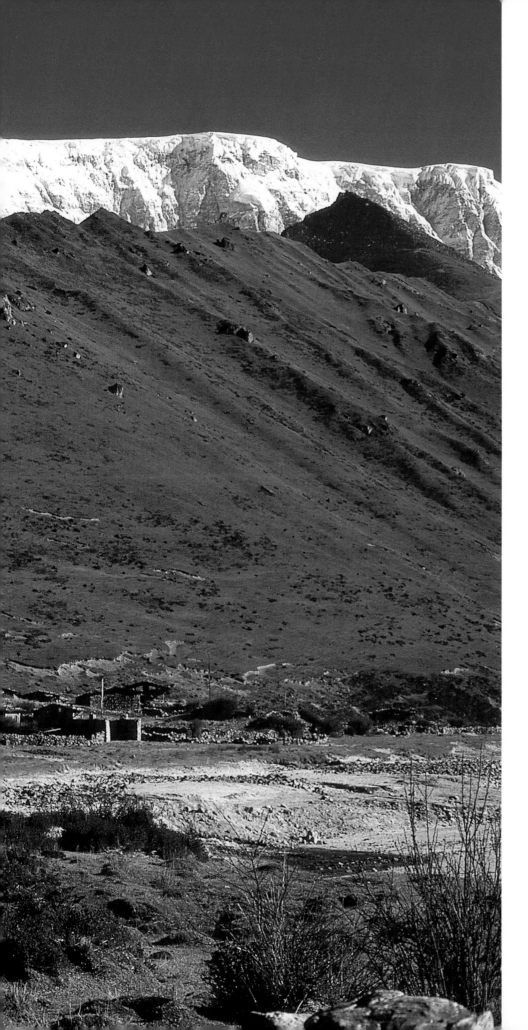

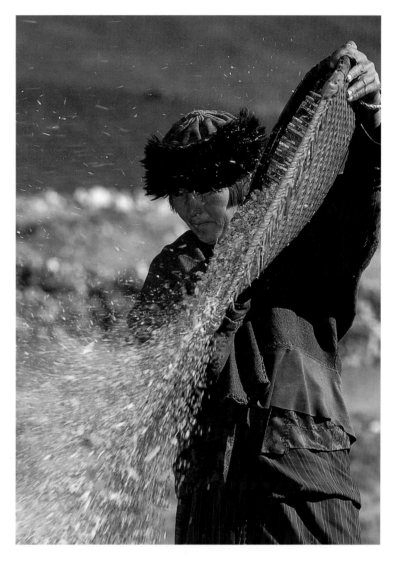

Nestling at the foot of the 7000 metre Phurbu Kang (Table Mountains), the village of Chözo Dzong is isolated for months during the winter. As at Thangza, the people of Chözo Dzong can only harvest a little barley at the end of the summer.

157

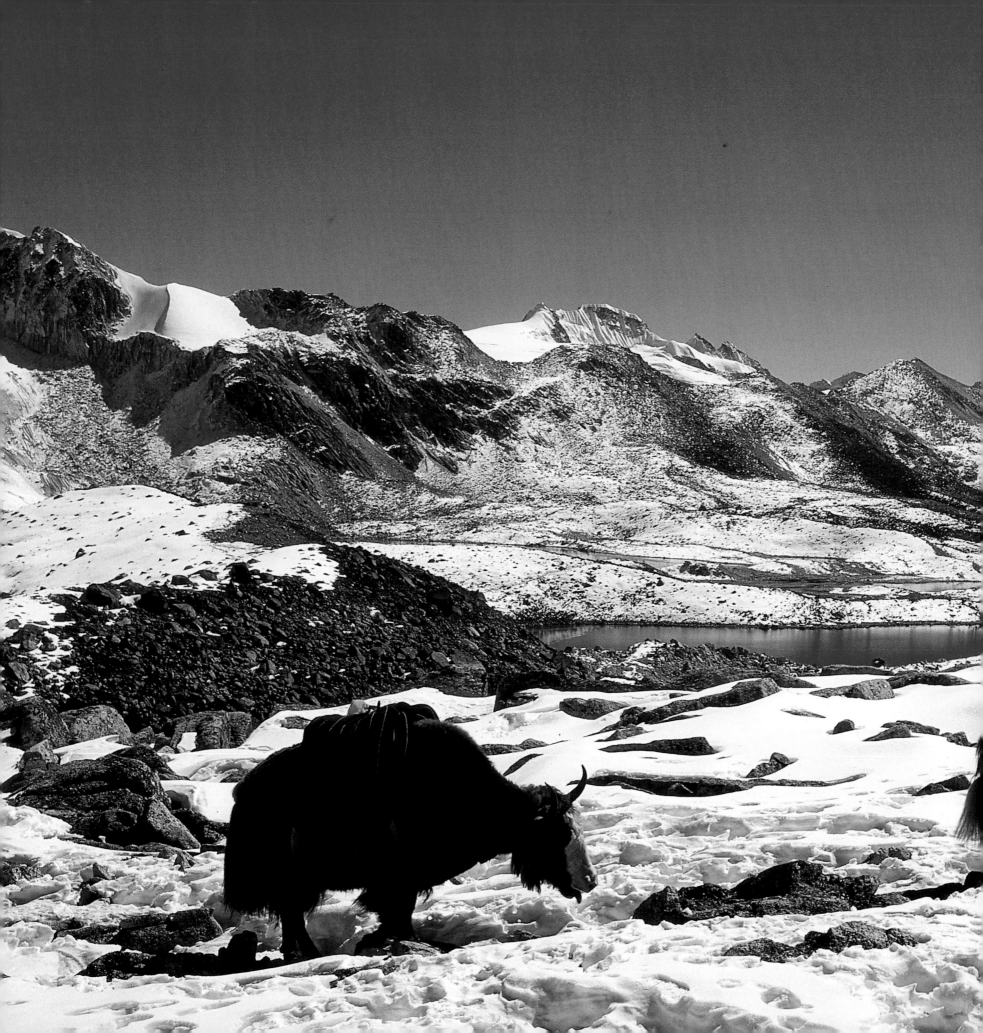

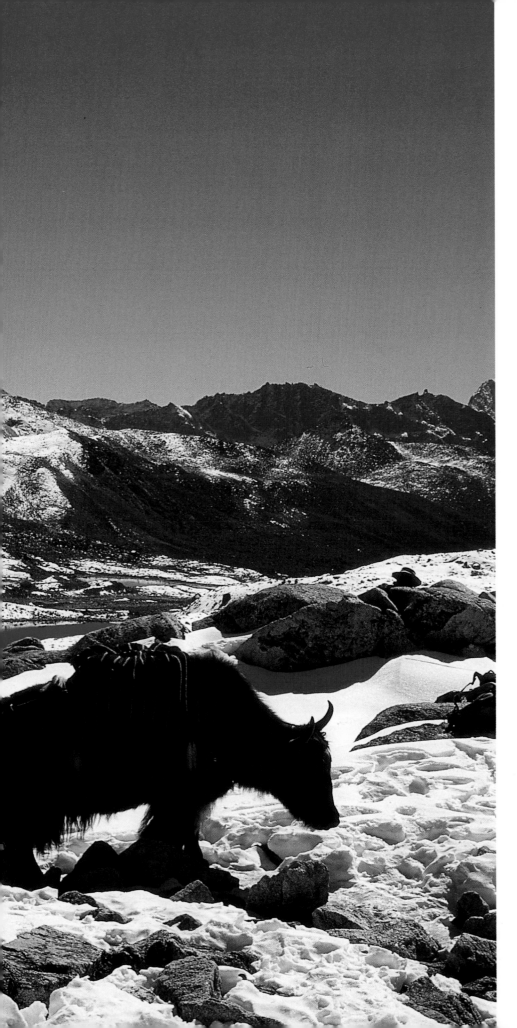

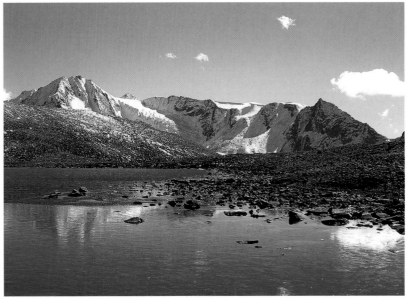

Above: One of the many lakes in Lunana, whose delicate colours range from emerald to turquoise.

Left: Crossing the Rinchhenzoe la (5200 m), a caravan of yaks hurries to reach Thangza before the snow becomes too deep.

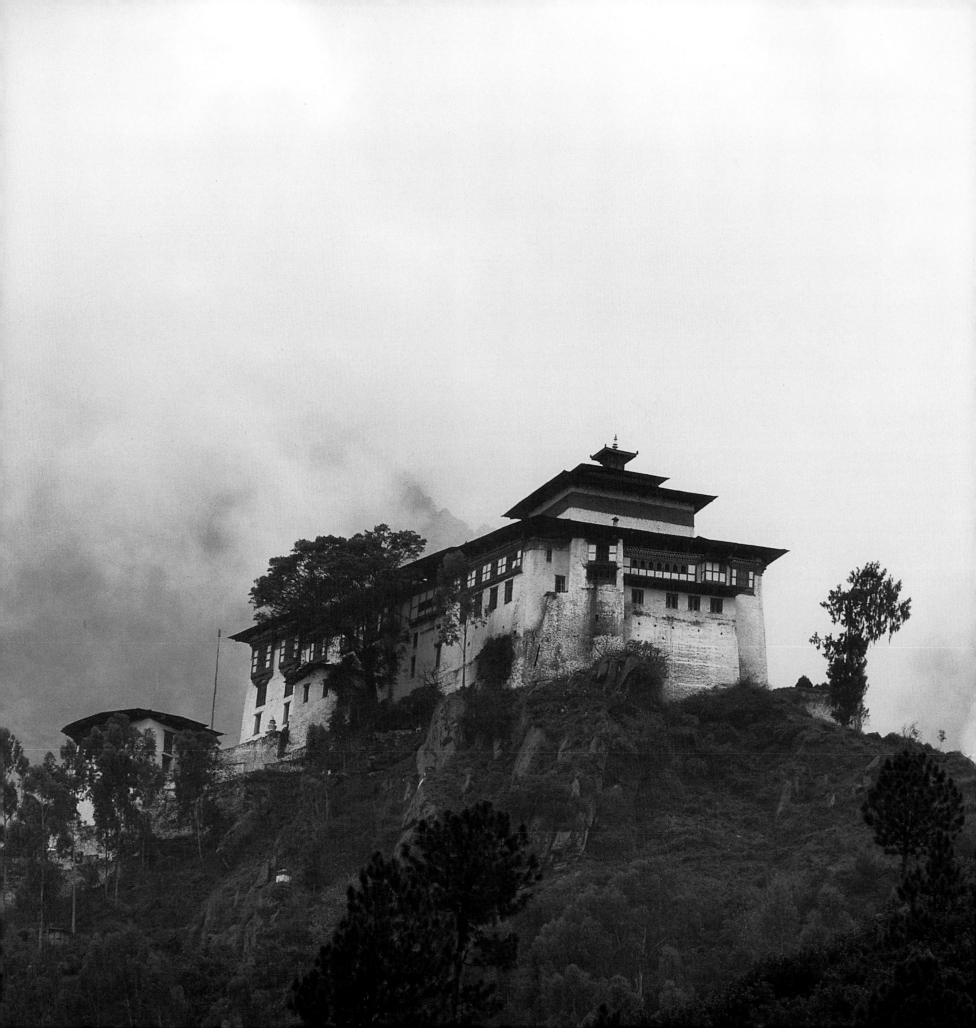

TREASURES OF THE EAST

Eastern Bhutan is a mysterious land, which most tourists and even many people from western Bhutan have never visited. It is, however, rich in cultural treasures, and its sub-tropical vegetation helps to balance the severity of the mountains.

A long, picturesque road leads from central Bhutan towards the towns of Lhuentse, Mongar and Trashigang. After crossing the daunting Thrumsing la at almost 4000 m, the road plunges in a long series of bends to the depths of a dark pine forest. In winter, when it is snowing or raining, there is something strange and even sinister about the surrounding countryside. The long strands of moss hanging from the branches seem like mysterious ghosts slipping between the trees. But the most astonishing part of this road is without doubt the section after the village of Sengor, where it is literally cut into the rock face, with the precipice falling away into a seemingly bottomless chasm. For several kilometres, the road clings to the rock face, before starting its descent to more hospitable regions. Bamboo, ferns, tropical creepers and bananas begin to appear. One hears the songs and laughter of women working in the maize fields. The lowest point along the road is about 650 m, where an iron bridge fluttering with many prayer flags crosses the river Kuri Chu that runs down from Tibet. Together with other tributaries, the Kuri Chu forms the Manas and this, in turn, crosses the Indian plain to join the mighty Brahmaputra.

Trashigang is the main town of Bhutan's most populous district. This is the country of the *Sharchops*. As at Lhuentse, the *dzong* is built at the top of a rock outcrop overlooking the river. Luxuriant vegetation including orange trees, magnolias and magnificent bougainvillaea add their touch of beauty to the place. The local crafts are particularly rich and the sumptuous textiles of Kurtoe or Radhi are much sought after throughout the kingdom, to the extent that until the middle of the twentieth century, the Bhutanese could pay their taxes with pieces of these fabrics in many parts of the country. Sitting on the ground near the entrances to their houses, the women weave cloth, sometimes using extremely complex techniques. Natural dyes made from bark, leaves and flowers enable them to obtain the most astonishing colours. The *Sharchops* have also been excellent

businessmen since time immemorial. These regions were traditionally routes between India and Tibet. Pilgrims and merchants went to the high plateaux of Tibet and, on the way, would make offerings to the divinities of Goem Kora or Chorten Kora. A caravan route from central Bhutan also went to Trashi Yangtse after crossing the Tang and Lhuentse valleys. The ancient *dzong* was transformed into a veritable trading post where salt, meat and wool from the north were exchanged for rice, spices and medicinal plants from the south. Many turned wooden objects are still made in the Trashi Yangtse region, using traditional foot lathes.

The people in the east include several ethnic minorities with unusual customs. Among these, the *Brokpas* of Merak and Sakteng live near the border with the Indian state of Arunachal Pradesh, two or three days' walk from Trashigang. These people are close in terms of their origins and traditions to the *Mönpas* who live in the Tawang region. Semi-nomadic yak breeders like the inhabitants of northern Bhutan, they take their herds to the high pastures in the summer. In winter, they live in stone houses gathered into compact villages that protect them from the cold.

Heading south from Trashigang, the road winds from crest to crest, overlooking green valleys where, in autumn, the yellow and pink of mustard and buckwheat blend into a colourful patchwork. All roads running southwards eventually offer a breathtaking view of the immense Indian plain that stretches as far as the eye can see. From the heights of Samdrup Jongkhar, rice fields and tea plantations form a uniform backdrop through which glides the silver strip of a river, finally disappearing into the distant mists of the sub-continent. What a striking contrast between this immense flat landscape and the rugged relief of Bhutan.

A natural fortress, Bhutan has been known since time immemorial as *Beyul*, the 'Hidden Land'. In an outstandingly beautiful natural environment, its people have learnt to live in step with nature, developing a harmonious society which is enhanced by the spiritual and cultural values of Buddhism. Far removed from the rush of the modern world, time seems to stand still.

Lhuentse *dzong*, on a rocky outcrop overlooking the valley.

Chorten Kora (Trashi Yangtse), prayer flags and *chorten*.

A monument commemorating the death (Parinirvâna) of Buddha Sakyamuni, the *chorten* also symbolises the universe, which is made up of five elements. The bottom, square part, corresponds to earth. Above is water, symbolised by the half-globe, while fire is represented by the conical section. The umbrella-like section at the top represents air. These four material elements are finally absorbed in the subtle element, ether, the essence of the spirit, symbolised by a flame above a sun and moon. This deep essence is comprehended through the Dharma, which leads the adepts through the last stages of their spiritual progress to Enlightenment. Corresponding to each element there is also one of the five Jina or Dhyâni-Buddha, the five primordial Buddhas. It is on account of their religious and didactic importance that *chortens* have always been objects of faith and veneration throughout the Buddhist world.

Following spread: Trashigang *dzong*, landscapes and peoples of eastern Bhutan.

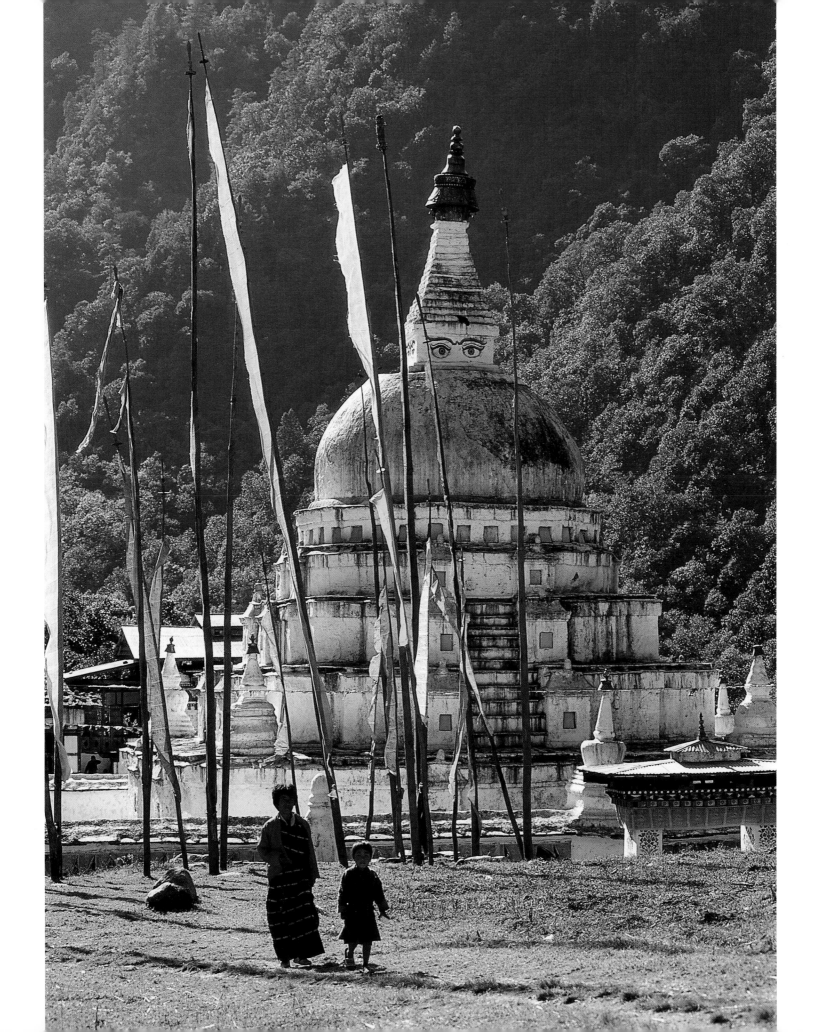

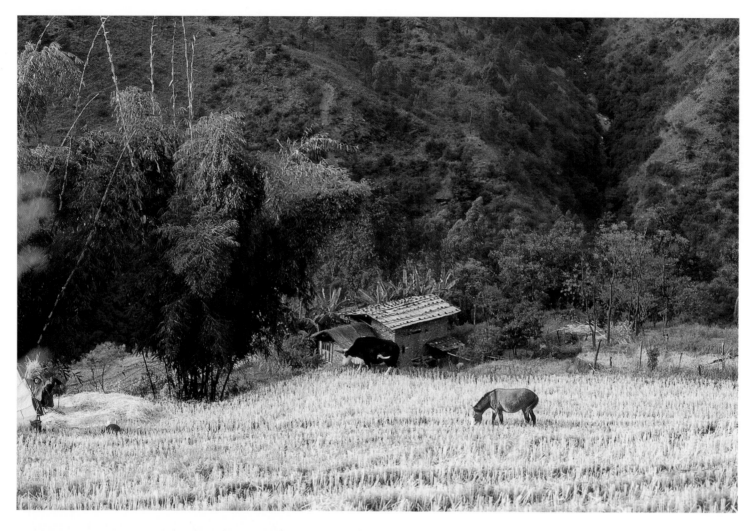

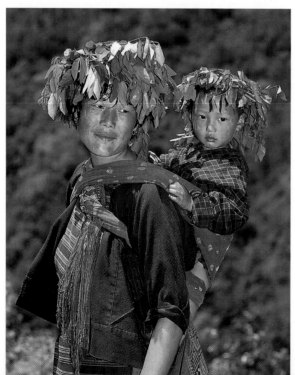

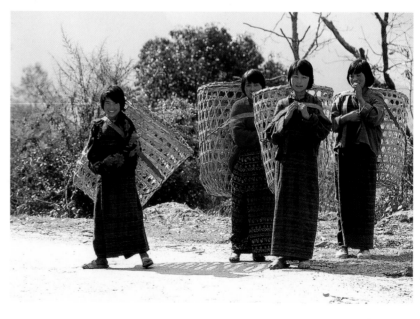

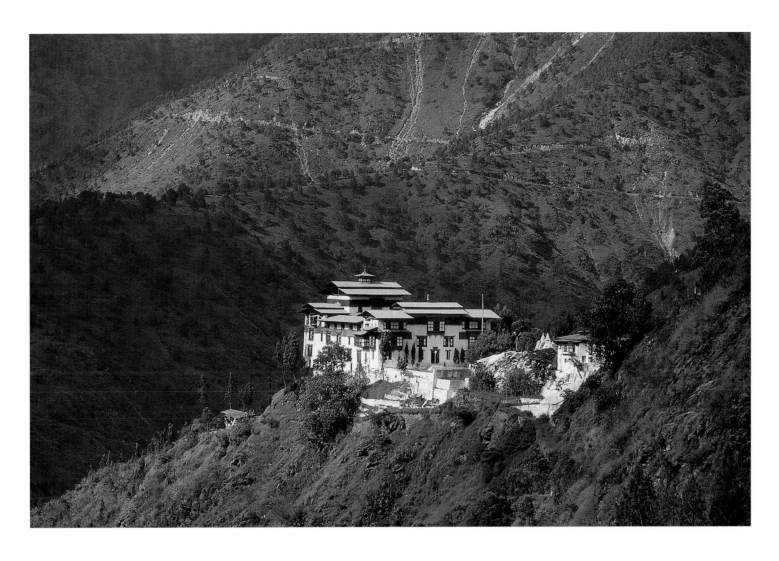

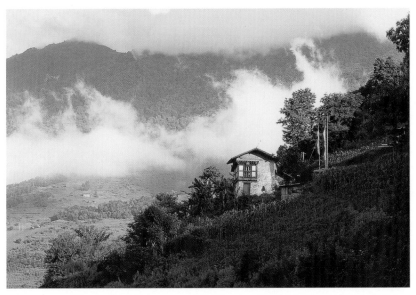

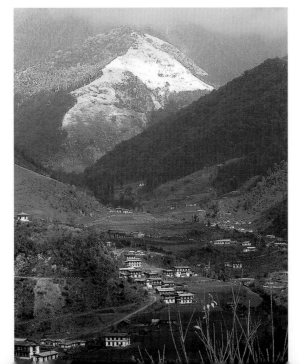

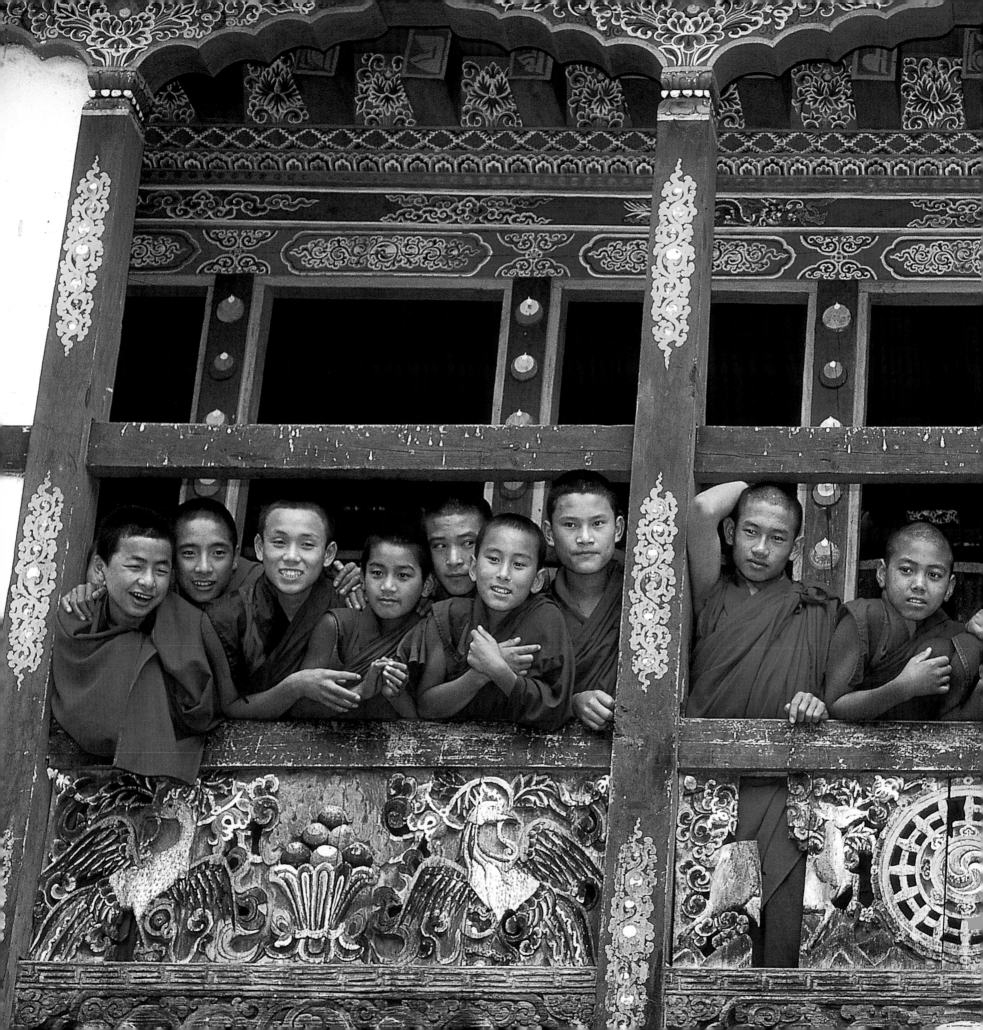

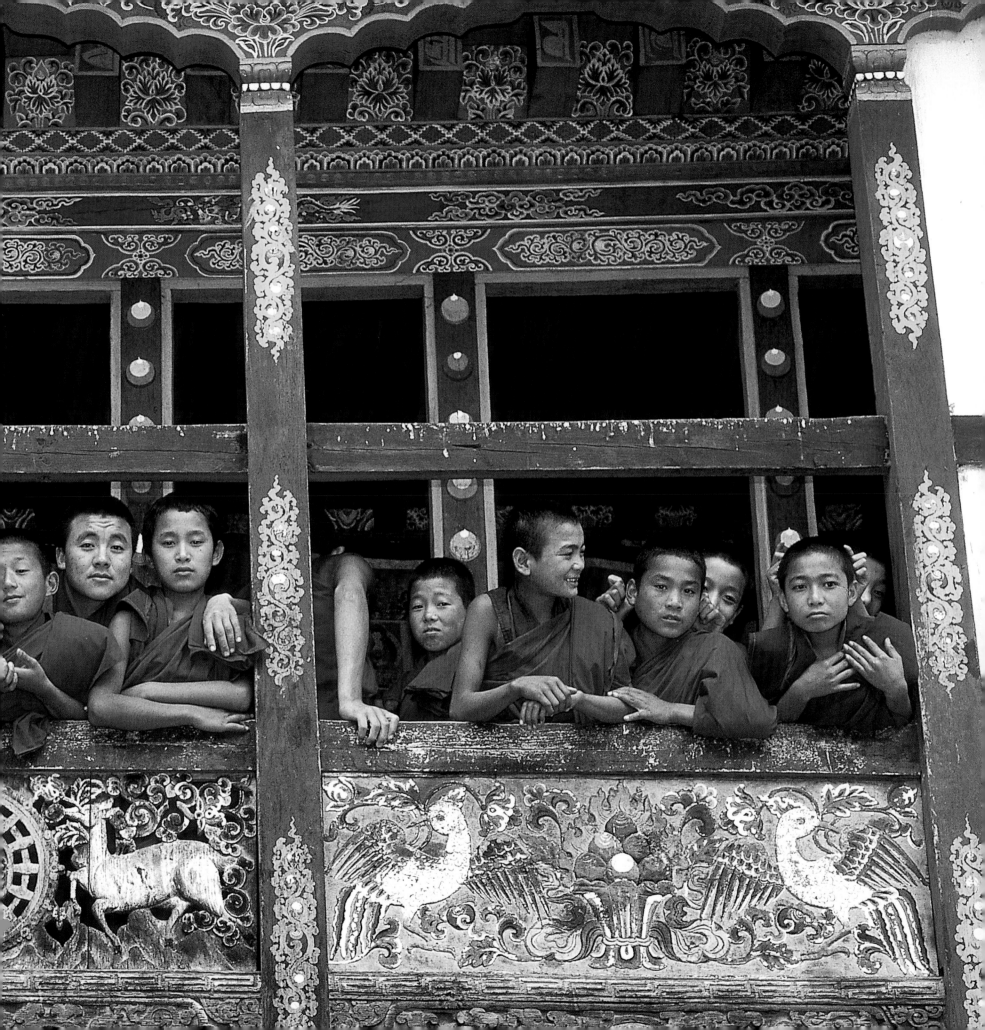

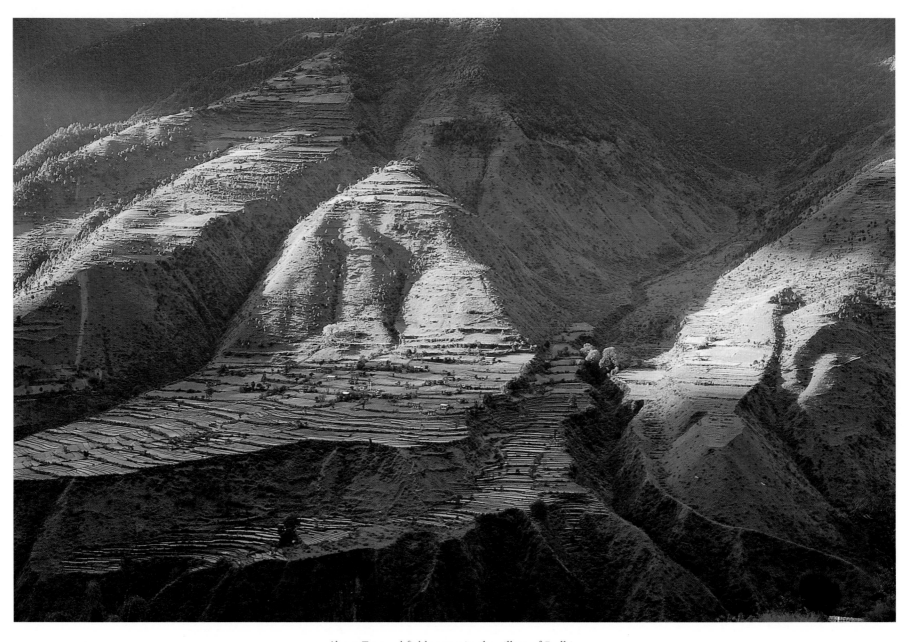

Above: Terraced fields opposite the village of Radhi.

Previous spread: Monks in Lhuentse *dzong*.

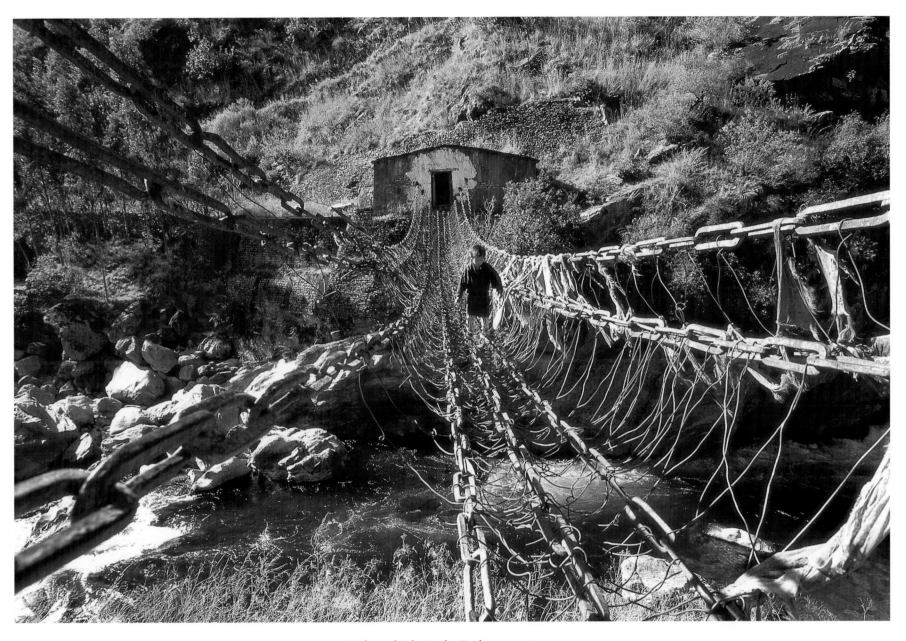

Doksum bridge in the Trashigang region.

Chain bridges are interesting examples of the construction techniques used in Bhutan. One of the most important figures in the history of these bridges is the Tibetan saint Thangtong Gyelpo, who lived from 1385 to 1464. Thangtong Gyelpo was born in central Tibet and visited Bhutan on several occasions. He is said to have built eight chain bridges in the country between 1433 and 1434, out of a total of 58 in central Asia and the outer regions of Assam. He was a remarkable inventor and is reputed to have discovered various iron-based alloys that he used in building the first chain bridges. He supervised the work himself, obtaining the strongest chains possible from smiths at Kongpo in Tibet or from the Trashigang region in Bhutan, and having them transported to the actual building site.

The chains run through the building at various heights and are held firmly in place by huge wooden chocks. Three chains, formerly covered with bamboo, form the deck, while 6 others on either side act as guard and hand rails.

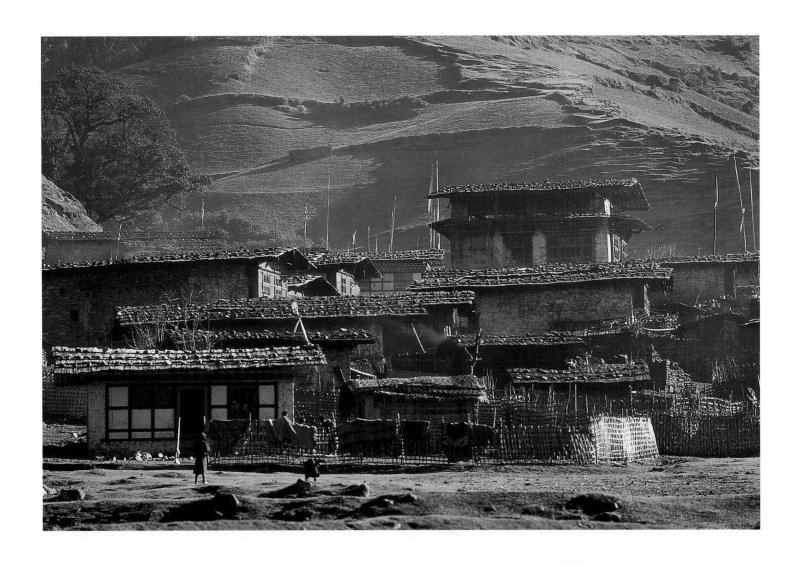

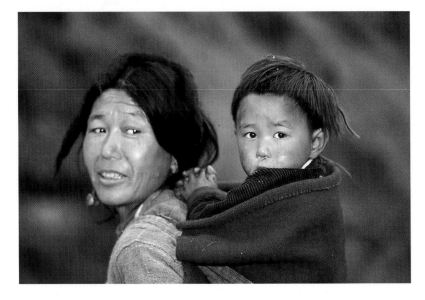

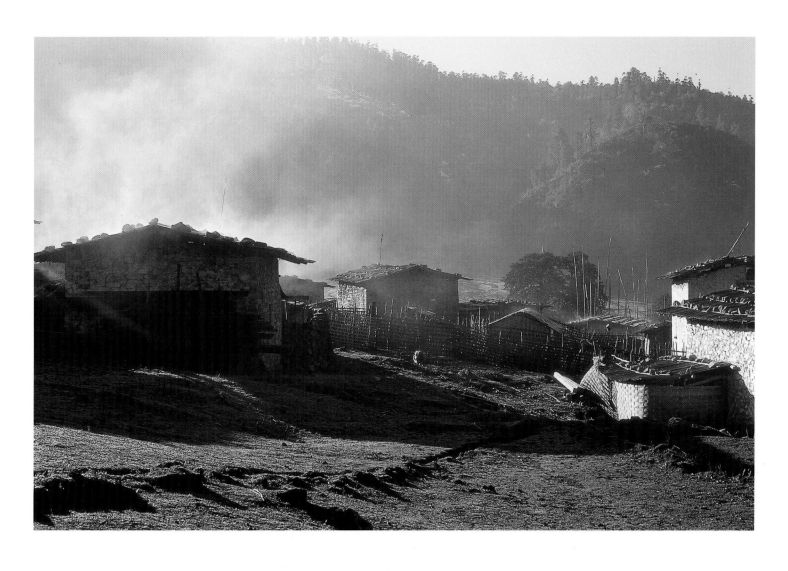

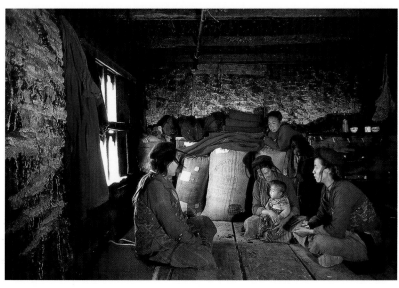

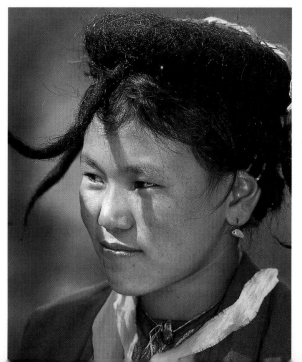

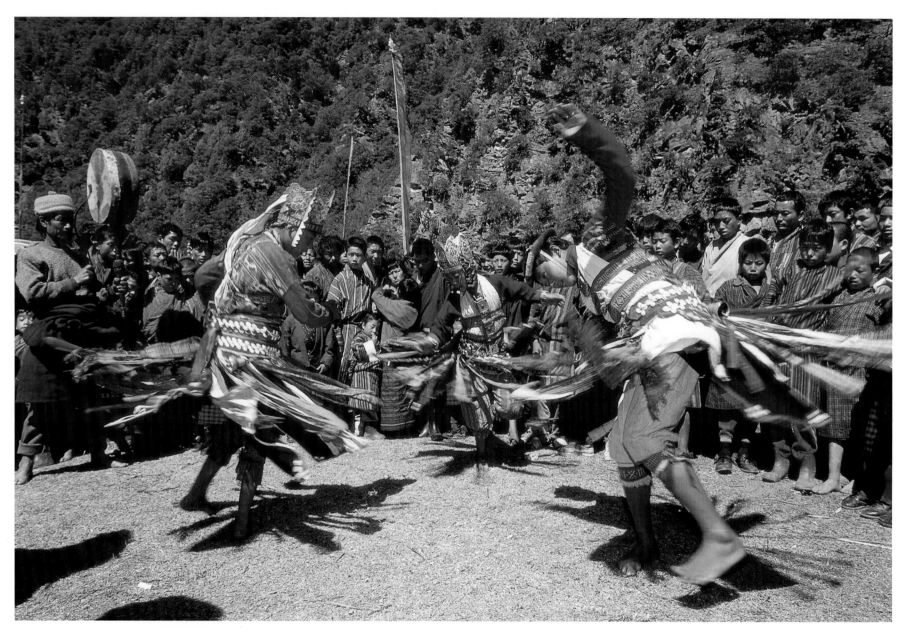

Many *Brokpas* attend the annual Goem Kora festival held to honour the place where Guru
Rinpoche subdued the demons in the 8th century. Here, young dancers from
Tawang take part in spectacular traditional dances.

Previous spread: Village of Sakteng and *Brokpa* people. Tradition says that the five points
on the yak-hair hat worn by the inhabitants of these regions are supposed to prevent
drops of water from falling on their faces when it rains.

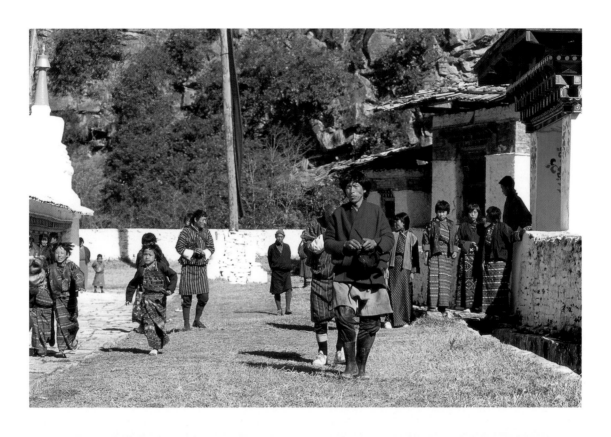

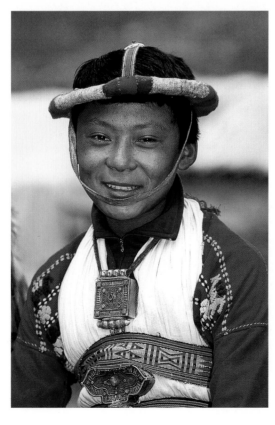

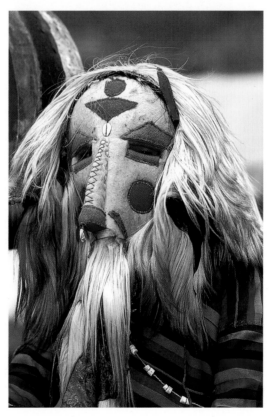

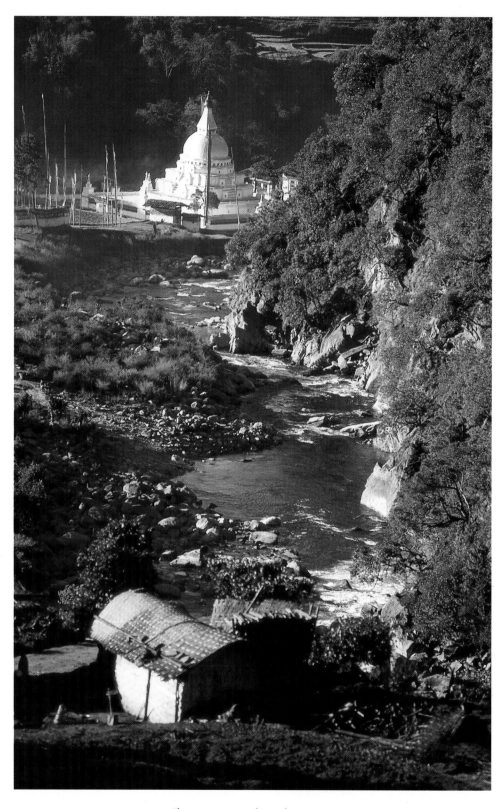

Chorten Kora in the early morning.

GLOSSARY

Aikapur: a particular pattern of woven textile, normally made out of raw silk by women in eastern Bhutan.

Anim: Buddhist nun.

Ashi: title borne by Queens of Bhutan and princesses of the Royal Family.

Banchung: small bamboo basket.

Boddhisattva: person who has reached Enlightenment but who willingly returns to earth to assist all beings.

Bön: animist religion that existed in Tibet and Bhutan before the introduction of Buddhism.

Brokpa: name given to yak-breeders, particularly in eastern Bhutan.

Bura: raw silk.

Cham: ritual dance.

Chang: barley, millet or rice beer.

Chhoesi: government based on principle of dual system (religious and political) introduced by the first *shabdrung*.

Chorten: Buddhist funerary monument sometimes containing relics, and recalling the death (Parinirvâna) of Buddha Sakyamuni.

Dasho: honorary title given by the King to certain senior Government officials.

Desi: secular leader of Bhutan at the time of the *shabdrungs*.

Doma: mixture of areca nut and lime wrapped in a betel leaf. A favourite habit in Bhutan.

Dramnyen: a type of lute with seven strings.

Dratsang: State monastic body.

Dromchoe: ritual dedicated to Yeshe Gombo (Mahakala), protective divinity of the *Drukpas*.

Druk Yul: Bhutanese name for Bhutan. It means "Land of the Dragon" or "Land of the Drukpas"

Drukpa: Tibetan religious school founded in 1189 by Tsangpa Gyare, which became the official school of Bhutan. By extension, the name is given to all the Bhutanese people.

Dungchen: long horns used in religious rituals.

Dzong: fortress, seat of the civil and religious authorities in each province.

Dzongda: district governor.

Dzongkha: national language of Bhutan, a close relative of Tibetan.

Dzongkhag: district.

Gelong: ordained monk.

Gelugpa: "those of the virtuous tradition". One of the four great religious schools of Tibet, reformed by Tsong Khapa in the 15th century.

Gho: traditional garment worn by men.

Gomchen: lay priest who has not taken vows, may be married and usually lives with his family.

Gompa: monastery.

Gönkhang: temple dedicated to the wrathful protective divinities.

Jachung: mythical bird often represented on walls of houses and monasteries. Garuda in Sanskrit.

Je Khenpo: spritual leader of Bhutan.

Kabney: scarf worn by men when entering a *dzong* or for certain official ceremonies.

Kagyupa: "those of the oral tradition". One of the four great religious schools of Tibet, going back to Marpa and Milarepa in the 11th century.

Karmapa: head of the karma-kagyu religious school.

Khemar: red band found at the top of walls to indicate the religious character of the building.

Kira: traditional garment worn by women.

Kuensel: Bhutan's national weekly newspaper.

Koma: buckles used to hold women's dresses at the shoulder.

Lhakhang: temple, literally "home of the gods".

Lhotsampa: people of Nepalese origin living in southern Bhutan.

Lyonpo: title borne by ministers.

Mandala: religious diagram, often with geometrical shapes, and used as a basis for meditation.

Mönpa: name given to certain people of central Bhutan and the Indian state of Arunachal Pradesh.

Ngadja: Indian-style hot, sweet tea with milk.

Ngalong: people living in western Bhutan.

Ngultrum: Bhutanese currency on par with Indian rupee.

Nyingmapa: the "tradition of the ancients", one of the four great religious schools of Tibet, founded in the 8th century by Guru Rinpoche.

Pazap: name given to soldiers recalling the troops of Ngawang Namgyel during the Punakha procession.

Penlop: name given to regional governors before the advent of the monarchy in 1907.

Rachu: strip of cloth worn by women over the left shoulder when entering a *dzong* for certain official ceremonies.

Rinpoche: title given to reincarnated lamas.

Serda: formal procession with musical band to welcome dignitaries.

Shabdrung: title given to Ngawang Namgyel and his successive reincarnations. Means literally "he at whose feet one submits".

Sharchop: people living in eastern Bhutan.

Sharchopkha: language spoken by the inhabitants of eastern Bhutan; its proper name is *tsangla*.

Sudja: Tibetan-style buttered and salted tea.

Stupa: Sanskrit equivalent of *chorten*.

Terma: sacred texts, hidden by Guru Rinpoche in the 8th century.

Tertön: discoverers of *terma*, appearing over the centuries to complete the teaching of Guru Rinpoche.

Thangka: religious iconography on cloth, painted or embroidered.

Thongdroel: huge *thangka* displayed during religious festivals.

Thrimpön: district judge.

Trulku: title for reincarnations of high lamas

Tsechu: religious festival given in honour of Guru Rinpoche on the tenth day of the month.

Tshogdu: Bhutan's national assembly.

Utse: massive tower at the centre of a *dzong*.

Yathra: woollen cloth woven in the Bumthang region.

Zao: toasted rice generally served with tea.

RECOMMENDED READING LIST

SACHARYA Sanjay - *Bhutan, Kingdom in the Himalaya* - Delhi, Lustre Press/Roli Books 1999.

ADAMS Barbara - *Traditional Bhutanese Textiles* - Bangkok, White Orchid Press - 1984.

ARIS Michael - *Bhutan, The Early History of a Himalayan Kingdom* - Warminster, Aris & Philips 1979.

ARIS Michael - *Views of Medieval Bhutan* - London, Serindia 1982.

ARIS Michael - *The Raven Crown: the Origins of Buddhist Monarchy in Bhutan* - London, Serindia 1994.

ARMINGTON Stan - *Bhutan* - Hawthorn, Lonely Planet 1998.

CHODEN Kunzang - *Folktales of Bhutan* - Bangkok, White Lotus 1993.

CHODEN Kunzang - *Bhutanese Tales of the Yeti* - Bangkok, White Lotus 1997.

COLLISTER Peter - *Bhutan and the British* - London, Serindia 1987.

DOWMAN Keith - *The Divine Madman, The Sublime Life and Songs of Drukpa Kunley* - London, The Dawn Horse Press 1980.

EDEN Ashley - *Political Missions to Bootan (1865)* - Delhi, Manjusri Publishing 1972.

EDMUNDS Tom Owen - *Bhutan, Land of the Thunder Dragon* - London, Elm Tree Books 1988.

INSKIPP Carol and Tim - *An Introduction to Birdwatching in Bhutan* - WWF Thimphu 1995.

KINGA Sonam - *Gaylong Sumdar Tashi, Songs of Sorrow* - Thimphu 1998.

MARKHAM Clements Robert - *Narrative of the Mission of George Bogle to Tibet and Bhutan* - Delhi, Manjusri Publishing 1971.

MYERS Diana K. and BEAN Susan S. - *From the Land of the Thunder Dragon, Textiles Arts of Bhutan* - London, Serindia 1994.

NISHIOKA Keiji and NAKAO Sasuke - *Flowers of Bhutan* - Tokyo, Asahi Shimbum Publishing 1984.

OLSCHAK Blanche - *Ancient Bhutan: A Study on Early Buddhism in the Himalaya* - Zürich, Swiss Foundation for Alpine Research 1979.

PEMBERTON Capt. R. Boileau - *Political Missions to Bootan (1865)* - Delhi, Manjusri 1972.

POMMARET Françoise - *Bhutan, The Himalayan Kingdom* - Hong Kong, Odyssey Guides 1994.

RICARD Matthew - *Journey to Enlightenment, The Life and World of Dilgo Khyentse, Spritual Teacher from Tibet* - New York, Aperture 1996.

SCHICKLGRUBER Christian and POMMARET Françoise - *Bhutan, Mountain Fortress of the Gods* - London, Serindia 1997.

SOLVERSON Howard - *The Jesuit and the Dragon, The Life of Father William Mackey in the Himalayan Kingdom of Bhutan* - Outremont, Robert Davies Publishing 1995.

TURNER Samuel - *Narrative of a Journey through Bootan and Tibet (1800)* - Delhi, Manjusri 1971.

URA Karma - *The Hero with a Thousand Eyes* - Thimphu, Karma Ura 1995.

URA Karma - *The Ballad of Pemi Tshewang Tashi* - Thimphu, Karma Ura 1996.

WANGCHUCK Ashi Dorji Wangmo - *Of Rainbows and Clouds, The Life of Yab Ugyen Dorji as told to his daughter* - London, Serindia 1998.

WHITE Jean Claude - *Sikkim and Bhutan. Twenty-one years on the North-East frontier* - Delhi, Vivek 1971.

WILLIAMSON Margaret - *Memoirs of a Political Officer's Wife in Tibet, Sikkim and Bhutan* - London, Wisdom 1987.

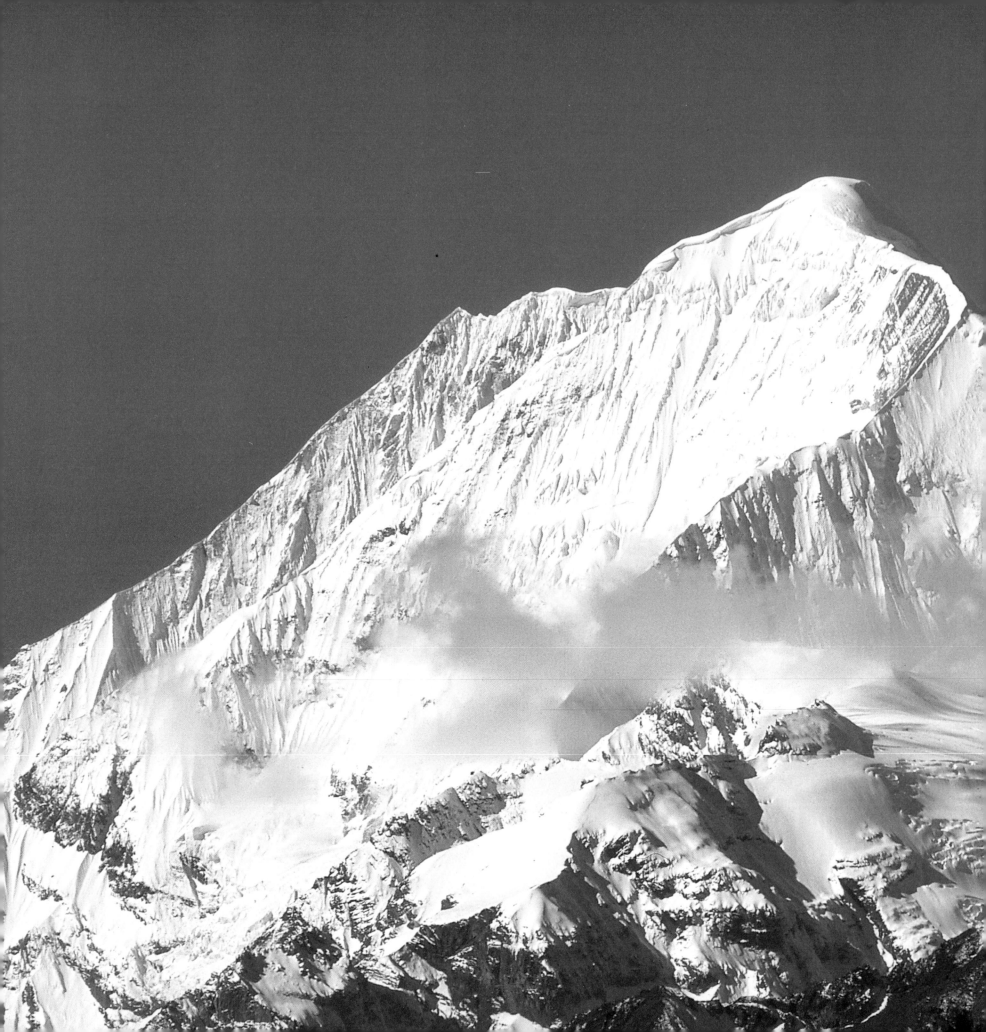